To my mother Lani DeLong who taught me to dream about mysterious places and fantastic worlds.

And to my wife Miyuki who travels them with me.

妖
怪

THE ULTIMATE GUIDE TO
Japanese Yokai

Ghosts, Demons, Monsters and
Other Mythical Creatures from Japan

By ZACK DAVISSON

TUTTLE Publishing

Tokyo | Rutland, Vermont | Singapore

Contents

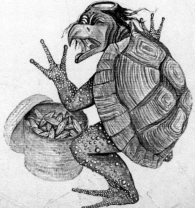

Introduction

"The most beautiful thing that
we can experience is the mysterious."
– Albert Einstein

"Countless variety of Yokai have been born, countless
Yokai stories told and art created. Not because they
are something we fear, but because playing with the
mysterious brings us great pleasure."

– Komatsu Kazuhiko

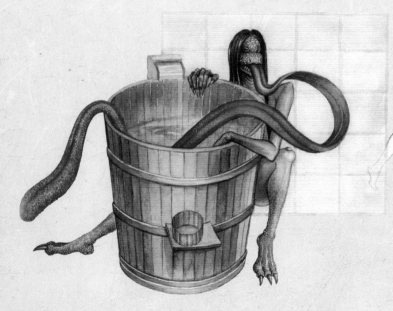

An Akaname (facing page) licks a bath as a woman flees in terror. (2011) Image courtesy Roberta Mašidlauskytė.

The ghost of Oiwa (right) portrayed by Ichikawa Yonezo from a *kabuki* play about the ghost story. (1865) Enjaku.

What are Yokai?

In *An Introduction to Yokai Culture* (2017), scholar Komatsu Kazuhiko tells a story. He was giving a talk on ghost stories and in the middle of his lecture the lights went off. It was eventually traced to a burned-out light bulb, but in those few delicious moments when there was no explanation, when the hint of the possibility of something beyond the realm of human knowledge lingered, when the spark of the unknown flowed through the crowd like lightning and their hairs stood on end, that sensation, that feeling—that was Yokai.

Any book that promises a complete, absolute definition of Yokai is probably not a book worth reading. Yokai are, by their nature, indefinable. They are the mysterious manifest. They are the unknowable. And yet, without understanding Yokai, you can never truly know Japan.

Yokai are not fears personified (although they can be). They are not cautionary tales (although they can be). They are not explanations of natural phenomena (although they can be). They are not once-worshipped gods faded with time (although they can be). Yokai are not even exclusively Japanese. Many have origins in China, India, Korea, and Arabia. Traders along the Silk Road brought stories along with goods for sale.

Yokai are creatures of the boundaries. They are the in-between, existing in twilight and at the turn of the seasons. Yokai are the shadowy corners of your room. They lie beneath the surface of dark water. They walk behind you at night. Yokai are also puns and clever word play. They are witty political commentaries. They are crude jokes. Yokai are imaginative designs by artists trying to sell you a glimpse

of the fantastic. They are characters invented by writers and playwrights. Yokai are stories told around campfires. They are product mascots. They are art. They are commerce. Yokai are an expression of human imagination and creativity, and equally limitless.

Scratch the surface of Japan and you'll find Yokai. They play a fundamental role in Japanese culture, and—given the penetration of Japanese entertainment—world culture.

Yokai are in the cinema. *My Neighbor Totoro* is an excellent Yokai film. As is *Godzilla* (Yes, I went there.). They are in comics and other entertainment media...manga, anime, and games burst with Yokai: *Demon Slayer, Naruto, Mushishi, Natsume's Book of Friends, Kitaro*.... If you are reading this book, I'm guessing you count some of these among your favorites. They are in the language (calling someone a Tengu means they are full of themselves). They are in food and drink, such as Kappa sushi and Kitsune udon. Yokai are everywhere in Japan. Tanuki smile from restaurant entrances. Red-faced Tengu peek out from the shadows. Oni guard the corners.

And they change. Bakemono, another name for Yokai, means "changing things." They are born and die. They reflect the times. Yokai today are not the same as Yokai from yesterday or of tomorrow. Freezing them in a single point of time, defining them absolutely, would end them.

That is not to say that some do not try. In the early Meiji period, philosopher Inoue Enryo pioneered the field of *Yokaigaku*—Yokaiology, the study of Yokai—with the specific goal of ending Yokai. Using the modern tools of science, he hoped to banish Yokai to a superstitious past. Folklorist Yanagita Kunio disagreed, seeing Yokai as valuable to Japanese culture. Their battle set the stage ever since. I promise that someone disagrees with everything you will read in this book. There will never be a universal consensus on Yokai. It's part of the tradition. Some such as Mizuki Shigeru and Komatsu Kazuhiko take a broader view. They see Yokai as threads on the grand supernatural tapestry of human existence. Others choose stricter definitions. You will find researchers who drill down on what can be codified and quantified, eliminating the rest as distraction, hunting for signal in the noise. Some view Yokai through the lens of history. Some through the screens of pop culture. I lean towards the broadest side.

Rokurokubi (below) with a neck of smoke. HappySloth/Shutterstock.com.

Dancing Nekomata (facing page) painted on three pieces of paper pasted together. Probably done as an art exercise. *Frolicking Animals, Cat and Raccoon* (19th century) Kawanabe Kyosai.

And now, in spite of what I said about Yokai being unexplainable, I give you an entire book explaining Yokai. For as elusive as Yokai are, we can catch glimpses of these things that hide in the shadows and flicker at the edge of human consciousness. We can coax them from their liminal spaces and have them stand in the light, if only for a little while.

The Evolution of Yokai: From Nothing to Something

Changing things change. Yokai as we know them today would be unrecognizable to the ancient people of Japan. They saw the dark places of the world occupied not with bouncing umbrella monsters or shape-shifting foxes, but with dangerous supernatural energy.

PREHISTORY AND MITAMA

The oldest known written version in a Japanese text of the word Yokai (妖怪) comes from *Shoku Nihongi* (772). It records a ritual to clean out "accumulated Yokai in the Imperial court." From context we assume Yokai referred to negative spiritual energy, something akin to "bad juju." However, the word was not in common usage.

> **Yokai** is written 妖怪
> 妖 (yo) – uncanny, suspicious, spooky, ominous
> 怪 (kai) – strange, wonderous, supernatural, weird

Of these, kai (怪) is the weightier one. It appears in words pertaining to the supernatural, such as Kaiju (怪獣) combining 怪 (kai; mysterious) + 獣 (ju; beast, animal) meaning "strange animal" or Kaidan (怪談) combining 怪 (kai; mysterious) + 談 (dan; stories) to mean "weird tales."

While not necessarily evil, Yokai (妖怪) gives a feel of the supernatural tinged with danger, beyond human control.

Before the eighth century Japan had no written records. Much of what we know comes from Chinese accounts. The Han dynasty *Records of the Three Kingdoms* (220–280 CE) tells of an island across the sea, the Land of Wa, governed by shaman-queen Himiko. She ruled with magic and sorcery and was able to predict the weather, a mighty power in the age of rice cultivation.

Like many cultures, Japan's beliefs were founded on animism. Derived from the Latin anima, meaning "breath," it defines a world filled with spirits. These can be spirits of nature, of rocks and trees and wind. Or spirits of animals and insects, both real and imaginary. Or spirits of the dead. In animism, these spirits are of "this world." They do not reside on separate planes, in Olympus

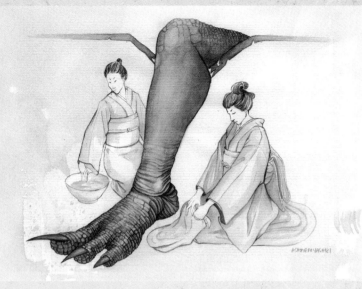

Ashiarai Yashiki descends from the ceiling as servants prepare to wash it. Once cleaned, the massive foot would rise and disappear. (2011) Image courtesy Roberta Mašidlauskytė.

or Hades. There is no distinction between spiritual and material worlds. All exist together.

These spirits are neither good nor evil. Like fire, earth, wind, and water, these primal forces are equally beneficial and harmful. The fire that warmed you could burn you. The oceans from which you pulled your livelihood could rise in a tsunami and destroy your village.

Sometimes known as Tama (霊) or Mitama (御霊), this spiritual energy had a dual nature. When pleased and harmonious, they were Nigi-mitama (和御霊) meaning gentle spirits. Conversely, the same energy could manifest as Ara-mitama (荒御霊), meaning rough or wild spirits. Nigi-mitama ensured good harvests and health. Ara-mitama brought famine, lightning, and disease.

Like cats on a couch, this spiritual energy was quick to lash out when annoyed. But it could be tamed into a gentle purr by a soft blanket and ear scritches. Ritual was the key to coaxing Mitama into showing their gentle face, their Nigi-mitama. Spirits needed to be fed and entertained. Dances were performed for them. Food set before them.

Ostensibly possessing powers beyond humanity, Mitama could be influenced and controlled. Shown proper respect, they were coaxed into shrines where they served as spiritual batteries for communities. Through ritual and worship, villages ensured Nigi-mitama manifested instead of Ara-mitama. This was the beginnings of the native Japanese religions we now call Shinto.

Powers beyond the realm of human influence, which could not be tamed, were known by terms such as Mono (物) or Oni (鬼). This was the beginning of Yokai.

Marebito

While Mitama was formless and invisible, there were legends of strange beings who walked Japan, bringing gifts and knowledge. Called marebito, they visited from beyond the horizons. An isolated island with no reason to believe anything existed over the oceans, it is easy to speculate on shipwrecked sailors from Asia or even Europe, washing up on Japanese shores with strange, advanced technology. They may have brought myths as well. Similarities between Japanese creation myths and those of southeast Asia have led to speculation of cultural exchange as early as the Jomon period (6,000–300 BCE).

> **Marebito** is written 稀人
> 稀 (mare) – rare
> 人 (hito) – people

The Arrival of Buddhism

In 552, envoys from King Seong of Baekje, modern day southwestern Korea, arrived in Japan. They brought gifts, including a statue of Buddha. Instead of the esoteric energy of Shinto, the elevated beings of Buddhism had physical representation in the form of statues worshipped in Temples. They had rules and regulations. This appealed to some of Japan's elite.

In a common story when two religions meet, Buddhism and Shinto went to war. In 587, the Buddhist Soga clan defeated the Shintoist Mononobe clan, and established a Buddhist government.

The usual outcome of religious wars is replacement and suppression; Japan instead chose merger. Shinto and Buddhism joined as Shinbutsu. In this new religion, Buddhist deities were the primary over-gods who ruled the heavens, while Shinto Kami were subordinate earthly over-seers. You could dance before the Shinto shrines for a good harvest and then pray to Vairocana for blessings of the universe.

KOJIKI – RECORD OF ANCIENT MATTERS

In 711, Empress Genmei ordered the writing of an imperial history. By 712, chronicler O no Yasumaro had compiled and edited *Kojiki*, or *Record of Ancient Matters*. *Kojiki* laid out an official mythology of the birth of Japan. It says Japan was created by Izanagi and Izanami, sibling gods who give birth to the Kami. Among their children are the sun goddess Amaterasu and her brother, the impetuous storm god Susanoo. One of Amaterasu's great grandchildren was Jimmu, the legendary first emperor of Japan. *Kojiki* established the imperial Yamato clan's divine right of rule.

There is controversy over *Kojiki*. The humanistic, emotional Kami of *Kojiki* have little in common with the formless energy of earlier folk beliefs. They are mostly likely a mélange of ancestral clan deities and creation myths wielded into a single mythology

with Yamato deities given the top spots. Some researchers connect the sun goddess Amaterasu with Queen Himiko. Given enough centuries the weather-predicting shaman-queen may have evolved into the goddess of the sun. Whatever the truth, historians believe *Kojiki* to be primarily a work of propaganda.

Successful propaganda. *Kojiki* cemented the celestial lineage of the Yamato clan. This lasted until 1946 at the end of World War II, when Emperor Hirohito official renounced his divinity.

FUDOKI – LOCAL LEGENDS

Empress Genmei also ordered provincial governments to create regional gazetteers, called *fudoki*. They collected names of districts, natural resources, and local myths and legends. Of these only the *Izumo Fudoki* remains intact, showing an interesting collection of deities and creation myths different from the official mythology of *Kojiki*. One tells of the god Yatsukamizu Omitsuno. Discontented with the small size of his domain he saw other lands over the waters. Omitsuno cut off chunks of them and pulled them across the sea to create the Japanese archipelagos.

The Heian Period and Mononoke

The influence of cultural contact kick started the Heian period (794–1185), and with it a new sobriquet for Japanese supernatural. In the court history *Nihon Koki* (840), an entry says Mononoke were causing illness in the Imperial court. An *Onmyoji* court sorcerer was summoned to pacify them with prayers.

Mononoke is written 物の怪
物 (mono) – thing, object, evil spirit
の (no) – possessive, "of"
怪 (ke, kai) – strange, wonderous, supernatural, weird

Tengu statue in front of Kurama Station, Kyoto, in front of Mount Kurama where Sojobo taught martial arts to Minamoto. b-hide the scene/ Shutterstock.com.

Also, incorporating 怪 (kai), Mononoke was adopted from the Chinese 物怪 (mokke) meaning things without form or voice. Mononoke were invisible, evil energy. Mononoke has a malevolent feel to it. The film title *Princess Mononoke* is more sinister in Japanese.

In a time before germ theory, illness was terrifying and mysterious. People fell ill for unperceivable reasons. Some got better. Some died. In the Heian period this was thought to be the work of Mononoke, and evil spirits called Yakubyogami. Vengeful spirits whose curses caused disease, Mononoke were often spirits of the dead. They attached themselves to living beings. *Onmyoji* could transfer or banish Mononoke, curing the possessed.

Mononoke was widely used and appears in other

literature of the time. The famed 11th century novels *Genji Monogatari* and *The Pillow Book* both mention Mononoke, as does historical fiction like *Okagami* (1119).

KONJAKU MONOGATARI – TALES OF TIMES NOW PAST

One of Japan's oldest collection of folktales, *Konjaku Monogatari*'s origin is a mystery. Neither author nor date are known. Estimated to have been completed sometime in the early 12th century, *Konjaku Monogatari* is the foundational text for all Yokai stories to follow. It collects supernatural tales of three countries, paralleling Buddhism's transmission from India, to China, and finally Japan.

Konjaku Monogatari are mostly morality tales involving humans and the supernatural. There are encounters with ghosts, talking animals, as well as Tengu and Oni. Tengu are evil Buddhists monks who have fallen off the path. Oni are malevolent spirits. The stories emphasize karmic retribution, showing punishment and rewards for sin and righteousness.

HYAKKI YAGYO – NIGHT PARADE OF A HUNDRED DEMONS

A story in *Konjaku Monogatari* tells of Fujiwara no Tsuneyuki out on a midnight stroll to meet his mistress, when he encountered a group of a hundred Oni. Fortunately, his wet nurse had sewn a Buddhist sutra into his clothing. This repelled the demons.

Similar tales of random encounters with monster hordes appear in other period texts. These stories end with the creatures fleeing before a talisman, demonstrating Buddha's power. Their number is often given as 100, which is not exact but means "really big number." The monsters are vaguely described. *Uji Shui Monogatari* (1220?) describes them as "having features such as a single eye."

From these stories spread belief in a nightmare parade that roamed the streets of Kyoto called *Hyakki Yagyo*. People took this parade seriously believing it was deadly to be caught in it. *Onmyoji* predicted the nights it would occur so people could stay home. However, there wasn't much to fear since holding a Buddhist talisman or chanting a simple charm protected you from the pandemonium.

> **Hyakki Yagyo** is written 百鬼夜行
> 百 (hyaku) – one hundred
> 鬼 (ki, oni) – evil spirit
> 夜 (ya) – night
> 行 (gyo) – to move

Hyakki Yagyo uses 鬼 (ki) instead of 怪 (kai). It is usually translated as the "Night Parade of 100 Demons," although this could easily be "Night Parade of 100 Oni."

MUROMACHI PICTURE SCROLLS

Yokai got something new and exciting during the Muromachi period (1336–573)—bodies. Inspired by *Hyakki Yagyo*, artists painted scrolls depicting a parade of creatures marching through the night. Called *Hyakki Yagyo-e*, the oldest extant comes from the 16th century, believed to have been painted by the artist Tosa Mitsunobu, although this is disputed. Known as the *Shinju-an* scroll, it is held in Daitokuji temple in Kyoto. There are records of older scrolls. An Edo period book *Honcho Gazu Hinmoku* tells of a 1316 scroll painted by Tosa Tsunetaka.

There are currently 18 surviving *Hyakki Yagyo-e*. They are not exact copies but have two distinct systems which modify which Yokai are represented and in what order. The *Shinju-an* scroll is the oldest and most basic in design, with fewer Yokai and less artistic flourishes. Most *Muromachi* scrolls follow these patterns with variations in order.

Recent discoveries uncovered another system of *Hyakki Yagyo*, with different Yokai and scenery. Most of these come from the early to late Edo period, however it is speculated that they are also copies of older scrolls now lost. The *Hyakki Yagyo Emaki* held at the Kyoto Municipal University of Arts is one of the earliest surviving of these.

We have no idea where the creature designs of either system originated, what their names were, or if they had stories. The Muromachi artists must have imitated some established template, but it is lost forever. Whatever their origin, these designs became the visual template for Yokai.

A red-haired Amabie (facing page) with the distinctive three fins. Christopher Volk/Shutterstock.com.

A Kitsune guardian statue (below) at Fushimi Inari shrine in Kyoto with a messenger scroll in its mouth. Olivier Lejade/Flickr.com.

The Edo Period and Obakemono

The Edo period (1603–1867) is the golden age of Yokai. During a period of isolation, Japan experienced an explosion of art, literature, theater—and Yokai.

The Edo period was a perfect storm of invention. Newly discovered printing techniques brought entertainment to the masses. *Kabuki* theater was invented in Kyoto. And a parlor game called *Hyakumonogatari Kaidankai* swept the nation. In this game, players lit a hundred candles and took turns telling spooky stories. With each tale, a candle was extinguished. The atmosphere thickened as the room grew darker and darker. *Hyakumonogatari Kaidankai* was a test of courage; someone always stopped the game before the final candle went out.

Artists and writers found supernatural works in high demand...too much demand. There was a larger appetite for works of the weird than there

was for traditional folklore. Not ones to pass up opportunities, artists and writers began inventing new Yokai, or Obakemono, as they were known.

KINMOZUI – ILLUSTRATIONS TO INSTRUCT THE UNENLIGHTENED.

Japan's first illustrated encyclopedia, *Kinmozui*, was compiled by scholar Nakamura Tekisai in 1666. Combining illustrations with descriptions in both Chinese and Japanese, this was intended to teach children about the natural world. While a catalog of the natural, and not the supernatural, there are several entries for Yokai. During the Edo period these were considered real creatures.

WAKAN SANSAI ZUE – ILLUSTRATED SINO-JAPANESE ENCYCLOPEDIA

In 1712, Doctor Terajima Ryoan from Osaka created *Wakan Sansai Zue* containing entries on astronomy, botany, and biology. Considerably larger than *Kinmozui*, there are multiple entries for Yokai including the oldest known illustration for Kappa.

GAZU HYAKKI YAGYO – ILLUSTRATED NIGHT PARADE OF A HUNDRED DEMONS

A four-volume series by artist Toriyama Sekien, *Gazu Hyakki Yagyo* revolutionized the representation of Yokai. Instead of treating them as a group, it created individual accounts of Yokai, giving them set locations and identities. This series is the ancestor of all subsequent Yokai encyclopedias, including the venerated *Pokédex* of the media franchise Pokémon and the book you are reading now.

Obakemono is written **お化け物**
お (o) – an honorific meaning "honorable"
化け (bake) – changing
物 (mono) – thing, object, evil spirit

Bakemono and the diminutive Obake are still in use in modern Japanese. They are colloquial terms. Children especially use Obake over the more formal Yokai. You also hear the terms when referring to haunted houses, known as Obake Yashiki.

With a literal meaning of "changing things," Obakemono originally referred to shapeshifting creatures. With time it evolved to encompass all manner of monsters. Bakemono was used by artists for picture scrolls such as the *Bakemono no e* (17th or early 18th century).

In the Edo period that Yokai developed identities and personalities. Many folktales had previously been auditory phenomenon.

But artists cannot sell the invisible. Characters were envisioned for them. An example is yanari, meaning strange noises in a house. An artist cannot sell you a picture of strange noises, so Toriyama Sekien envisioned miniature elf-like creatures running around shaking a house to produce the sounds.

The Meiji Period and Yokai

At last, we come to when Yokai became Yokai. Although it has ancient origins, the word Yokai is a modern term that refers to Japan's supernatural creatures. It came about around the Meiji period, with the advent of academic Yokai research.

When the Edo period ended, Japan was pushed into the modern world. It was a rude awakening for the technologically stunted nation. Change was rapid as Japan adopted revolutionary advancements in technology and science. It was during this era, the Meiji period, that scholars first began researching Yokai. Professors needed to call them something, and Yokai was the chosen word. Researchers attempted to explain Yokai, define them, and structure Japan's eclectic supernatural world. They largely failed to bring about concensus, but their research was invaluable.

TONO MONOGATARI – TALES OF TONO

Inspired by the Brothers Grimm, in 1910, folklorists Yanagita Kunio and Sasaki Kizen headed to the northern region of Tono to capture vanishing folklore and oral traditions. Writing down tales of Kappa and Zashiki Warashi, their book *Tono Monogatari* became the foundation for all folklore studies to follow.

The Showa Period and Manga

The Showa period was a turbulent time, from the destruction of World War II to the heights of the economic miracle and the Bubble Era then crash and crescendo all over again. For Yokai, it was a period of transition from folklore to pop culture.

Manga artist and folklorist Mizuki Shigeru was almost single-handedly responsible for the Showa Yokai boom. His comic *Kitaro* ignited a national mania for Yokai. Mizuki branched out beyond comics, creating Yokai encyclopedias, Yokai art books, and Yokai cartoons and films. His influence on modern culture cannot be overstated.

Others took up the torch, such as Takahashi Rumiko with her Yokai series *Urusei Yatsura* (1976). and *Inu Yasha* (1996). Her work inspired others, and Yokai steadily became a vital part of Japanese popular culture, which they remain to this day.

Kasaobake (facing page) stands on its one leg. G.Rena/ Shutterstock.com.

A Tanuki (below) prepared for a journey and ready for adventure. Stygian_ Art/Shutterstock.com.

KITARO

Mizuki Shigeru's comic *Kitaro* told the story of Kitaro and his father Medama Oyaji as they fought against hordes of evil Yokai. *Kitaro* introduced Yokai to generations of Japanese children and continues to be popular to this day.

Yokai Hakase – The Yokai Professors

While many studied and influenced Yokai, there are a few names you will hear repeatedly. These are the *Yokai Hakase*—the Yokai professors who have innovated, influenced, and instructed on Yokai over the centuries.

Sawaki Sushi (1707–1722) A disciple of Hanabusa Icho, Sawaki Sushi was an Edo period painter whose greatest work was *Hyakkai Zukan* (1737). Based on *Muromachi Hyakki Yagyo* scrolls, Sawaki's painting was a bestiary, showcasing 30 individual creatures with labeled names. Many of these creatures appeared appeared here for the first time.

Toriyama Sekien (1712–1788) Retired servant of the Tokugawa Shogunate and an artist trained in the Kano school traditions, Toriyama Sekien illustrated four mass-market Yokai encyclopedias that influenced all Yokai studies to follow. A skilled, innovative woodblock printer, Sekien was inspired by Sawaki's painting and the popular *Wakan Sansai Zue* (1712) natural encyclopedia. He created *Gazu Hyakki Yagyo* (1776), illustrating 51 Yokai. Unlike Sawaki's painting, Sekien's was mass-produced. It could be printed and reprinted to meet demand. And the demand was certainly there. He followed with a sequel, *Konjaku Gazu Zoku Hyakki* (1779), which added text to the images to create the first Yokai encyclopedia. Sekien's spark of genius was to present Yokai as distinct, separate entities instead of as parts of a larger group.

When readers demanded more, Sekien had a problem; he had run out of Yokai. Unperturbed, he simply invented more. From the third volume on, Sekien supplemented folk stories with his own creations. He based them on puns and clever word play, political and cultural parody, or adopted them from popular literature. Of the more than 200 Yokai in Sekien's books, it is estimated that 85 are his own creations.

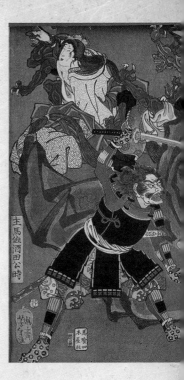

Inoue Enryo (1858–1919) The first
person to be referred to as a *Yokai
Hakase*, Inoue founded *Yokaigaku*,
or Yokaiology, the study of Yokai.
His ultimate goal was the debunk-
ing of superstitious beliefs so Japan
would fully move into the modern
world. Inoue popularized the word
Yokai, supplanting the colloquial
Obakemono and historic Mononoke.

In his *Yokaigaku Kogi* (1893 and
1894), Inoue cataloged and explained
folk beliefs as misunderstood natural
phenomenon or the result of human
behavior.

Yanagita Kunio (1875–1962) In opposi-
tion to Inoue, Yanagita Kunio founded
Minzokugaku, or folklore studies.
Inspired by the Brothers Grimm and
their efforts to preserve German
traditions, Yanagita and his partner
Sasaki Kizen traveled northern Japan
collecting and recording oral folklore.
Together they published *Tono Monogatari* (1910), Japan's version of
Grimm's Fairy Tales.

Lafcadio Hearn (1850–1904) Also known by his Japanese name
Koizumi Yakumo, Hearn lived in Japan from 1890 until his death in
1904. Fascinated by folklore, Hearn gathered ghost stories and other
legends to record them in books such as *In Ghostly Japan* (1894)
and *Kwaidan: Studies and Stories of Strange Things* (1904). Hearn's
work was very popular abroad as well as in Japan. His stories were
written in English but translated into Japanese and are the best-
known version of many traditional tales.

Mizuki Shigeru (1922–2015) Philosopher, folklorist, and comic artist
Mizuki Shigeru popularized Yokai and sparked the Showa Yokai
boom. Raised on old stories told to him by a local elderly woman
he called Nononba, Mizuki loved Yokai and filled his comic *Kitaro*
(1960s) with them. Mizuki included Yokai quizzes and trivia in his
works, fascinating the children of Japan. He would later publish
more scholarly works, following in Toriyama Seiken's footsteps to
create definitive Yokai encyclopedias. To most of modern Japan,
Mizuki Shigeru IS Yokai.

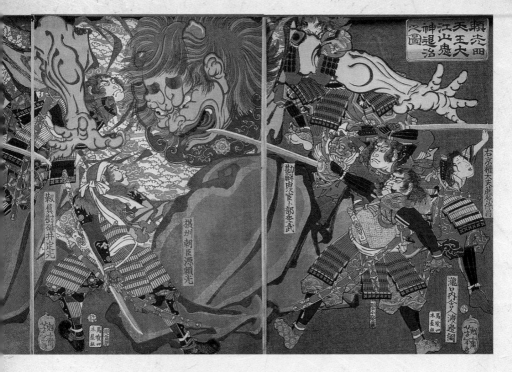

Komatsu Kazuhiko (1947–) Sparking the first academic exploration of Yokai since the Meiji period, Komatsu challenged older beliefs in *Yokaigaku Shinko* (1994) and helped in the creation of the Kaii-Yokai Densho Database, a government-sponsored database of Japanese folklore and Yokai.

Noriko Reider (1958–) A pioneer of English-language Yokaiology, Reider explored the evolution of Yokai storytelling in *Tales of the Supernatural in Early Modern Japan* (2002) as well as deep-dive explorations of Oni and Yamauba.

Michael Dylan Foster (1965–) A student of Komatsu, Foster has brought much new insight into English-language Yokaiology and has bridged academia and pop culture with his works *Pandemonium and Parade* (2008) and *The Book of Yokai* (2015).

There are others involved in modern Yokai research and popularization. Matt Alt and Hiroko Yoda. Matthew Meyer. Me. All are part of an ever-growing movement as enthusiasm for Yokai grows.

Categorizing Yokai

The two big debates in Yokai research are "What are Yokai?" and "How do you categorize them?" Categorization of Yokai began with Meiji

period *Yokaigaku* studies. Academia requires categorization; things must be segmented, labeled, grouped. It is how you forge order out of chaos. And how you systematize. It is also required when you write books. Ideas must be organized into chapters. There needs to be some logical structure. But of course, everyone disagrees about what that structure should be.

Inoue Enryo had a complex taxonomy of Yokai depending on how mysterious they were. Under the broad category of Yokai, he split them first as Kyokai (虚怪) and Jikkai (実怪), or true and fictitious mysteries. Kyokai (fictitious) was then split into Gikai (偽怪), or artificial mysterious created by people, like the Fiji mermaid, and Gokai (誤怪), or misunderstood mysteries, meaning misidentification. True mysteries, Jikkai, could then be split as Kukai (仮怪), meaning provisional mysteries that could be explained. Kukai was further divided into Bukkai (物怪), or natural phenomenon, and Shinkai (心怪), or mental disorders. Inoue identified one more type of Jikkai, Shinkai (真怪), or true mysteries. In this category Inoue reserved space for the unknowable nature of the universe, the mind of God. A philosopher and Buddhist as well as scientist, Inoue did not claim to have all the answers. But he felt the Gikai, Gokai, and Kukai distracted from the true search to understand Shinkai.

Yanagita Kunio generally accepted Inoue's definitions, although he further split the broadest category of Yokai. Yanagita differentiated between Yokai, which he said haunted places, and Yurei, or ghosts, which he said haunted people. Yanagita also argued that Yokai were fallen deities of vanished cultures. Kappa, for example, were once water gods.

While Yanagita's ideas dominated for decades, Komatsu Kazuhiko points out how they don't hold up to scrutiny. Oni were always evil deities. There was never a time they were worshipped as gods. Many more Yokai were simply the invention of artists. Komatsu also points out how Edo period artists saw no need to differentiate between Yokai and Yurei. Toriyama Sekien merrily put Yurei next to Tanuki in his books. All that mattered was that they were mysterious—that they were Yokai.

Komatsu proposed his own categories:

* **Incidents** – Unexplained encounters, strange phenomena.
* **Supernatural entities** – Tengu, Oni, and other creatures that have plagued Japan since prehistory.
* **Depictions** – All the Yokai invented by artists, writers, and other creatives who have added to the vast pantheon of Yokai.

I like Komatsu's categories, but they are a little esoteric for a Yokai guide.

Others such as folklorist Ema Tsutomo, have categorized based on a Yokai's base form. He focused on shapeshifting Yokai called Henge and categorized them by human, animal, plant, object, or other. Some books categorize them by region of origin. Or by era. The five-volume *Sogo Nihon Minzoku Go* (1956) categorized them by location. Mysteries of mountains. Mysteries of trees. Mysteries of sound. Mysteries of snow. Etc....

Mizuki Shigeru, in his *Yokai Daihyakka* (2004) said that while Yokai were too amorphous to fit neatly into groups, if you wanted to organize Yokai by large categories, you could say there are:

* **Henge (shapeshifters)** – Beings that change from ordinary to extraordinary forms.

* **Kaiju (creatures)** – Beings with mysterious and magical powers.

* **Choshizen (super nature)** – Mysterious or puzzling natural phenomena.

* **Yurei (ghosts)** – The spirits of the dead lingering in the living world.

I find Mizuki's definitions to be tidy and workable for a guide to Japan's Yokai so that is what I chose. These categories are not meant to be academic or absolute. I chose them because they provided a good framework for the book, and to honor Mizuki Shigeru. As Michael Dylan Foster once said, all of us are disciples, or *"ha"* in Japanese, of the Yokai scholars who preceded us. He is Komatsu-ha. I am Mizuki-ha. Mizuki Shigeru was my entry into all things Yokai and my own personal *Yokai Hakase*.

In this book, I modified the categories a bit by substituting Kaibutsu for Kaiju, which I'll explain in that category. Not every Yokai is going to fit elegantly into every category. In fact, some won't fit at all. But that's Yokai for you. Much to Inoue Enryo's chagrin, they are folklore, not science.

I have tried to represent a broad range of Yokai, showcasing the breadth of their possibilities. Where possible, I have included counter arguments against their inclusion. Ultimately, whether you agree or disagree with my choice of Yokai and their categories, I hope that, as Komatsu said, "playing with the mysterious brings us great pleasure." Let's have fun!

CHAPTER 1
Henge
Shapeshifters

What are Henge?

In Japanese folklore, ordinary creatures can become extraordinary...if they live too long. Animals that live past their natural lifespans are said to transform into Yokai, gaining supernatural powers and abilities. This age depends on the animal. Foxes must live 50 years before transforming. Cats need only exceed their natural lifespan of 20 years or so. Spiders must live several centuries.

> **Henge** is written 変化
> 変 (hen) – strange, weird, peculiar
> 化 (ge) – changing
> Henge means "strange changers."

The chief power of Henge Yokai is shapeshifting. Having metamorphosed from normal animals they can continue to mold their bodies. They are not equally skilled. Japanese martens are said to be the most talented shape changers. Otters are the worst.

Much of Japan's transformed animal folklore is adapted from China. The *xian li* or *senri* was a native leopard cat thought to be able to transform to human shape past a certain age. The Huli Jing are magical, shapeshifting foxes that gain greater powers and tails the older they get.

I broaden the definition of Henge here, to be not only those that can transform but including those that have been transformed. Yokai can be formed in many ways.

The ability to gain magic with age is not limited to living things. Although they do not shapeshift, certain objects gain life and magic if they exist for a hundred years.

Bakezori (facing page) A straw sandal come to life as a Tsukumogami. (2011) Image courtesy Roberta Mašidlauskytė.

Obake Hochin (top) A traditional representation of a lantern ghost. G.Rena/ Shutterstock.com.

Kitsune Magical Foxes

Kitsune (bottom)
An illustration of a Kitsune holding her own heart. (2013) Image courtesy Eleonora D'Onofrio.

Tamamo no Mae (facing page), the nine-tailed fox, flees from China to India, where she takes the name Lady Kayo and torments Prince Hanzoku, as told in the 15th century book *Tales of Three Countries*. (19th century) Utagawa Kuniyoshi.

The woman you have called your wife for decades has always been perfect. Beautiful to behold, of gentle disposition, a good mother to your children. Even your judgmental family could find no fault with her. And yet one day, when she thinks you are away, you sneak back into the house to surprise her. You see her as she really is at last, a red tail tipped in white escaping her kimono. She is a Kitsune.

Kitsune—magical foxes—are one of Japan's oldest Yokai. *Nihon Shoki* (720), Japan's second oldest book, records a celestial phenomenon like a shooting star called 天狗. Normally read "tengu," *Nihon Shoki* gives the reading as amatsu Kitsune, or celestial fox.

> **Kitsune** is written 狐
> 狐 (Kitsune) – fox
> Another term for Yokai foxes is 化狐 (Bakegitsune).

Foxes are found across Japan. Fossil records show they have had a relationship with humans since ancient times. Kitsune folklore arrived in Japan from China and Korea, where they are respectively called Huli Jing and Kumiho. Those fox spirits are long-lived, evil animals able to take on female form. They seduce men and slowly consume the life-force.

Japanese Kitsune stories tend towards the romantic. Fox bride tales appeared in *Nihon Ryoiki* (787–824) and *Konjaku Monogatari* (12th century). A typical story tells of a lonely man who meets a beautiful woman. They fall in love and have a child. Everything is perfect until the man buys a puppy for their young boy, which attacks his wife and bites her arm. Startled, the woman reveals her true form as a fox and scampers away. The heartbroken man spends every night calling his beloved to come home. He does not care that she is a Kitsune.

These stories show genuine love between men and their fox wives, and often bitter sadness at their inevitable parting. The offspring of such unions were thought to have magical powers. Abe no Seimei, the famous Heian period (794–1185) *Onmyoji* (a court sorcerer who specialized in controlling spirits) was one such child.

Japan's Kitsune soon evolved from their origins, developing a unique, complex mythology. Kitsune merged with

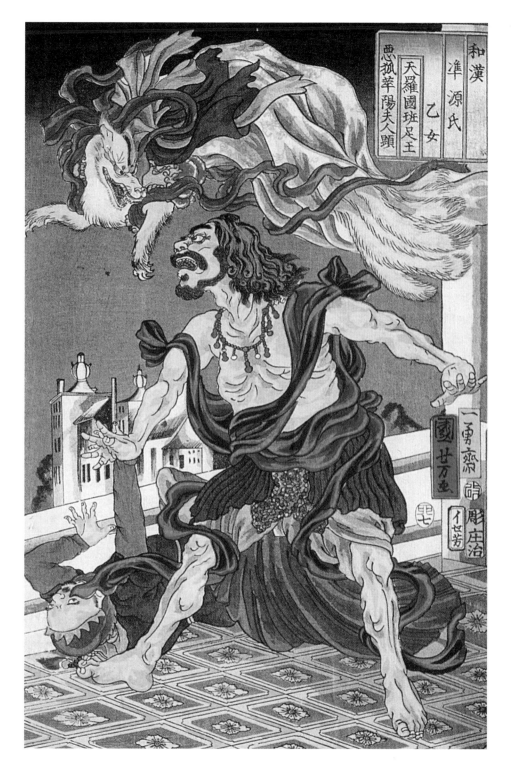

Henge Shapeshifters

A gathering of foxes (top left) at the Enoki tree in Oji on New Year's Eve breathe foxfire. By tradition, Kitsune would gather under here every year in formal attire to seek official positions. From the series *One Hundred Famous Views of Edo.* (1857) Hiroshige Ando.

The Kitsune Hakuzo (top right) who lived in Shorin-ji in Osaka and pretended to be a priest, lecturing hunters on the evils of killing foxes. After his disguise is revealed, he will be captured. From the series *One Hundred Aspects of the Moon.* (1886) Tsukioka Yoshitoshi.

Miuranosuke Tsunetane and Kazusanosuke Hirotsune (facing page) mounted on horseback killing the the nine-tailed demon fox of Nasu Moor with spears. Part of a triptych print. (1834) Utagawa Kuniyoshi.

sacred Kami, becoming the messengers for Inari Okami, the goddess of rice. Inari was said to have arrived in Japan astride a magnificent white fox. Kitsune shrines sprung up, where people prayed for good harvests.

Kitsune still acted as tricksters, drunkards, and general mischief makers. Unlike Huli Jing and Kumiho, Kitsune were not limited to female form. Kitsune fluidly transformed into old men, young women, and anything else that would help them work their trouble. They were often given away by a flash of tail or ear. After a few drinks too many, their concentration slipped.

In the Edo period, there were attempts to reconcile this sacred and profane. Confucian scholar Asakawa Zenan wrote *Zenan Zuihitsu* (1850) where he mused on clocks, soba noodles, and a hierarchy of Kitsune:

* Nogitsune/Yako (野狐; field fox) – The lowest form of magical Kitsune. Mischief makers, they possess humans and cause trouble. The only Kitsune visible to humans.

* Kiko (気狐; spirit fox) – A rank above Nogitsune, they exist as pure spiritual energy.

* Kuko (空狐; sky fox) – Thousands of years old and in full command of their magical powers.

* Tenko (天狐; heavenly fox) – A celestial being equivalent to a Kami. Possibly a Tengu.

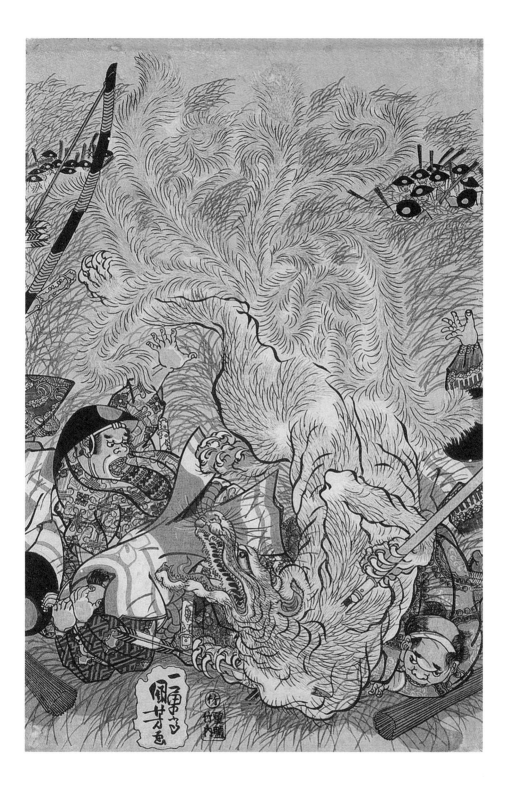

Henge Shapeshifters

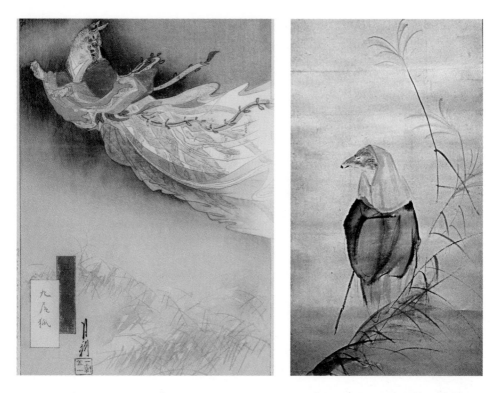

A nine-tailed **fox** (top left) flies through the sky, from the series *Gekko's Miscellany.*(1893) Ogata Gekko.

Hakuzo (top right), the Kitsune who lived in Shorin-ji in Osaka and pretended to be a priest. (19th century) Otagaki Rengetsu.

Kitsune at the Enoki tree (facing page) in Oji. From the series *Comical Views of Famous Places in Edo.* (1859) Utagawa Hirokage.

Miyakawa Masayasu's *Kyuusensha-manpitsu* (1853) added more ranks. He claimed an actual Kitsune as his source, who told him about Kitsune society. Miyakawa defines two types, Zenko (善狐), or good Kitsune, and Akko (悪狐), or bad Kitsune. The Zenko ranks are based on fur color:

* Kokuko (黒狐 black fox) – Auspicious omens.
 Avatars of the Big Dipper.

* Byakko (白狐 white fox) – Servants of Inari Okami,
 the Kitsune who marry humans.

* Ginko (銀狐 silver fox) – Manifestation
 of Yang energy, avatar of the Moon.

* Kinko (金狐 gold fox) – Manifestation
 of Yin energy, avatar of the sun.

* Tenko (天狐 heavenly fox) – A celestial being
 equivalent to a Kami.

Kitsune are ubiquitous in modern Japan. Their shrines are everywhere. They are characters in manga and animation. Kitsune are deeply beloved, respected, and feared.

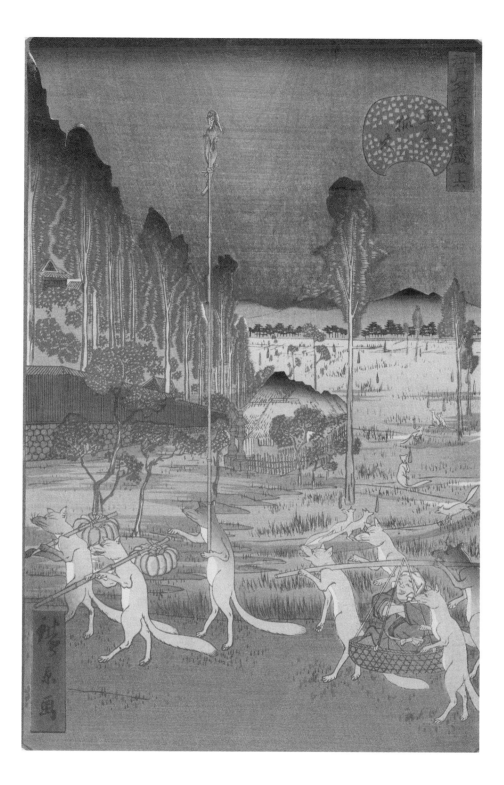

Henge Shapeshifters

Tanuki Mischievous Racoon Dogs

Wandering home one night, a little drunk from the evening festivities, you see lights in the distance and hear the beating of drums. There are all indications of an epic party happening just a little bit into the woods. You know you shouldn't, but excitement gets the better of you and you leave the path to go chasing after the fun. The next morning finds you dazed, confused, and far from home.

Beating rhythmically on their round bellies with huge testicles swinging to the beat, Tanuki are some of the most boisterous of Japan's Yokai. Cannier shapeshifters than Kitsune, and more filled with mischief, Tanuki are Japan's great tricksters.

Tanuki are often called in English raccoons or badgers, but in fact they are a species of dog. Cousins to wolves, coyotes, and jackals, *tanuki* are native to east Asia and the only canid species capable of hibernating.

> **Tanuki** is written 狸
> 狸 (tanuki) – Tanuki
> Another term for Yokai Tanuki is 化狸 (Bakedanuki).

Although *tanuki* have existed in Japan since prehistory, it is difficult to know when they entered the Yokai pantheon. The kanji 狸 used for *tanuki* originally meant "small furry creature." It referred equally to cats, weasels, flying squirrels, and badgers. Another kanji, 貉, *mujina*, was possibly used for *tanuki*. When the *Nihon Shoki* (720) says *"In the 2nd month of spring, in the Province of Mutsu, there was a Mujina. It took human form and sang songs,"* we don't know exactly what animal was doing the singing.

The first magical Tanuki we know for sure appears in *Uji Shui Monogatari* (13th century), in a story called *The Hunter who Shot at Buddha*. It tells the tale of a Tanuki playing a joke on an arrogant monk, transforming into the bodhisattva Fugen Bosatsu. A nearby hunter shoots the apparition with an arrow, revealing its true form.

Like other Henge Yokai, old age gives Tanuki their powers. Early stories copied Chinese fox lore, showing Tanuki who are cruel, and often murderous. As Kitsune and Tanuki evolved away from their roots, Kitsune became sacred while Tanuki took up the roll of humorous tricksters.

Tanuki lore expanded during the Edo period, adding new elements. In the 18th century, artists moved away from naturalistic portrayals of Tanuki and showed them with rotund bellies. This most likely has to do with their hibernation,

A Tanuki dressed in travelers clothes. Nastia Shulbaeva/ Shutterstock.com.

Sumo wrestler Onogawa Kisaburo blowing smoke in the face of a Tanuki who transformed into a three-eyed giant to terrify him. From the series *One Hundred Tales of China and Japan* (1865) Tsukioka Yoshitoshi.

as hibernating animals fatten up before their sleep. In time Tanuki used their bellies as massive drums, leading to legends of *Tanuki Bayashi*, or Tanuki parades. Wanderers at night would hear revelry in the woods, and when they went to join the party, it would move further and further into the distance. Matsura Seizan, 9th lord of the Hirado domain, wrote in his diary of the night he chased after a *Tanuki Bayashi*.

Most notable of Tanuki are their giant testicles. This is an integral part of Tanuki lore. Children sing about them. They are celebrated in art for their magical powers. In fact, the origin of Tanuki's magical sack is gold.

According to Owaka Shigeo's *Hagane no Chishiki* (1971), legends of Tanuki's supernatural scrotum can be traced back to metal workers in Kanazawa Prefecture. They used animal skin to pound out gold leaf, and Tanuki scrotum had perfect softness and strength. Rumors spread that using Tanuki scrotum, a small piece of gold could be stretched into an eight-tatami mat sheet of gold leaf.

With the end of the Edo period and the industrialization of the Meiji period, Tanuki became symbolic of Japan's lost past before the unrelenting engine of modernity. As train

Henge Shapeshifters

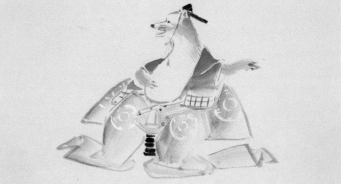

A Tanuki who transformed into a tea kettle (top left) to live with a monk from the series *New Forms of Thirty-Six Ghosts,* depicting famous Yokai stories. The Priest Raigo of Mii Temple (1889–1892?) Tsukioka Yoshitoshi.

Tanuki with their giant scrotum extended (top right) perform an arial attack on a human hunter below. The silhouettes of each character form the figures of goldfish. From the series *Witty Shadow Play.* (1848–51?) Utagawa Kuniyoshi.

A Tanuki (bottom) in a small watercolor painting probably done as an art exercise. (1850?) Utagawa Hiroshige.

tracks were laid across the country and steam trains roared through the lands, conductors started to tell strange stories of phantom trains huffing along the tracks. At night, they would see the light of an oncoming train in the distance, barreling towards a head-on collision. Conductors would pull the brakes and send their train screeching along the rails trying to avoid disaster. The oncoming train would suddenly disappear. As conductors got out of their train to see what happened, they often found the body of a Tanuki lying dead next to the tracks. Unfamiliar with the technology of steam engines, the Tanuki used their shapeshifting powers to imitate and play, with deadly consequences.

Tanuki were featured in the Studio Ghilbli film *Pom Poko* (1994). The English translation rendered them as raccoons, and their magical testicles became inoffensive pouches.

Mujina Enigmatic Cryptids

When the empress complains you are making too much noise, enough that it gets written up in the official historical record, you are in for trouble. The best solution is to not exist at all. In the *Nihon Shoki* (720) says *"In the 2nd month of spring, in the Province of Mutsu, there was a Mujina. It took human form and sang songs,"* What exactly this animal was we have no idea.

Few Yokai are as elusive as Mujina. Like other Henge they are shapeshifters, able to transform into Buddhist monks and even entire houses. They appeared in naturalist encyclopedias alongside Kitsune, Tanuki, and Japanese badgers. However, unlike those other animals—Mujina are not real.

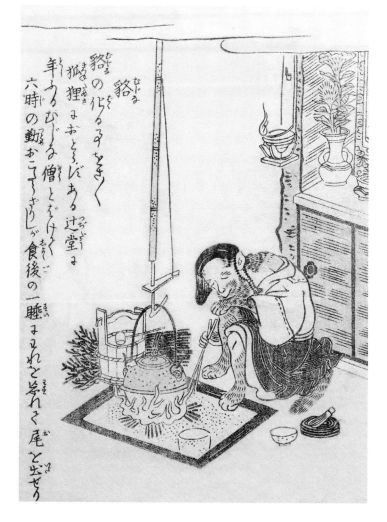

Mujina from *Konjaku Gazu Zoku Hyakki*, the second of Toriyama Sekien's Edo period Yokai collections. It shows a Mujina transformed into a human with only a tail as a giveaway. (1779 – Toriyama Sekien).

> **Mujina** is written 狢
> 狢 (mujina) – mujina
> In Chinese, 狢 means Tanuki.

Wakan Sansai Zue (1712) has an entry for Kitsune. An entry for Tanuki. And one for Mujina. The confusion is one of biology and geography. Japan is home to three animals roughly the same size, same color, and with similar black and white "mask" markings on their face. *Tanuki*, badgers, and *hakubishin*, known in English as the masked palm civet, have all been called *mujina* at some point. These are not specific animals, just names that have been applied to various animals in various locations at various periods of time. For example, in Tochigi Prefecture *tanuki* referred to badgers, while *mujina* referred to *tanuki*.

This confusion landed in the courts in 1924. A hunter was arrested for illegally hunting *tanuki*. At his trial, he said in his region the animal he was hunting was called *mujina*. There were no laws against killing *mujina*. The judge found this logical and acquitted him.

Mujina are about the size of a dog, with shorter front legs than hind legs. They have brown hair, and when older white hair grows on its back in the shape of a cross. When these markings are complete, they are old enough to transform. Supernatural Mujina are almost indistinguishable from Tanuki. They tend to change into humans and Buddhist monks. Toriyama Sekien's *Konjaku Gazu Zoku Hyakki* (1779) shows a Mujina transformed into a monk tending the fire at a temple. The story says this Mujina was devout in its worship and even performed the devotions at six in the morning every day. But one day after a meal it got tired and its tail flipped out, exposing its true nature.

Not content with just one, Toriyama Sekien invented a variation on Mujina in *Gazu Hyakki Tsurezure Bukuro* (1781), of a Mujina carrying a sack. This was called Fukuro Mujina, or "sack Mujina." It is a pun based on the adage of "don't price a Mujina in its hole" or "don't count your chickens before they are hatched." The value of what is in the Mujina's bag cannot be known until it is opened.

One famous Mujina tale comes from Lafcadio Hearn's *Kwaidan: Studies and Stories of Strange Things* (1904). It tells of a wanderer at night encountering faceless people. In modern times those faceless people are their own Yokai, called Nopperabo. But in the Edo period many Yokai encounters were considered to be Tanuki or Mujina playing tricks.

A Mujina from the *Wakan Sansai Zue*, one of the oldest Japanese encyclopedias on astronomy, botany, and biology. (1712) Terajima Ryoan.

Tesso Vengeful Rats

The monk Raigo stared at the emperor. Rage boiled inside of him as he realized the promise made to him would go unfulfilled. Unforgivable. Raigo secluded himself in his room. Consumed by bitterness, his body twisted into the form of a rat. It was then he had his revenge.

There are other ways of becoming a Yokai than old age. Overwhelming emotions can manifest physically, creating a form that can achieve vengeance in a way their human body never could. In the Heian period (794–1185), such creatures were classified as Onryo, vengeful spirits.

> **Tesso** is written 鉄鼠
> 鉄 (tetsu) – iron
> 鼠 (so, nezumi) – rat

Until the Edo period, Tesso was known as Raigo Nezumi (頼豪鼠), meaning Raigo the Rat.

Tesso is different from many Yokai in that it is a singular character. There is only one. In fact, Tesso is based on a real person. The priest Raigo lived during the reign of Emperor Shirakawa, when he killed a child.

The story of Raigo Nezumi comes from *Heike Monogatari* (1330), an epic poem from the Heian period that tells of the Heike/Taira wars that split Japan as two factions struggled for the throne. *Heike Monogatari* is often called Japan's version of *The Odyssey*, freely mixing historical fact with the supernatural and mythological. Because it came from an oral tradition, there are multiple variations of the tale.

The story begins with Emperor Shirakawa desperate for an heir. He enlists the aid of Raigo, abbot of Midera temple and a powerful Buddhist monk. He promises Raigo anything he desires if he uses his spiritual powers to give the emperor a son. Accepting the offer, Raigo uses his magic to ensure the birth of Prince Atsufumi. As a reward he asked for funds to build a platform to ordain monks at Midera. While a seemingly simple request, this was a direct attack on Enraku-ji, the only temple where monks could be ordained. Enraku-ji was powerful and not about to give up their position. The monks of Enraku-ji were not normal, peaceful monks, but a terrible army of militant warriors feared across Japan. It was said the emperor could influence all

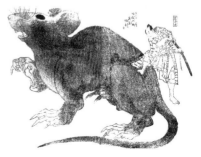

A rat appears before Nekoma Michizane as he tries to kill Shimizu Yoshitaka in an Illustration from the story "Raigo Ajari Kaisoden" by late Edo period author Kyokutei Bakin. (1808) Katsushika Hokusai.

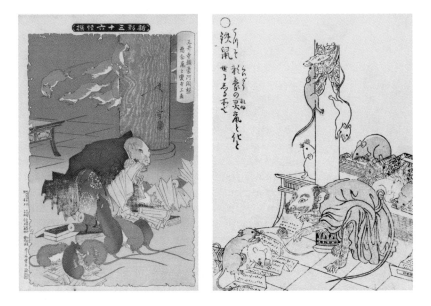

on Earth except three things—the blowing of the wind, the rolling of dice in a cup, and the monks of Enraku-ji.

Emperor Shirakawa broke his promise. He begged Raigo to ask anything else, but the monk was adamant. He cursed the emperor and went on a hunger strike until his body shriveled. At the hour of his death, a grotesque figure appeared beside the cradle of four-year old Prince Atsufumi, who died soon afterwards. What Raigo had given, Raigo took away.

A story this good could not end here. Later versions of the story extended Raigo's curse. *Genpei Seisuiki* (14th century) adds Raigo attacking Enraku-ji with an army of rats. *Taiheike* (14th century) describes Raigo transforming into 84,9000 rats with stone bodies and teeth and claws of iron. The swarm devours the sacred texts of Enraku-ji as well as their statue of Buddha. Some claim a shrine was built at Higashakamoto to quell his rage, known as Nezumi no Hokura, or the Rat Shrine.

Edo period artists further expanded Raigo's legend. Toriyama Sekien renamed him Tesso, the Iron Rat, in his first Yokai encyclopedia *Gazu Hyakki Yagyo* (1776). Takizawa Bakin recast Raigo as a hero in his late Edo period *Raigo Ajari Kaisoden* (19th century). The story tells of Minamoto no Yoshinaka praying at the Nezumi no Hokura shrine. The spirit of Raigo is moved and teaches Yoshinaka rat magic to defeat his enemies.

As great as the stories are, however, none of them are factual. Records show Prince Atsufumi died in 1077 and Raigo died seven years later in 1084. Azuchi-Muromachi records

Raigo transforms into a rat (top left) to get revenge, from the series *New Forms of Thirty-Six Ghosts*, depicting famous Yokai stories. (1891) Tsukioka Yoshitoshi.

Tesso (top right) from *Gazu Hyakki Yagyo*, the first of Toriyama Sekien's Edo period Yokai collections. (1776) Toriyama Sekien.

show the Nezumi no Hokura is dedicated to the sign of the Rat in the Chinese zodiac. And although there was conflict between Midera and Enraku-ji over building an ordination platform, which led to conflict and the burning of Enraku-ji, none of the historical accounts mentions an army of iron-clawed rats lead by a giant rat sorcerer.

Kawauso Vicious Otters

Wandering down a dark street at night, a beautiful stranger steps from the shadows. They smile at you flirtatiously. Intrigued, you offer a greeting. They answer back "oraya." Perturbed but still enchanted, you try another line. They respond with "araya," in a smooth, confident voice. They move towards you. Their voice, while sexy, isn't right. It sounds like someone doing an imitation of a language they don't speak. They come closer, and...

Kawauso are some of the most vicious and incompetent of Japan's shapeshifting animals. They take the form of beautiful girls to seduce, kill, and eat the men who are their prey. However, while they can easily mimic human form, the best they can do is an unintelligible mimic of human voices. If their mark tries to speak to them, they answer with sounds like "oraya," "araya," and "kawai." This is their attempt to imitate the sounds of human speech.

Kawauso is written 川獺
川 (kawa) – river
獺 (uso) – otter

Kawauso—the Japanese river otter—was declared extinct in 2012. The last confirmed sighting was in 1979, in the Shinjo River. But there was a time when they thrived in the rivers of Japan. They became extinct due to over harvesting of pelts during the Meiji period and a gradual destruction of their habitat by human development and pollution.

Yokai Kawauso date back to the Muromachi period, although in a much different form. The dictionary *Kagakushu* (1444) says that aged Kawauso transform into Kappa. Researchers speculate that much early Kappa lore was based on river otters. The oldest known picture of a Kappa in *Wakan Sansai Zue* (1712) shows a hairy creature that barely resembles the Kappa we know today.

As with Kitsune, Chinese folklore depicts otters transforming into beautiful women to hunt men. During the Edo period, Kawauso joined their ranks, becoming a Yokai in their own right instead of the first stage of a Kappa. Books like

Taihei Hyakumonogatari (1732) and *Urami Kanawa* (1752) have stories of Kawauso luring men off to eat them. A particularly deadly Kawauso was said to live in the moat of Kaga castle. It would shapeshift into a beautiful woman to lure men to their deaths. Kawauso also disguised themselves as children, usually in checkered coats.

When Toriyama Sekien drew a Kawauso for *Gazu Hyakki Yagyo* (1776), it is dressed as a monk with an umbrella hat. Perhaps bringing them more in line with the playful nature of otters themselves, Edo period Kawauso tales focused on foolishness and hijinks. They blew out people's lanterns walking alone at night. They tried to trick humans into sumo wrestling rocks and trees. Other stories maintain the general thread of the seduce-murder-eat tales, but instead of food the Kawauso are after that most human of commodities—alcohol. Kawauso transformed into lovely ladies and mumbled out their crude imitation of human speech to get the fellas to buy them a few drinks.

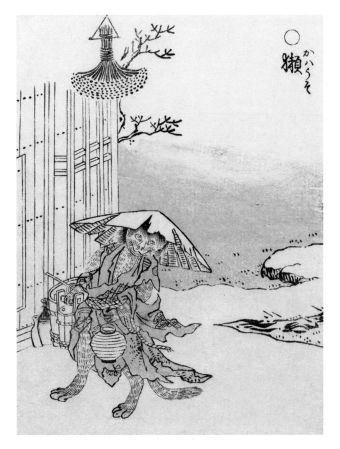

Kawauso dressed as a monk with an umbrella hat from *Gazu Hyakki Yagyo*. (1776) Toriyama Sekien.

Chapter 1

These Kawauso are more vulnerable, transforming and placing themselves in a potentially dangerous situation; surrounded by humans with language and customs they don't fully understand, all for the sake of some booze.

Aosagibi Luminous Herons

Late at night, a pale, bluish light flashes through the trees. Looking closely, you can see the movement of wings in the glow. It glides on the wind. You have been lucky to see Aosagibi, a rare and beautiful sight.

Like many animals in Japanese folklore, preternatural long life can manifest powers in aosagi, a bird known in English as night heron. Aosagi are said to develop a flaming aura, called Aosagibi or night heron fire. Along with this pale, blue glow, their breath is said to release a golden, heatless fire. While a beautiful display, Aosagibi were harmless and fled before people.

> **Aosagibi** is written 青鷺火
> 青 (ao) – blue
> 鷺 (sagi) – heron
> 火 (hi) – fire
> Although the literal Japanese for Aosagi is blue heron, night herons are different birds. Blue herons are called *himeaka kurosagi* in Japanese.

Aosagibi is first described in the Edo period encyclopedia *Wakan Sansai Zue* (1712). It describes a natural phenomenon instead of a supernatural one, saying that night herons flying in the sky at night give off bright glow. It says is especially true on moonlit nights, and people might mistake them for Yokai.

Henge Shapeshifters

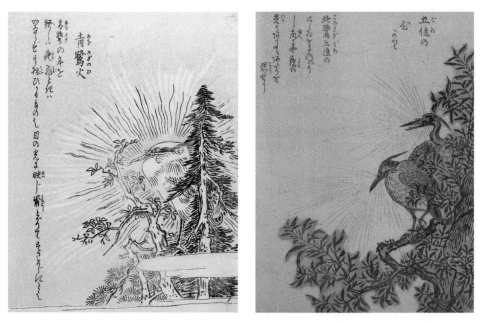

Toriyama Sekien included aosagi in the second volume of his series, *Konjaku Gazu Zoku Hyakki* (1779). Toriyama specifies it is the wings of the night heron that glow, and that their eyes shine, and their beaks are fiercely sharp. The book *Bakemono Haru Asobi* (1793) by Sakuragawa Jihinari tells of a willow tree that blazed with light every night. The locals said the tree was haunted. A local man was determined to solve the mystery. During a downpour, he went to the tree thinking the rain would extinguish the flame. When he arrived, he instead found the tree glowing brighter than ever. He fainted in fear. The true cause of the light was Aosagibi nesting in the branches.

Aosogabi (top left) from *Konjaku Gazu Zoku Hyakki,* the second book in Toriyama Sekien's Edo period Yokai collections. (1779) Toriyama Sekien.

There are other Aosagibi legends across Japan, and perhaps most surprisingly across Britain and the United States as well. There have been no confirmed sightings, but reports go back as far as 1909 and as recent as 1977. Some say they have seen herons scattering a glowing powder from their feathers that they use to draw unwary fish to the surface as easy prey.

A pair of Aosogabi (top right) from *Ehon Hyaku Monogatari,* an illustrated book of Yokai intended as a continuation of Toriyama Sekien's work. (1841) Takehara Shunsensai.

There may be some truth to these legends. Herons have powder-producing feathers, called powder down. Some researchers speculate that phosphorescent bacteria might cling to these feathers, especially on birds who live close to water. Another theory is that the bright white of the heron's breast might appear to glow in the moonlight. However, scientific or supernatural, the phenomenon has never been authenticated and remains folklore.

Kyuso **Ancient Rats**

A common solution for rat problems is to set a cat on them. But if you do, be careful. The cat does not always win.

Some Yokai are born from ancient stories, some from natural phenomena. Some are creatures of the forests taking on supernatural form. And some are born from puns and clever wordplay. That is most likely the case with Kyuso, a pun that sprang to life that entered the ranks of Yokai.

The particular pun comes from an old proverb, "A cornered rat may bite a cat" (*Kyuso Neko wo kamu*). The saying means that even the weak will fight back against the strong when backed against a wall. In addition, the word for "cornered rat (Kyuso; 窮鼠)" is a homophone for "old rat (Kyuso; 旧鼠)." Like many animals in Japanese folklore, it is thought that a preternaturally long life can transform a rat into a Yokai—thus the name "old rat" makes a perfect name for a magical rodent.

> **Kyuso** is written 旧鼠
> 旧 (kyu) – old
> 鼠 (so, nezumi) – rat

Kyuso first appears in the essay series *Okinagusa* (1791) by Kanazawa Teikan. The story tells of a house in Chukyo where the lanterns went dark almost every night. The owners of the house found out that at night a huge rat was drinking the lamp oil. They set a cat to catch the mouse, but instead the ancient rat tore out the cat's throat and killed it. The owners sought out another cat, who was renowned for ratting, and set it against the rat. But the rat prevailed again, killing the cat.

The better-known version of Kyuso appears in *Ehon Hyaku Monogatari* (1841). *Ehon Hyaku Monogatari* was conceived when Tosanjin noticed the popularity of Toriyama Sekien's *Gazu Hyakki Yagyo* series. He created his own Yokai collection, and like Toriyama's books, they are a mixture of collected folktales and original Yokai.

In the entry for Kyuso, Tosanjin writes about a cat-eating calico mouse who lives in Shiki, Yamato province. He also tells the story of an old mouse who lived in the stables of a house in Dewa province, who was friendly with the housecat. The cat gave birth to five kittens and then tragically ate poison and died. The rat cared for the orphaned kittens. When the cats were grown, the Kyuso left never to return. When this story was told to haiku master Matsuo Basho, he replied "There is nothing strange about it. After all, there are some cats who have raised mice." The image accompanying the text in *Ehon*

Hyaku Monogatari leaves it unclear as to which story is being depicted, the cat-eater or cat-nursemaid.

Giant rats have been a part of Japanese folklore for years. Some were called yoso, or "strange rat." However, with the popularity of *Ehon Hyaku Monogatari*, Kyuso became the common name for these types of stories. But whatever the name, most of these Yokai rats are monstrous killers. The benevolent playmate who raises kittens being the rare exception.

Neko Musume Cat Daughters

If your daughter mews instead of speaking, and spends her time climbing on furniture, licking things, and hunting rats, then you might want to examine what past actions have led you to this terrible fate. Because most likely you are suffering from the curse of the cats and have given birth to a Neko Musume.

Half-cat. Half-human. Neko Musume—cat daughters— have a unique place in Japan's Yokai lore. They are some of the few Hanyokai (half-Yokai) in Japanese folklore, although they are a blending of essence not blood. Neko Musume are the result of a curse or magic, not human/cat intercourse. There are human/Yokai marriages; early Kitsune tails are full of fox wives and there are even children of ghosts. But while the children may have some lingering supernatural abilities from their Yokai lineage, they are 100% human. Neko Musume area is something else. They are also among the few Yokai who can be traced back to a single, actual person.

Neko Musume is written 猫娘
猫 (neko) – cat
娘 (musume) – daughter

The original Neko Musume was exhibited in the 1760s in Asakusa, Edo, as part of a *misemono* show. Translating as "viewing shows," these were the equivalent of 19th century freak shows. People with exceptional talents were exhibited

besides inventive taxidermy and those whose physical attributes made them stand out in daily life. Neko Musume claimed to be a cat/human hybrid. Little is known of this original cat daughter, other than her appearance was startling and that she looked exactly like what she claimed to be. When *misemono* shows faded, the real Neko Musume vanished from history.

Her legend lived on, however. Artist Hayami Shungyosei illustrated stories from older works such as *Konjaku Monogatari* (12th century) and *Heike Monogatari* (1330) combined with modern tales as *Ehon Sayoshigure* (1801). One of the stories in the compilation, *Ashu no Kijo* told the tale of a rich merchant whose daughter had the strange habits of licking things. Her tongue was rough like a cat, so she was nicknamed Neko Musume. She was more of an oddity than a Yokai, which is how she appears again in *Kyoka Hyakki Yako* (1830) under the name of Name Onna or licking woman. A fuller account is given in *Ansei Zakki* (1850). The work by Fujikawa Seisai records events of the time, articles of foreign affairs, major crimes, and local rumors. One such tells of a girl named Mutsu in Ushigome Yokoderamachi, Edo. Mutsu had eccentric habits of eating the head and guts of fish and running over fences and under floors catching mice to eat. Neighbors called her Neko Kozo or Neko Bozu. They said she must be the consequences of some lingering karma from a past life. Her parents availed every doctor and priest they could, but there was no cure. Eventually they accepted their fate and hired Mutsu out to neighboring homes as a ratter.

Neko Musume was one of the first Yokai stars in modern pop culture. In 1936 Kamishibai artist Urata Shigeo turned the Neko Musume story into a Buddhist morality fable. Her father is a *shamisen* maker who skins cats to make drumheads for the instruments. His soul bears the weight of all the cats that he has killed, and his daughter is born as a strange cat/human hybrid. Mizuki Shigeru revised the story in his comic *Kaiki Neko Musume* (1958). He later included her as a regular character in his popular Yokai comic *Kitaro* (1960s), where she became known across all of Japan.

Jorogumo Spider Women

If a beautiful woman approaches you at a shrine at night, it isn't really a question of "Is this a Yokai?" but more like "What kind?" Look around you for tell-tale signs of Kitsune, Tanuki, or Bakeneko. And hope that you do not see webs. You don't want to meet the Jorogumo.

While many of Japan's transformed animals range from mischievous to deadly, Jorogumo are plain evil. They transform into women to put men off their guard, then spin their web to feast. The orb spider called *joro* spiders are probably named after the Yokai, and not the other way around.

Jorogumo is written 絡新婦
絡 (karamu) – entangling
新婦 (shinbu) – bride
Although the kanji for Jorogumo refer to a newlywed bride, the pronunciation is a homophone for 女郎蜘蛛, or whore spider. Both names and kanji have been used over the years.

Jorogumo appeared during the Edo period, in the book *Tonoigusa* (1677), in a story called *Things Ought to be Pondered, Even in Urgent Times*. It tells of a traveling samurai who seeks shelter in an abandoned temple to spend the night. As evening falls a beautiful young woman of nineteen- or twenty-years old approaches, holding a small child. She puts the child on the ground and tells it, "Go and hug your father!" The child, afraid, needs further encouragement. The woman again sends it toddling towards the samurai. His patience exhausted by this transparent scheme, the samurai draws his sword and slashes the woman. With a scream she bounds for the rafters dragging the child along. At dawn, the samurai climbs to the ceiling and finds a massive spider, now dead.

Jorogumo (bottom left) from *Taihei Hyakumonogatari*. A man has a dream of a woman who turns out to be a transformed spider. (1732) Yusuke or Yusa (pronunciation unknown).

Jorogumo (bottom right) from *Gazu Hyakki Yagyo* (1776) Toriyama Sekien.

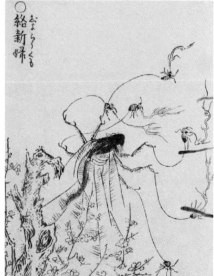

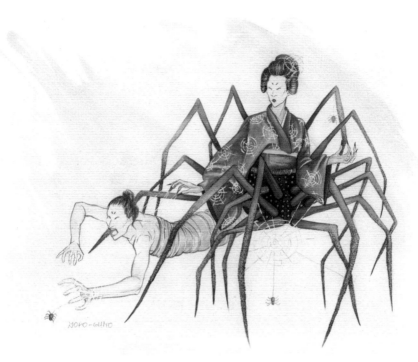

Scattered around are the bones of her many victims. He also sees the stone that the Jorogumo transformed into the guise of her son. If the samurai had struck the child first, his sword would have shattered. That was the Jorogumo's true stratagem. The eponymous "thing that should be pondered" of the title is how one must keep a cool head, even during a crisis. If you panic, even acts of bravery can result in disaster.

Jorogumo next appear in *Taihei-Hyakumonogatari* (1732). This time she is a bit more clever, appearing before an old man and asking to be his bride. But the man is already married and refuses. Pleading, she says the man owes her for almost killing her mother the day before but the man will not be swayed and flees from the apparition. Coming out of the revery, he spies a small *joro* spider and recalls that he had swept away a larger one the day before.

Toriyama Sekien included Jorogumo in *Gazu Hyakki Yagyo* (1776). His illustration is related to no known legends, showing a spider woman commanding several small spiders who appear to be breathing flame. Sekien included no story for this illustration, only the name of Jorogumo.

There are several known nests of Jorogumo throughout Japan, such as the Joren Falls in Shizuoka or Kashikobuch

in Sendai. Most of these are near water, relating to legends of hapless lumberjacks almost pulled in by the Jorogumo's webs. Smart lumberjacks manage to survive by fixing her silk to a nearby tree stump. Belief persists in Jorogumo in these locations, and shrines have been created to transform these monsters into guardian spirits who protect people from drowning.

Ten Shapeshifting Martens

Seeing a Yokai shapeshift is terrifying enough. Seeing one transform into another Henge Yokai in a dazzling demonstration of metamorphosis means that you are in the presence of the greatest shapeshifter of them all—the Ten.

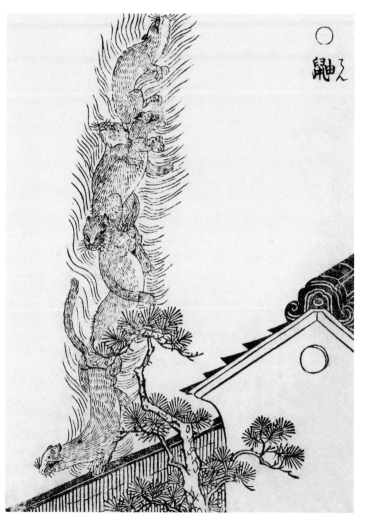

Ten from *Gazu Hyakki Yagyo* forming a pillar of fire. (1776) Toriyama Sekien.

Ten—Japanese martens—do not appear often in Japanese folklore. Or at least not where they are recognized. They are considered to be the masters of shape changing, able to transform not only into other Yokai but even into other shapeshifting animals such as Kitsune and Tanuki. There is an old saying, "Kitsune nanabake, Tanuki hachibake, Ten kubake" meaning Kitsune can transform into seven shapes, Tanuki into eight, and Ten as the masters with nine forms.

> **Ten** is written 貂
> 貂 (ten) – marten
> Toriyama Sekien used the kanji for weasel 鼬
> when referring to Ten, meaning martens.
> This led to confusion between the two species in
> terms of Yokai.

Toriyama Sekien's image of Ten in *Gazu Hyakki Yagyo* (1776) shows several Japanese martens entwined like a ladder, forming a pillar of fire. There was a belief that if Ten could stack on top of each other in this form they would ignite into a blaze, potentially burning any houses around them. Sekien's image is confusing because he uses the kanji for *itachi* (Japanese weasels) referring to *ten* (Japanese marten). This is most likely based on beliefs that weasels and martens were the same creature. Martens were thought to be the older version of weasels, and that when weasels lived long enough, they transformed into martens and gained their supernatural powers.

Regional folklore of Ten includes Akita and Ichikawa Prefectures, where it says a Japanese marten crossing your path is bad luck, similar to black cats in Western folklore. In Hiroshima, it is said killing a Ten causes fires to break out.

A Kitsune (facing page) possesses a woman. (17th or 18th century) Hohashi Gyokuzan.

YOKAIOLOGY
Tsukimono
Possessing Spirits

"The number of possessing spirits in Japan is something enormous. It is safe to say that no other nation of forty millions of people has ever produced its parallel...." – Percival Lowell, *Occult Japan* (1894)

Spirit possession is an ancient and ubiquitous belief in Japan. There are eight million gods and monsters in Japan, and more than a few of them like to ride around in human bodies from time to time. Yurei. Kappa. Tanuki. Tengu. Kitsune. Snakes. Cats. Horses. Almost anything can possess a human. But when they do, they are all known by a single name—Tsukimono, or possessing things.

> **Tsukimono** is written 憑物
> 憑 (tsuki) – possessing
> 物 (mono) – thing
> object, evil spirit

Probably the most ancient form is god possession. There have long been mediums who voluntarily drew the power of Kami or ancestor spirits into their bodies to serve as oracles. This kind of God possession—known alternately as Kamiyadori (神宿り; Kami dwelling), Kamioroshi (神降ろし; Kami descending), or Kamigakari (神懸り; divine possession)—is different from Tsukimono.

Until the Edo period, people didn't think of Yokai as having individual forms and personalities. They were

considered to be a horde of invisible spirits, affecting people through illness and natural disasters. One of the ways that Yokai—known then as Mononoke or Obakemono—most directly affected human beings was through possession.

Possession was rarely a spontaneous event—often spirits possessed humans as an act of revenge, for killing its children, destroying its home, or insulting it in some way. Or it could be greed, like a fox wanting to eat a delicious treat it couldn't get its paws on. The reasons are as innumerable as Yokai themselves. Tsukimono is involuntary on the part of the possessed. No one invites a Tsukimono into their body.

The effects of possession vary widely as well. In most cases the victim takes on attributes of the Yokai or animal. A victim of Tanuki-tsuki (Tanuki possession) is said to voraciously overeat until their belly swells up like a Tanuki, causing death unless exorcized. Uma-tsuki

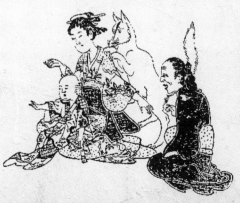

(horse possession) can cause people to become ill-mannered, huffing at everything and sticking their face into their food to eat like a horse. Kappa-tsuki become overwhelmed with the need to be in water and develop an appetite for cucumbers.

In general, the only way to free someone from a Tsukimono is through an exorcist. In the Heian period, if you were an aristocrat, you called on the services of an *Onmyoji* sorceror. Or you might prevail on the abilities of wandering *Shugendo* priests called *Yamabushi*. They were the great sorcerers and exorcists of pre-modern Japan, roaming through mountains and coming down when called to perform sacred services and spiritual battles.

Like all things Yokai, there is no agreement on Tsukimono. Yanagita Kunio split Tsukimono into two distinct types: snakes (Hebi-tsuki) and foxes (Kitsune-tsukai). Very few folklorists agree with Yanagita's fox/snake categories. Most researchers have seen a greater variety in Tsukimono.

In *Mujara*, Mizuki Shigeru identifies the following types of possession. It is by no means a complete list:

* Jizo-tsuki – Possession by Jizo
* Kappa-tsuki – Kappa possession
* Gaki-tsuki – Hungry Ghost possession
* Tengu-tsuki – Tengu possession
* Shibito-tsuki – Ghost possession
* Neko-tsuki – Cat possession
* Hebi-tsuki – Snake possession
* Tanuki-tsuki – Tanuki possession
* Hannya-tsuki – Hannya possession
* Ikiryo-tsuki – Living Ghost possession
* Uma-tsuki – Horse possession
* Inu-tsuki – Dog possession
* Kitsune-tsukai – Fox possession

Kudagitsune Spirit Foxes

A villager is overcome with a strange illness. They fall to the ground, start foaming at the mouth and make barking noises. Their limbs claw at the air. The following day, a stranger wanders into town. He examines the villager, smiles briefly, and offers to cure them—for a fee.

Kudagitsune—pipe foxes—are often said to be a breed of fox but described as something quite different. In some regions they are called *izuna*, which refers to a species of weasel. Their physical shape, however, matters little as they are invisible. As seen by their name, they are small enough to fit into pipes. These can be thin *kiseru* pipes used for smoking or small bamboo pipes. Sorcerers who carry these pipes are known as *Kitsune-tsukai* (fox users), said to have Kudagitsune at their command and able to send them to possess people at will.

Kudagitsune is written 管狐
管 (kan) – pipe
狐 (kitsune) – fox

Kitsune-tsukai gain power over the Kudagitsune in what is known as the *izuna-ho*, or *izuna* rite. The complete ritual is laid out in *Honcho Shokkan* (17th century). 1) Find a pregnant fox, feed her and tame her; 2) When she gives birth, take special care of her cubs; 3) When her cubs are strong enough, she will eventually come and ask you to name one as thanks. With that done, the fox you named is under your control. It will respond to the power of its name. Continue to feed the fox, and you are now a *Kitsune-tsukai*. You can ask it questions that it must answer or send it to perform nefarious deeds. Using its abilities *Kitsune-tsukai* could read fortunes, make prophecies, and cast curses.

Kitsune-tsukai sent Kudagitsune to possess people for a variety of reasons, from revenge to profit. In a particularly devious type of extortion, *Kitsune-tsukai* would send their familiars to possess someone, then appear in the guise of an exorcist to drive the spirit out for an exorbitant fee. *Kitsune-tsukai* felt like a bodily attack, with shortness of breath, phantom pains, speaking in strange voices, and epileptic fits. Symptoms resembled classic demonic possession found in Western culture. Kudagitsune entered through the fingernails or breasts. They spoke in different voices than those they possess.

Another hallmark of the *Kitsune-tsukai* is that they were the

A Nogitsune (facing page) from the *Hyakkai Zukan*, an early Edo period Yokai scroll. Sawaki's depiction served as a template for many images of Yokai to follow. (1737) Sawaki Sushi.

The Kudagitsune (right) pictured in this illustration is from a supposed eyewitness account. The creature was said to have a cat-like face, a body like an otter, and was about the size of a squirrel. (1850) Miyoshi Shozan.

nouveaux riches—people of poverty who suddenly gained wealth and property. There was no possible explanation for the sudden rise in status of these people other than they had a magical, invisible fox at their command. These Kudagitsune would breed and need to be fed, and families needed to keep expanding their wealth. A sudden collapse of fortunes might be blamed on being literally eaten out of house and home.

Kitsune-tsukai was thought to be hereditary. Becoming a *Kitsune-tsukai* taints your entire line, and from that time forward invisible foxes will hang around the houses of your ancestors. You are now part of a *Tsukimono-tsuji*, a witch clan. *Kitsune-tsukai* and *Tsukimono-tsuji* were actively discriminated against. It was a curse that lasted forever, and people would carefully check the family background of potential marriage or business partners to ensure that they had no hint of *Kitsune-tsukai* lineage. To bind your family to a tainted family was disastrous—you and all your heirs would also carry the curse. During the Edo period in particular people were vigilant against *Kitsune-tsukai*. Accused families would be burned out of their homes and banished.

Up until World War II, *Kitsune-tsukai* was treated with deadly seriousness, by both mystics and scientists. F. Hadland Davis wrote about it in his book *Myths and Legends of Japan* (1913). Prejudice against *Tsukimono-tsuji* and *Kitsune-tsukai* families lasted well into the 1960s when human rights laws were enacted forbidding discrimination against them. To this day, however, I am sure you can find a few people who would be shy to marry or do business with a *Kitsune-tsukai* family.

Inugami Bedeviled Dogs

Go to a crossroads in the evening. Bring along a starving dog. Tie it to a stake and put food in front of it, just out of reach. As it struggles for the food, cut off its head. Bury it at the crossroads. The trampling over its head by thousands of people would inflame the rage of the beast until it becomes a curse. A curse you can now use, called Inugami.

Japan has many legends of magical cats, but very few of supernatural dogs. Inugami are an unpleasant exception. They are a form of Tsukimono, similar to Kudagitsune. They have no agency of their own but are magical creatures created by dark rituals to grant power to human sorcerers. These rituals are called *kodo* or *kodoku*, derived from Chinese *gu* magic and involve acts of animal cruelty to harvest their

power. *Kodoku* was folk magic opposed to court-sanctioned sorcery of *onmyodo*. It was banned in the Heian period. But this did not stop people from performing it.

Inugami is written 犬神
犬 (inu) – dog
神 (kami) – god

Inugami legends are ancient, stretching back to before the Heian period when the rituals were officially banned. They are mostly found on the islands of Shikoku and Okinawa, places in Japan without fox populations. A similar ritual was written about in the Chinese text *Soushen Ji* (350 CE). When this transmitted to Japan is unknown. There were some variations, all involving cruelty. In *Nihon no Tsukimono* (1977), Ishizuka Takatoshi writes of a shrine maiden who prepared a magic powder by gathering starving dogs to fight. After all

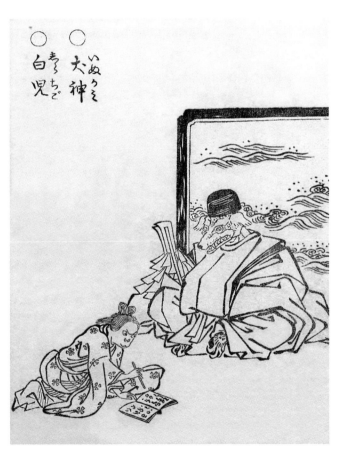

Inugami dressed as a Shinto priest from *Gazu Hyakki Yagyo*. (1776) Toriyama Sekien.

Henge Shapeshifters

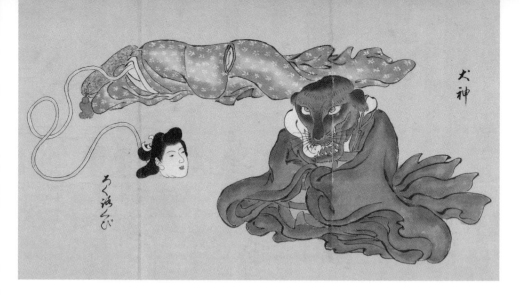

the dogs were dead but one, its head was cut off and dried. The maggots in its head were harvested, dried, crushed into powder and sold to thankful parishioners.

As they are invisible spirits, there is no agreement on the appearance of an Inugami. Asai Ryoi's book *Otogi Boko* (1666) describes an Inugami as about the size of a grain of rice, with a black and white mottled color. Other legends describe them as looking like a shrew or a rat. This is not unlike Kudagitsune, who are described as something like a weasel instead of a fox.

Sawaki Sushi portrayed Inugami as a dog in Buddhists robe in *Hyakkai Zukan* (1737). This was possibly parodied by Toriyama Sekien, who depicted Inugami in *Gazu Hyakki Yagyo* (1776) as a dog in the robes of a Shinto priest, attended by another Yokai called Shirachigo. This is also possibly a play on its name, referencing Kamigakari, or Kami possession practiced by oracular mediums and shrine maidens. A completely different Inugami was illustrated in the Edo period *Jian* (18th century?) by scholar Oka Kumaomi. He described Inugami as about a foot in length and resembling a bat.

Those who commanded Inugami were called *Inugami-mochi*. As with *Kitsune-tsukai*, this was hereditary. Once an Inugami was created it stayed with the family lineage forever. These Inugami families could command great influence and power, although if they lost control of their spirit, it would turn on the family in rage. In time, Inugami families were pushed to the edges of society, and marrying into a bloodline was taboo. Despite this, Inugami curses became a popular subject for Japanese entertainment, appearing in multiple films, books, and animated series.

Rokurokubi and Inugami from the *Bakemono Zukushi* scroll. (18th century) Artist unknown.

Nobusuma Flying Rodents

Walking in the forest at night, a dark shape swoops from the trees directly at your lantern. Knocking the light from your hand, the shape is gone. Was it a bat? A bird? Or... something else? A Nobusuma.

Nobusuma are described as nocturnal flying rodents that stretch their entire bodies out to use as a wing. They eat the usual fare for such creatures, like nuts and seeds. However, they also feed on fire and cat's blood. When they attack, Nobusuma sometimes breathe fire and can use their outstretched bodies as blankets to smother people. As they leap from the trees they look like blankets in flight.

> **Nobusuma** is written 野衾
> 野 (no) – field
> 衾 (fusuma) – quilt, bedding
> "Field blanket" is thought to come from their appearance.

Accounts of Nobusuma come mostly from the Edo period and rarely agree with each other. *Honcho Seji Danki* (1734) tells of locals afraid of a Yokai called Nobusuma that eats the fire from torches and breathes it back out. Toriyama Sekien referenced that legend in *Konjaku Gazu Zoku Hyakki* (1779). He illustrated Nobusuma as a giant flying squirrel, with a description boarding on the scientific until he gets to the part about eating fire.

Nobusuma's legend grew in the telling. The Edo period *Baiou Zuihitsu* (1789–1801) describes Nobusuma as looking like weasels with wings, fully stretched out on both sides. They were said to attack cats and suck their blood. *Kyoka Hyaku Monogatari* (1853) illustrates Nobusuma as having distinctly bat-like creatures, covering people's mouth and nose to suffocate them. This could be a different Yokai, however. Their name is given as Hikura, which was later considered to be an alternate name for Nobusuma. *Ehon Hyaku Monogatari* (1841) describes a bizarre, Pokémon-like evolution. They start from an aged bat that transforms into a Nobusuma, which then reaches its final stage as a breath-stealing mountain simian called Yamachichi.

Early accounts of Nobusuma clearly refer to the Japanese giant flying squirrel. Their nocturnal eyesight is easily dazzled by bright lights, and lanterns and torches may have confused

Nobusuma from the *Bakemono Zukushi* scroll. (18th century) Artist unknown.

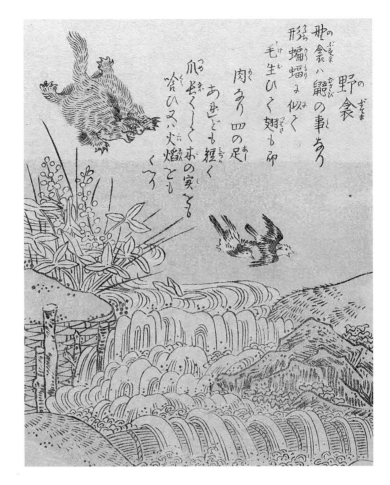

A Nobusuma soars above a river in this illustration from *Konjaku Gazu Zoku Hyakki*. (1779) Toriyama Sekien.

them at night, causing collisions. It's easy to understand how wanderers in the forests, suddenly dive bombed by dark shapes swooping from the trees that knock the lanterns from their hands, would see this as a terrifying Yokai attack.

The mix of bat and flying squirrel is also not unusual. At the time, not all animals were cataloged as separate species. For much of Japanese history creatures as dissimilar as Tanuki and foxes were considered to be the same animal and called as such. It was not until later, with greater scientific understanding of the natural world, that they became separated as individual animals. *Wakan Sansai Zue* (1712) lists flying squirrels in the rodent section, calling them *musasabi no fusuma*, with "*fusuma*" being the same character as "*busuma*" in Nobusuma. In modern Japanese, both *musasabi* and *nobusuma* are used interchangeably as names for Japanese giant flying squirrels.

Iwana Bozu Shapeshifting Fish

If you are fishing on the river and a wandering monk tells you to stop, you had better listen. Random encounters in the wilderness are a sure sign of Yokai, and most likely you have just met an Iwana Bozu.

Iwana Bozu are a species of rockfish called char that has lived a preternaturally long life and learned how to shape change. They adopt the guise of Buddhist monks. Unlike other Yokai who imitate priests to cause mischief and mayhem, Iwana Bozu are pious. They patrol the rivers where they were born to ensure no one is overfishing or using cruel techniques. They have no problem with people taking enough fish to feed their families, but when someone gets greedy and keeps fishing more than he can eat, Iwana Bozu steps in.

Iwana Bozu is written 岩魚坊主
岩魚 (iwana) – rockfish
坊主 (bozu) – monk

Iwana Bozu appeared in Miyoshi Shozan's *Shozan Chomon Kishu* (1850), a collection of 57 strange tales of animals, plants, ghosts, and gods. The book tells of a village where a monk interrupts fishers using cruel methods, such as using Japanese pepper to cause fish to float to the surface where they are easier to catch. These monks look entirely human but are in fact fish. Other than char, yamane trout and river eels also transform. On coastal waters, cod can also take a human form.

There are variations on the story. In one the fisher offers rice to the monk, who gladly accepts it. Properly bribed he wanders off and leaves the fisher to his task. Later, the fisher catches an enormous char. When he cuts it open, he finds rice inside its belly. Sometimes, poisonous fumes also come from the fish carcass, killing the fisher in karmic revenge.

Iwana Bozu can be heroic as well. A story is told of a traveling monk who rents a room for the night. Outside, rain begins to pour, and it seems like the river dam is about to burst. To the surprise of everyone sheltering in the inn, the monk runs out into the storm. The dam holds. The next day, they find the body of a fish wedged into a crack in the dam. It had sealed the crack with its own body. The fish's stomach was split open, and inside the villagers saw the rice that the traveling monk had eaten the previous morning.

Even though Iwana Bozu represent good Yokai who are faithful to Buddha, their story is often a tragic one. They almost always end up dead.

Bakeneko Shapeshifting Cats

Your cat turning magical might seem like the most wonderful thing, until you consider a cat's true nature. Imagine your furry friend, the same size as you and possessed with magical powers. Then you might know the fear of the Bakeneko.

Cats are not native to Japan. They arrived during the Heian period, traveling the silk road from Egypt to China and Korea and then to Japan. Originally imported as expensive gifts used to curry favors between emperors, they eventually bread and spread to the lower classes. Acknowledging their usefulness as ratters, in 1602 they were ordered outside by government decree to protect the silkworm industry from an infestation of rats. This led to an enormous population of stray cats.

A Bakeneko
(facing page, top) is confronted by two warriors in a scene from a *kabuki* play, with Mimasu Gennosuke I as Shirasuga Juemo, Onoe Kikugoro III Neko-ishi no Kai and Ichimura Uzaemon XII as Inabanosuke, from the series *Plum Spring: The Fifty-three Stations*. (1853) Utagawa Kuniyoshi.

A Bakeneko (facing page, bottom) appears suddenly from the tall grass. (19th century) Kawanabe Kyosai.

> Bakeneko is written 化け猫
> 化け (bake) – changing
> 猫 (neko) – cat

Like many of Japan's animal Yokai, Bakeneko are cats who have lived unnaturally long lives. Although for Bakeneko this is surprisingly short. Twelve or thirteen years is the age cats gain supernatural powers, although some say it is as young as seven. There are many regions where people were cautioned to kill their cats at seven years old, lest they turn into Bakeneko and kill their owners. In China, it was as short as three. A telltale sign of a cat on the verge of transformation

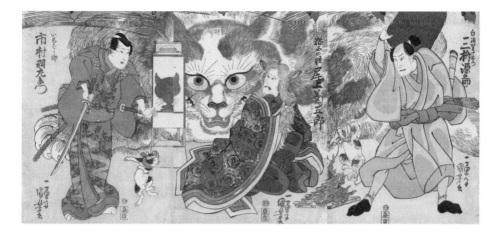

was a long tail. Many bobbed their cats' tails hoping to put off the inevitable.

Legends of supernatural cats stretch back to the Kamakura period (1185–1333). The *setsuwa* collection *Kokon Chomonju* (1254) mentions cats displaying mischievous behavior and suggests these are the ones who transform into monsters. There is no specific mention of Bakeneko, however, until the Edo period. Tales of Bakeneko appeared in numerous *kaidan* collections. Cats stood on their hind legs and spoke like humans. One legend told of a soy sauce merchant noticing his towels were

A Bakeneko wearing a napkin on its head and dancing. By the poet and painter Yosa Buson, in his humorous Yokai collection *Buson Yokai Emaki*. (1754) Yosa Buson.

disappearing. He stayed up late at night to spot the thief and discovered his cat putting the towel on its head and standing up right. Following the cat, he found it dancing with a group of other cats, all with towels on their heads. Many believed this was an integral part to the Bakeneko transformation from ordinary house cat. Period artists often depicted them dancing with towels on their heads.

Bakeneko began to be associated with the pleasure districts near most major cities. Most famous was the Yoshiwara of Edo. Rumors spread that some of the courtesans of the Yoshiwara were not human at all but transformed cats plying their trade. In 1841 the Tenpo Reforms were initiated to crack down on public morals. Artists were forbidden from selling pictures of the pleasure quarters or *kabuki* theater, which was a lucrative industry. Enterprising artists saw a loophole and started swapping out cat heads on the denizens of the Yoshiwara. They created the idea of a world of Bakeneko who got together outside of human society and had a wild time. When the Tenpo Reforms were repealed in 1845 and artists were legally able to do *kabuki* portraits again, they found customers were still hungry for cat prints.

There are some legends of Bakeneko who transform not by age, but by licking blood. The most famous of these, the Nabeshima Bakeneko event, tells of a lord who slew his opponent in the game of *Go*. The dead man's widow poured out her sorrows to her cat, then committed suicide. The cat licked the blood from her dead body. Transforming into a Bakeneko, the cat sought revenge for its mistress. It was eventually slain by samurai Komori Hanzaemon.

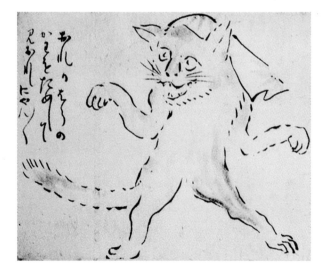

Nekomata Man-eating Cats

The cat felt stirrings of power. Unable to contain its strength, its body swelled in size. Its massive, twitching tail split into two and its teeth and claws grew sharper. That nice lady that always brought it dinner and scratched its ears—what did she taste like? And a Nekomata is born.

Whereas Bakeneko can be fun and frivolous, Nekomata are monsters. They are massive, human eating beasts, more like tigers than housecats. Often confused with Bakeneko, the chief differences are that while Bakeneko are urban stray cats Nekomata are creatures of the wild and the forests. And of course, Bakeneko have only one tail. Nekomata have two.

Unlike Kitsune, who can grow a number of tails until they evolve into a powerful nine-tailed fox, Nekomata never have more than two tails.

> **Nekomata** is written 猫又
> 猫 (neko) – cat
> 又 (mata) – again, once more
> The kanji *mata* possibly refers to the twin tails of the Nekomata, or to a cat's being born again in this new, monstrous form.

Nekomata playing a *shamisen* from the *Hyakkai Zukan*, an early Edo period Yokai scroll. Unlike most Nekomata, she has a single tail. *Shamisen* are traditionally skinned from cats. (1737) Sawaki Sushi.

Nekomata appeared during the Kamakura period (1185–1333). In his diary *Meigetsuki* (1233), poet Fujiwara no Teika recorded a Nekomata stalking and killing people in the woods of Nara Prefecture. It was described as having the eyes of a cat and the body of a large dog. In *Tsurezuregusa* (1330–1332), the monk Kenko talks of a Nekomata in similar terms, as a large species of man-eating cats who dwell deep in the forests. They grow larger with each telling gaining size

Tesso from *Gazu Hyakki Yagyo*. There are three cats, but only one is old enough to transform while the other two look on in envy. (1776) Toriyama Sekien.

to being compared to a wild boar. By the time of *Guiso* (1809) they are able to hold a large dog in their fangs.

There is much speculation of these early Nekomata. Because the commentary is so similar and appears in sources that are simply recording the day-to-day of life at the time, researchers think these Nekomata may have been real creatures. Perhaps they were some animals infected by rabies. Or more fantastically, an escaped tiger imported from China. Many early Nekomata pictures show striped animals and look far more like tigers than domestic cats.

During the Edo period, legends of Nekomata took on aspects of Bakeneko, including being housecats that transform with age. *Hyakki Zukan* (1737) shows an anthropomorphic cat in kimono strumming a *shamisen*. As *shamisen*

An O-neko (top) is shown stalking Kogai-cho in Tokyo in this Edo period *kawaraban* broadsheet. The twin tails mark it as a Nekomata. (17th or 18th century) Artist unknown.

Nekomata (bottom) from the *Kaidan Ektoba* scroll profiling thirty-three Yokai and human oddities from Japan and overseas. This Nekomata was said to have been encountered in the Nasuno area of Tochigi. (mid-19th century) Artist unknown.

were made exclusively from cat skin, this is one of the saddest pieces of art ever produced in Japan. The Nekomata's melancholy face implies she is strumming someone she knew, perhaps a child or a lover.

Toriyama Sekien showed Nekomata in *Gazu Hyakki Yagyo* (1776) as a trio of cats, only one who is old enough to stand on two legs. It is a delightful representation of age bestowing supernatural abilities. Sekien's picture has the split tail of a Nekomata paired with the towel on its head of a Bakeneko. Toriyama's illustration is a rare instance of this.

During the Edo period, Nekomata also became associated with Kasha, a cat-like demon from Buddhist mythology that steals corpses. Nekomata developed necromantic powers, able to manipulate the dead like puppets. This association is believed to come from cats known proclivity of eating human corpses, a phenomenon known as postmortem predation.

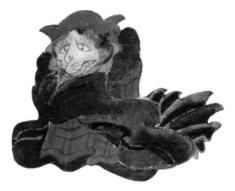

Henge Shapeshifters

Sazae Oni Nautical Demons

A woman floats alone in the sea, clinging to a piece of wooden flotsam. The sailors eagerly bring her aboard, thanking fate that put such a beauty in their path. But their thanks soon turn to terror as they realize exactly what they have let on board. The Sazae Oni demands a price that no one wants to pay.

There are two origins of Sazae Oni. According to one legend, Sazae Oni are typical animal Yokai, that have lived a long time—in the case of the Sazae Oni, 30 years—and transformed by the magic of long life into a supernatural creature. Sazae Oni grow to an unusual size, and becomes a blend of human and animal features, gaining two powerful arms and eyes on its shell. The other legend is more terrifying.

Sazae Oni is written 栄螺鬼
栄螺 (sazae) – turban shell
鬼 (oni) – demon, monster

Toriyama Sekien uses Sazae Oni as a metaphor for the mysterious universe that we live in, a realm where all things are possible. In *Gazu Hyakki Tsurezure Bukuro* (1781) he wrote:

"If a sparrow becomes a clam upon entering the sea, and a field-rat can transform into a quail, then in this unfathomable universe it is no impossible thing that a turban shell might become a demon. I have seen this in something like a dream."

Toriyama is making a reference to a Chinese proverb, which comes from *Liji* (date unknown). It says that a sparrow may become a clam in the sea, and a field rat may become a quail. The proverb means that even impossible things can happen in the mysterious world we live in.

Another legend appears in the book *Yokai-majin-seirei no sekai* (1974) by Yamada Nori. This story says that in Kishu Province (modern day Wakayama and Mie Prefectures), there is a legend that Sazae Oni are born from lustful women who are thrown into the ocean as punishment for their wanton ways.

The story tells a ship of pirates hugging the coast heard the cries of a woman drowning in the waves. Seeing that the woman was beautiful, the pirates decided to rescue her. Once on board, the pirates planned to rape her but found instead that the woman was willing. Over the course of the night, she had sex with every member of the crew.

The woman had her own agenda—she kept a souvenir from each of her conquests, the man's testicles that she supposedly bit off when she was finished. Discovering that they had been robbed of the precious possessions, the men charged at the woman who revealed herself as a Sazae Oni. She offered to sell

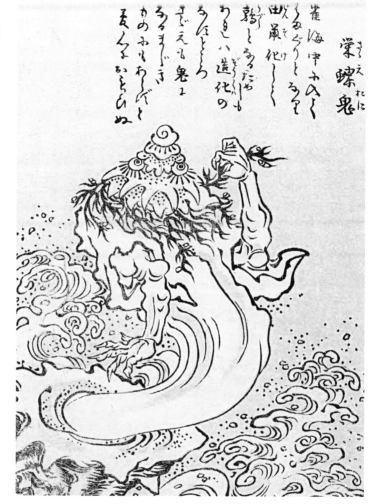

the pirates back their testicles in exchange for their plundered treasure. In this way the Sazae Oni traded "gold" for gold, as testicles in Japanese is *kintama* (golden balls).

Yamada was known for creating stories of many Toriyama creations. There are no historical sources for this legend and odds are good it sprang from Yamada's mind. It has correlation with the European succubus. In the witch hunter's manual *Malleus Maleficarum* (1486), it is said that succubi gather semen from lovers in order to breed. In a similar way, Sazae Oni collects testicles. Some legends sprang up saying Sazae Oni also use semen from the testicles in order to breed new Sazae Oni. This is a modern theory, however, and has no folkloric provenance.

Henge Shapeshifters

Nureonna Snake Women

Walking home one dark and rainy night along the lake, you see a woman struggling along with her baby. Her entire body is drenched, and she is soaked from the top of her head to the tips of her toes. She is attempting to adjust her pack and seeing you she begs you to hold her baby for just a moment so she can get set. As you hold the baby, it gets heavier and heavier. Your feet sink into the soft soil of the shore. Frozen in place, you see the woman uncoil her body and open her mouth showing wide fangs, ready to strike. A Nureonna.

Nureonna—wet women—are one of several Yokai who prevail on the kindness of strangers as their means of attack. Appearing on rainy evenings, they ask strangers to hold their baby. Once prevailed upon, their hapless victim is frozen in place, unable to drop the rock they now see they are holding. The only hope is if you hold the baby while wearing gloves. In which case you could slip off the gloves and make your escape.

> **Nureonna** is written 濡女
> 濡 (nure) – wet
> 女 (onna) – woman

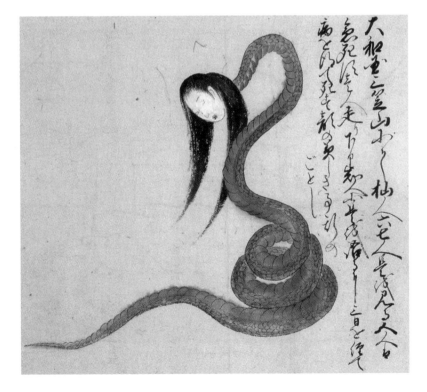

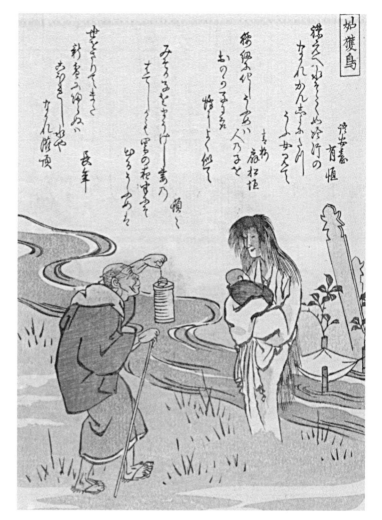

Nureonna (facing page) from the *Kaidan Ektoba* scroll. She was encountered by six people on Mt. Mikasa in Nara, killing five of them. (mid-19th century) Artist unknown.

Nureonna (right) from *Kyoka Hyaku Monogatari*. She is depicted in her human form. (1853) Ryukansai.

Nureonna are a common sight in Edo period pictures scrolls. They appear in Sawaki Sushi's *Hyakki Zukan* (1737) and Toriyama Sekien's *Gazu Hyakki Yagyo* (1776). In both cases, these show a creature with a snake body and a woman's head, with no other explanation.

The snake body is at odds with most stories of Nureonna, which depict her as a drenched woman. It is possible they were influenced by the naga snake people from Hindu mythology, or the snake-bodied goddess Nuwa of Chinese mythology. Or it is possible Sawaki Sushi just thought it looked cool. In truth, we don't know. In one story by folklorist Morihiko Fujisawa in his essay *Yokai Gadan Zenshu* (1929), there is an encounter with a Nureonna that resembles

Henge Shapeshifters

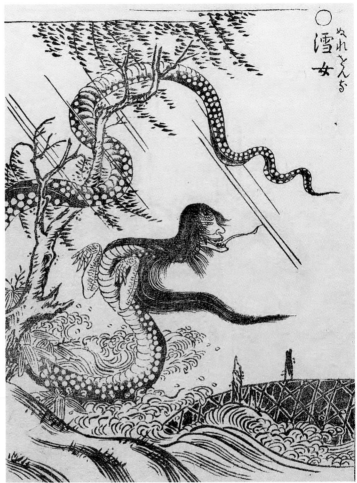

Nureonna (top) from *Gazu Hyakki Yagyo.* (1776) Toriyama Sekien.

Nureonna (bottom) from the *Bakemono no e* scroll. (17th or 18th century) Artist unknown.

more of a sea serpent. A group of sailors swept out to sea encounter a woman calmly washing her hair. Screaming in fear, they rowed away. Later they said the Nureonna had a tail about 1,073 feet (327 meters) long. This is not specifically said to be a snake tail, but it can be implied. Morihiko says this story comes from 1818 but offers no primary source.

There are regional variations of Nureonna with different names. In Kyushu, Isoona (beach women) appear at seas and rivers. In Nagasaki, they are called Nureonago (wet girl). In his essay *Iwami Ushioni Tan* (1933), folklorist Okada Kenbun presents legends of Nureonna working with another Yokai, the Ushi Oni. The Nureonna traps the victim with her baby, and then the

monstrous Ushi Oni emerges from the water to feast. In *Yokai Zukan* (2000), authors Kyogoku Natsuhiko and Tada Katsumi speculate that Nureonna legends may have come from a transformed sea snake able to take human form.

Tsuchigumo Spider Demons

The brave warrior Minamoto no Yorimitsu was prepared for whatever came out of the cave. He held his sword at ready, knowing that he would have little time to prepare against this onslaught. When a woman came stumbling out, begging for help saying she had just escaped from the clutches of a massive spider, Yorimitsu struck without hesitation.

While many Yokai change over time, in few has the transformation been as drastic as Tsuchigumo. Here is your hint; they were not originally spiders.

Tsuchigumo from the *Bakemono no e* scroll. (17th or 18th century) Artist unknown.

Tsuchigumo is written 土蜘蛛
土 (tsuchi) – dirt
蜘蛛 (gumo) – spider

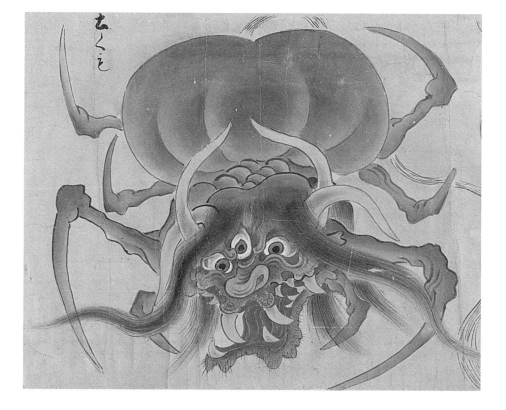

The oldest known mention of Tsuchigumo comes from *Kojiki* (712) and *Nihon Shoki* (720). These books mention Tsuchigomori as "those who hide underground." The name is possibly literal; Tsuchigomori may have been underground dwellers who dug houses in the earth instead of building them upwards. It is speculated Tsuchigomori were indigenous people displaced by the Yamato, who crossed to Japan from east Asia sometime during the Yayoi period (300 BC to AD 300). It may also have referred to renegade clans using caves and fortified underground mounds for military purposes. Either way, someone was digging in.

Tsuchigomori were described as humanoid but having long, glowing tails they used to push around rocks. This odd appearance makes more sense when you realize that Japan has no native species of tarantula or other large spiders.

That transformation happened in the 14th century. By the 14th century the Yamato were firmly established as the dominating people. Commerce with China brought new and wonderful things, including fabulous animals like the Chinese bird spider, a large, tiger-striped tarantula that burrows into the ground to build its nest. The word-switch from Tsuchigomori (those who hide in the ground) to the Tsuchigumo (earth spider or dirt spider) was a short leap.

The scroll *Tsuchigumo Soushi* (14th century) reinvented the historical Tsuchigumo as a tribe of monstrous Yokai that invade the capital. Heroic commander Minamoto no Yorimitsu repelled the invasion. Following the trail of skulls, he was led to a cave in the Rendai field, in a mountain north of Kyoto. There he hacked his way through an army of Yokai, fighting through the night until dawn.

With the welcoming rays of the sun, a beautiful woman emerged from the cave, claiming to be held prisoner. Yorimitsu was no fool. He drew his sword and slashed her. She left a trail of white blood as she fled into the cave. Pursuing her, Yorimitsu confronted her true form, a gigantic spider with the stripped body of a tiger. He battled the Tsuchigumo for hours, finally cutting off her head. The heads of 1,990 dead people came pouring from her stomach. Countless small spiders—her babies—came flying from her body to seed the country with more Tsuchigumo.

Tsuchigumo Soushi inspired further legends of Minamoto no Yorimitsu and battles with Tsuchigumo. In one story, Yorimitsu fell ill, and only recovered when he followed a dubious monk into the forest where he fell under the spell of a giant Tsuchigumo. Yorimitsu pierced it with an iron spike, that later became the sword Kumo-kiri (Spider Cutter). For Yokai, the Tsuchigumo were unusually crafty and vengeful.

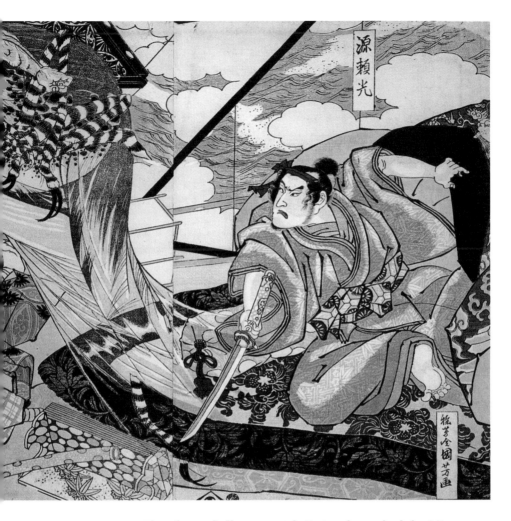

源頼光

A Tsuchigumo
battling the legendary
hero Tsuchigumo
Minamoto no
Yorimitsu. (19th
century) Utagawa
Kuniyoshi.

They formed alliances with Oni and attacked the Minamoto family, including Yorimitsu's father.

Tsuchigumo changed to mean enemies of the empire. All who refused to submit to Yamato authority were branded Tsuchigumo. There are several descriptions of the emperor attempting to tame these rogue people. In the Hizen no Kuni Fudoki, it states Emperor Keiko captured the Tsuchigumo Oomimi and Taremimi on a state visit to Shiki Island. Other legends tell of five great Tsuchigumo gathering forces in the Katsuragi Mountains to oppose imperial rule.

In modern Japan, the giant spider legends are all that remain of these aboriginal Tsuchigomori. The Yamato clan was successful in erasing them from the record books, leaving only half-whispered legends.

Henge Shapeshifters

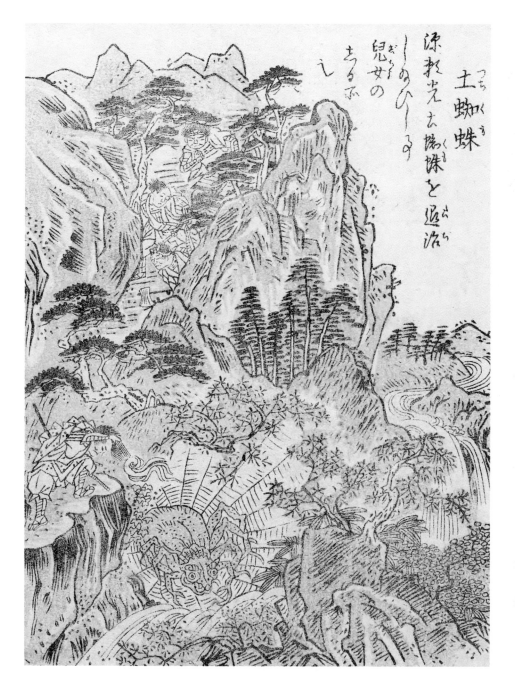

土蜘蛛

源頼光土蜘蛛と返治
しのひ√る
児女の
おるふ
し

Tenjoname (above) from *Konjaku Hyakki Shui.* (1780) Toriyama Sekien.

Kasha (facing page) from *Bakemono no e* scroll. (17th or 18th century) Artist unknown.

Kasha Flaming Cats

You knew your uncle wasn't the nicest of people. He had robbed, murdered, and been justifiably executed. Still, you had to have a funeral. And while you had made preparations against all manner of karmic retribution, the one thing you hadn't prepared for was a cat. Or a Kasha.

Kasha are a true embodiment of Bakemono—changing things. They started as a flaming cart from Buddhist hells coming to claim the souls of sinners, and over time transformed to corpse-eating cats surrounded by a halo of fire.

> **Kasha** is written 火車
> 火 (hi, ka) – fire
> 車 (kuruma, sha) – wheel, vehicle

Kasha first appeared during the Heian period. This was a time when Buddhism was being spread to the populace. This was similar to the European spread of Christianity, using the fear of Hell as punishment as the primary driver for good behavior. Independently, both in Europe and Japan, paintings of Hell began being produced to terrify an illiterate population. In Europe these were called doom paintings. In Japan they were jigoku-zoshi, or hell scrolls.

In these jigoku-zoshi, various demons were created to populate the hells. This was the first glimpse of what would later be known as Oni. One of these demons was a monstrous, fanged creature pulling a flaming cart. This gave rise to the name Kasha, meaning "flaming cart." In works such as *Kizo Danshu* (1687) Kasha are said to appear during

An encounter with
a Kasha from the
book *Kii zotan-shu*.
Kuronyudo (1850)
Artist unknown.

funeral processions and attempt to steal the corpses of sin-
ners to drag them to hell. There are several similar stories in
period volumes, and illustrations at the time show Kasha as a
demon similar to the thunder god Raijin.

The transition to a cat was a strange one, and not well
understood. Toriyama Sekien drew a somewhat catlike
creature for Kasha in *Gazu Hyakki Yagyo* (1776). It resembles
earlier depictions, although its face and fur are catlike. It is
surrounded by a flaming aura, and has a single, fiery tail.
There is no cart in sight. The puller of the cart has become
the cart.

Later depictions followed Toriyama's lead. There was also
the merging of Kasha with other Yokai. In the late Edo period
Boso Manroku (1833), there is a catlike illustration of a demon
called Moryo with the reading given as kuyashiya. Spirits of
Chinese folklore, Moryo are small, childlike creatures with

red skin and long ears. They eat the organs and brains of the dead. Merging corpse stealers with corpse eaters was not too far a stretch. *Hokuetsu Seppu* (1837), a collection of customs and folktales from northern Japan, describes a ball of fire that covered a coffin at a funeral. Inside was a giant cat with a forked tail. The demon is repelled by a priest named Kitataka, and his vestments are afterwards known as the Kasha-defeating robe. The Kasha in *Hokuetsu Seppu* describes a Nekomata with its two tails.

The transformation of Kasha from a flaming cart to a flaming cat is also speculated to be associated with the phenomenon of post-mortem predation. Cats are known to eat the corpses of their owners. By custom, cats are kept outside during Buddhist wakes. Rumors spread that this was because the scent of the corpse would drive cats mad with hunger and transform them into Kasha.

Kasha from *Gazu Hyakki Yagyo*. This is the first instance of the Kasha being given a cat-like form. (1776) Toriyama Sekien.

YOKAIOLOGY
Tsukumogami
Animated Objects

"According to Miscellaneous Records of Yin-Yang, when containers reach a hundred years old, they gain a soul and trick people. They are called Tsukumogami." – *Tsukumogami Emaki* (16th century)

Tsukumogami is one of the oldest stories told by humanity; "My god is better than your god." The story demonstrates the primacy of Buddhism over the native religion of Shinto, all while doing it in a charming, funny way full of puns and cute character designs.

Tsukumogami is written 付喪神
付 (tsuku) – attached
喪 (mo) - grief
神 (gami) – god, spirit

Literally, Tsukumogami means "Grief-bringing god." It refers to their evil nature and the destruction they bring. An alternate kanji, 九十九神, means "ninety-nine-year god." As is often the case in Japanese, "ninety-nine" was not meant to be a specific age but was a metaphor for "very old."

Most define Tsukumogami as objects that come to life after a hundred years. The belief is thought to have come from the Chinese Tangmi sect, known as Shingon Buddhism in Japan, which preaches that all things have an inherent Buddhist nature and can become enlightened. Depending on the version of the legend, there can be some provisos and qualifications. One such is that the object must be something that is used, like a comb or a chair or a guitar. It can't be a decoration. Another says that the object must be

An old umbrella animated and walking with a cane. From the *Hyakki Yagyo* scroll. (1860?) Hiroharu Itaya.

An *utsubo* quiver transformed into a Yokai. From the *Hyakki Yagyo* scroll. (1860?) Hiroharu Itaya.

abandoned, disrespected after years of service. Items on display and appreciated in museums do not qualify.

The origins of Tsukumogami are obscure. *Ise Monogatari* (10th century) mentions Tsukumogami, but the kanji for "*gami*" refers to hair and *tsukumo* means "a hundred minus one," or ninety-nine. It is a poetic way of saying white-haired. An annotated version of *Ise Monogatari* points out that Tsukumogami was also used for foxes and Tanuki who had lived a hundred years and gained supernatural abilities. It may have been an allusion to the strange powers brought on by age.

Legends of object Yokai can be traced to the Heian period as they appear in literature at the time. *Konjaku Monogatari* has two such tales, one involving a discarded copper decanter and another about an Oni that possesses a small oil pot. In the stories, these are called Mononoke. The oldest known images of Tsukumogami are in *Tsuchigumo Soshi* (14th century), a picture scroll of the account of the hero Minamoto no Raiko in his battle against an enormous Tsuchigumo. As Minamoto attacks the spider in its home, several Yokai rush to fight him, including possessed objects.

Tsukumogami clearly reference *Hyakki Yagyo* beliefs, and several period picture scrolls have object Yokai marching in the parade. Tsukumogami and *Hyakki Yagyo* seem to be parallel beliefs, although *Hyakki Yagyo* is most likely older.

Tsukumogami are first called Tsukumogami in the picture scroll series *Tsukumogami Emaki*. While several copies survive, we don't know when the original was made. The oldest reference to the scroll is in *Sanetaka Koki* (1485), the diary of court noble Sanetaka Koki. The oldest known surviving copy comes from 1666. All surviving copies have key differences, and it is only best guess which, if any, are closest to the original.

Tsukumogami Emaki tells of discarded household objects that come to life after a hundred years. Bitter at their neglect, they plot revenge. A set of rosary beads cautions them against it but is beaten. In the mountains they build a shrine to their god, Henge Daimyojin (Great God of Henge). They come into town to take humans

A copper gong (above) and a *biwa* and *koto* (left) musical instruments reborn as a Tsukumogami. From the *Hyakki Yagyo* scroll. (1860?) Hiroharu Itaya.

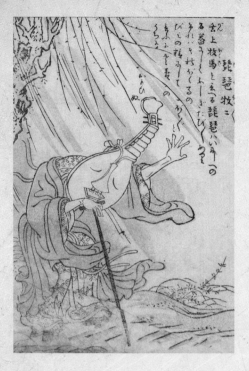

century). The so-called "Miscellaneous Records of Yin-Yang" referenced in the first sentence does not exist and is possibly there to give readers a sense of antiquity. At least one copy gives an explicit reference to Shingon Buddhism telling readers that they too can receive bodily enlightenment. This sort of moral at the end of supernatural stories common at the time, as they were often added so works could pass official censors as having religious merit. But the sheer amount of play in the language of *Tsukumogami emaki* shows that at least these copies were intended for entertainment more than moral edification.

Tsukumogami beliefs vanished after the Muromachi period and were rediscovered during the Edo period as artists excavated the past to fill out the ranks of their new Yokai work. *Wakan Sansai Zue* (1712) and Sawaki Sushi's *Hyakkai-Zukan* (1737) did not include any Tsukumogami, and Toriyama Sekien does not illustrate any until his fourth release, *Gazu Hyakki Tsurezure Bukuro* (1781) which is dedicated to them. This fourth volume is known to be entirely Sekien's original creations.

The dancing pots and pans found new life during the 19th century with a children's card game called *Obake Karuta*. This featured various Yokai illustrations as children matched cards against each other in a precursor to modern card games such as Pokémon. With cute character designs of recognizable objects, Tsukumogami were a natural addition to this game. It is through *Obake Karuta* they became known and loved by the children of Japan.

and animals to eat, and spend their time drinking, gambling, and reciting poetry. To worship Henge Daimyojin, they parade through the capital of Kyoto in a Shinto festival procession. Encountering the prince regent, they are repelled by a Buddhist sonsho darani charm he carries. The prince asks the priest who made the charm for help, and the priest summons Buddhist deities who appear before the Tsukumogami. Awed by the majesty, they immediately convert to Buddhism.

Different versions of *Tsukumogami emaki* can be more or less didactic about the Buddhist lesson. The objects are described mostly as vessels, pots, and such, which is a metaphor for a container that can be filled with Buddhist knowledge. The text is filled with puns and clever word play, and the title itself may be an allusion to a Chinese text *Sou shen ji* (4th of 5th

Kasaobake Maqical Umbrellas

Caught outside on a rainy night without an umbrella, you spy one leaning abandoned against a wall. Thinking it is your lucky day, you grab for it only to see it leap away. A single eye opens in its folded fabric, and a tongue lolls out of a wide mouth. The umbrella hops about on one leg, laughing at your surprise.

Kasaobake is easily the most famous of the Tsukumogami, which is ironic as they weren't Tsukumogami to begin with. Kasaobake appeared during the Edo period as images in popular entertainment. They have no stories from traditional folklore and did not appear in any of the major collections. Kasaobake's enduring fame is entirely from their delightful character design.

> **Kasaobake** is written 傘お化け
> 傘 (kasa) – umbrella
> お化け (obake) – changing thing
> Kasaobake are known by other names such as
> Kara Kasa **(から傘)** meaning old umbrella, and
> Kara Kasa Kozo **(唐傘小僧)** meaning old umbrella boy.

Creatures with umbrellas on their heads appear as far back as the Muromachi period. The oldest known *Hyakki Yagyo* scroll, *Hyakki Yagyo-zu* (16th century) shows a humanoid creature in traditional clogs with an umbrella for a head, and the handle sticking out as its nose or tongue. This could be a precursor to Kasaobake, or it could be Amefuri Kozo, a Yokai boy who wears an umbrella as a hat. Or perhaps neither.

Edo period humorist Ihara Saikaku wrote *Kasa no Gotakusen*, or Umbrella Oracle, in his book *Saikaku Shokoku Banashi* (1685). In it he mocked Shinto beliefs and rural people with the story of an abandoned umbrella found in a small village. The poor people, having never seen an umbrella, venerate it as Kami. Their worship gives the umbrella a divine spirit. It demands a beautiful virgin as a servant, but none are willing. An adventurous widow volunteers, but the umbrella god turns her down. In anger at being spurned, she tears the umbrella to pieces.

In *Sasayaki Senrishingo* (1762) there is a reference to the seven Obakemono that haunt Kofuku-ji temple, one of which is called kara kasa. There are no further details given, but it suggests there was some legend of an umbrella Yokai known at the time.

In *Gazu Hyakki Tsurezure Bukuro* (1781), Toriyama Sekien created a new Yokai called hone kara kasa, or bone

Postcard of **kabuki** actor Onoe **Kikugoro V** (right) dressed as Kasaobake for a performance. (1903) Photographer unknown.

Kasaobake (far right) from the Meiji period board game *Mukashi Banashi Bakemono Sugoroku.* (1848–854?) Utagawa Yoshikazu.

Kasaobake toy (bottom) from the film *Yokai Monsters: 100 Monsters.* (1968) Photographer unknown.

umbrella, His creature was an allusion to chiwen of Chinese folklore, an arched-back dragon fish rain god that is placed as an ornament on buildings to protect them from fire. Toriyama's hone kara kasa is bent and flared out like the fins of a fish and has little in common with what we know as Kasaobake. *Hyakki Yagyo Zukan* (Edo period) by Kano Enshin shows a stout umbrella monster with two clawed feet poking out the bottom and a single eye. Instead of hands it has a stick running through it.

Perhaps the oldest true image of a Kasaobake is *Shichi Henge Sangoru* (1815), a print series by Utagawa Toyokuni I of *kabuki* actor Arashi Sangoro III. The series shows Arashi in a Kasaobake costume with one foot bound and his face and arms sticking out. Kasaobake was part of a *kabuki* performance called *shichi Henge*, or seven changes, which featured an actor performing miraculous quick changes for seven characters. They would enter as the Kasaobake, one foot bound, hopping on stage, until they shed their costumes in rapid sequence. There are other prints from this time showing *kabuki* actors in Kasaobake costumes, so obviously the character was familiar.

At the end of the Edo period the game *E-sugoroku* became popular. A table game similar to chutes and ladders, there were myriad variations. Maps of Japan, historic epics, actors, and anything you could think of became e-sugoroku boards. Artist Utagawa Yoshikazu

A Kasaobake portrayed by an unidentified *kabuki* actor, possibly Onoe Tamizo II. (1857) Gosotei Hirosada.

Henge Shapeshifters

made *Hyakurui kaidan yomono sugaroku* (1858) featuring all manner of Yokai. One was a Kasaobake, labeled as "One foot from Sagizaka."

Games, art, and *kabuki* theater ensured Kasaobake a prominent place in the Yokai world. Eventually, as a living umbrella, it became attached to Tsukumogami legends and folklore was built around it as an abandoned umbrella that came to life. But the truth is, Kasaobake simply looks cool. That is its magic.

Koto Furunushi Ghostly Zithers

Dwellers in the village often told stories about the house of the old musician. Many years dead and long abandoned, no one would go near the ancient dwelling. Not only did they tell tales of strange lights and movements in the house, but they also talked about hearing strains of music wafting from the ruins, music of a type no one had played for a hundred years.

Koto Furunushi is a Tsukumogami of a koto. Introduced to Japan from China in the 7th and 8th century, koto are a form of zither. Made of roughly six feet of curved wood in something like a half-pipe, they are strung with thirteen strings attached to a movable bridge. Plucked using finger-picks, koto sit on four short legs and are played seated. Their squat appearance makes them natural Yokai.

> **Koto Furunushi** is written **琴古主**
> 琴 (koto) – 13-stringed Japanese zither
> 古 (furu) – old
> 主 (nushi) – master, guardian spirit

Yokai koto can be seen marching along in the night parade. *Hyakki Yagyo-zu* (16th century) depicts a walking biwa, a guitar-like Japanese instrument, leading a koto on a leash like a dog. With its long body and squat, four legs, this is a natural transformation for a koto. Like many Tsukumogami, there is no folklore or name for these creatures. They were purely visual designs.

Koto Furunushi was created by Toriyama Sekien for *Gazu Hyakki Tsurezure Bukuro* (1781), his illustrated collection of Tsukumogami. Sekien imagined Koto Furunushi not only as an abandoned instrument, but as a forgotten style of music once played on its strings, music from the Tsukushi school. Prestigious and self-important, Tsukushi school did not allow its style to be taught to women or the blind. Thus, the irony when blind composer Yatsuhashi's style entirely supplanted it. In Sekien's version, the abandoned koto's

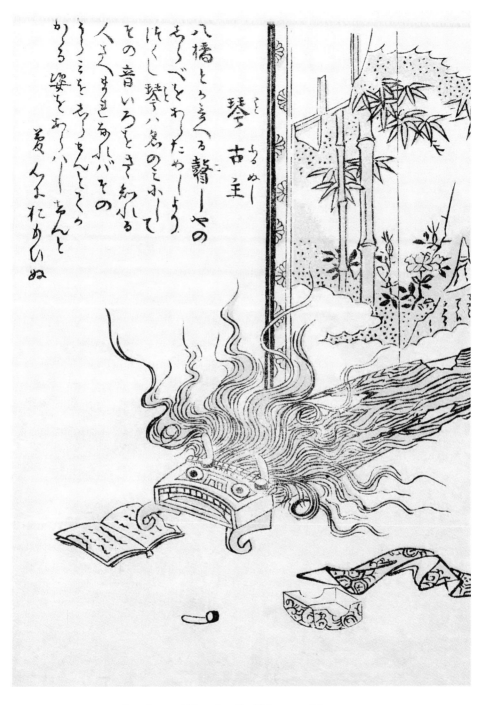

八幡とうぐゐる鼕ーや
そーべとわらたやしよう
けくし琴ハ気のとふして
その音いろをき知れる
人ぐまゝにるればその
ろことをゝもんとゝっ
かくる姿をあらハしゐんと
美んよたやいぬ

Koto Furunushi from *Gazu Hyakki Tsurezure Bukuro*.
This is Sekien's original creation. (1781) Toriyama Sekien.

Henge Shapeshifters

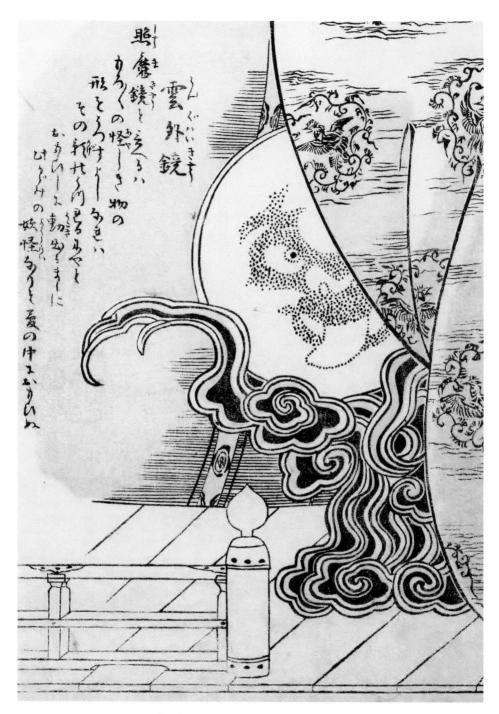

Ungaikyo from *Gazu Hyakki Tsurezure Bukuro*. This is
Sekien's original creation. (1781) Toriyama Sekien.

strings split and curl around the head like a wild mane. It stamps angrily on a book of sheet music.

While Sekien's Koto Furunushi is an original creation, there is some folklore of enchanted koto. In *Hizen Kuni Fudoki* (8th century), a compilation of the culture of the Hizen provinces, a story is told that Emperor Keiko looked at a flat plain and declared it needed a hill. He immediately ordered a hill to be built. When it was finished, he climbed to the top and held a magnificent banquet. After the festivities, he buried a koto standing vertically. From this koto grew a magnificent camphor tree. The tree still stands to this day, at Kushida shrine in Kanzaki, Saga Prefecture. Legend says if you stand silent by its roots you can hear the strains of koto music. The hill is called the Hill of the Koto Tree.

Heisei period (1989–2019) Yokai collections connected these two legends, and it is not uncommon to see Koto Furunushi described as koto made from the wood of the Koto Tree. Some say koto made with even a piece of wood from this tree become Tsukumogami.

Ungaikyo Enchanted Mirrors

Staring into a mirror is always an act of bravery. You never know what may be looking back. But should you find an abandoned shrine mirror, its face swirling with clouds, looking inside it will show you the monster within yourself.

Ungaikyo are Tsukumogami shrine mirrors. They are said to possess the peculiar power to show their viewer their own self as a Yokai.

> **Ungaikyo** is written 雲外鏡
> 雲 (un, kumo) – cloud
> 外 (gai, soto) – outside
> 鏡 (kyo, kagami) – mirror

Ungaikyo are not ordinary mirrors. They are shinkyo—divine mirrors—placed in Shinto shrines as representatives of Kami. Every shrine has a divine object that is meant to be the actual embodiment of the Kami, called the shintai. In some shrines the shintai maybe be a sword. In some it may be a natural formation, a tree, a rock, or even a mountain. Mt. Fuji is probably the most famous shintai. Mirrors, however, are the most common. In 1895, the Ministry of the Imperial Household decreed all newly founded national shrines must have mirrors as their shintai.

Shinkyo are said to have their origin in China, where divine mirrors are also used. In ancient societies mirrors

were rare and expensive to make. Their ability to show true reflections was akin to magic. These ancient mirrors were often highly polished bronze. The bronze mirror Yata no Kagami is one of the three imperial regalia of Japan and said to have been passed from the sun goddess Amaterasu to her grandson Ninigi-no-Mikoto, ancestor of the Japanese imperial lineage. Shinkyo—divine mirrors—are often small, about 3–4 inches in diameter. They sit in wooden stands.

Ungaikyo was created by Toriyama Sekien for *Gazu Hyakki Tsurezure Bukuro* (1781), his illustrated collection of Tsukumogami. The name is possibly a reference to *Sengaikyo* (4th CE?), a classic Chinese bestiary of mythical monsters and places. Ugaikyo is a notable entry for being one of the few times Sekien uses the word Yokai. He depicts a shinkyo on its wooden stand, peeking behind a curtain and giving a mischievous look. Sekien references Shomakyo a legendary mirror wielded by Chinese king Zhou of the Shang dynasty. Shomakyo's name means demon-revealing mirror and was used by King Zhou to reveal the true nature of his concubine Daiji as an evil fox spirit. Her identity uncovered, Daiji fled first to Korea and finally to Japan where she became the nine-tailed Kitsune Tamae-no-Mae. Sekien speculates that after so many years of showing the reflections of Yokai, could it not be transformed to become a Yokai mirror itself, able to move around?

Mizuki Shigeru used Ungaikyo for the story *Great Mirror Battle* (1968) in his comic series *Kitaro*. Mizuki expanded its powers to be able to trap people in the mirror. This has likely influenced later appearances of the Yokai. Heisei period (1989–2019) Yokai collections describe Ungaikyo as a typical Tsukumogami, a shrine mirror that has come to life after a hundred years, influenced by the power of the evil Yokai who live in the mirror. They say that those who gaze into Ungaikyo will see their own faces reflected as Yokai.

Ittan-momen Cloth Monsters

A flash of white dives from above, and before you know it you are being strangled by a mysterious cloth. Chocking, you pull out your dagger to cut yourself free. Slicing the cloth, it disappears as quickly as it arrives. Gasping for air you see blood on your blade. You cut something, but what?

Ittan-momen are living lengths of cloth, about 33 feet (10 meters) in length. They fly through the sky and dive bomb people, either smothering them by covering their faces or wrapping around their necks. Cut this cloth and they will bleed.

Ittan-momen is written 一反 木綿
一反 (ittan) – one tan (about 33 feet or 10 meters)
木綿 (momen) – cotton

Although now considered a Tsukumogami, the mysterious Ittan-momen have very little folkloric provenance. A white cloth monster with clawed feet poking out appears in *Hyakki Yagyo-zu* (16th century) and most researchers consider it a version of this strange creature. Unfortunately, Ittan-momen do not appear in any other emaki scrolls or Edo period Yokai collections.

The first mention of Ittan-momen is found in *Osumi Kimotsukigun Hogen Shu* (1942) jointly authored by folklorist Yanagita Kunio and educator Nomura Denshi. Yanagita enlisted Nomura to gather folk stories in local dialects in the Kagoshima area of Japan, on the southern island of Kyushu. Ittan-momen legends come from a town called Kimotsuki. They describe a strip of white cotton cloth, measuring about

An Ittan-momen attacks, likely the last thing the victim saw. (2011) Image courtesy Roberta Mašidlauskytė.

ITTAN - MOMEN

Henge Shapeshifters

89

A cloth Yokai that is likely an Ittan-momen from the *Hyakki Yagyo Emaki* scroll. (16th century or 17th century) Artist unknown.

one tan (about 33 feet or 10 meters). It flaps as it flies through the sky and attacks people at night. It served a role as a boogieman for children, with parents warning them if they were not home by nightfall the Ittan-momen would get them. It was especially said to appear before certain Shinto shrines, and children would run past them in fear. They believed Ittan-momen would attack the slowest child in any group.

Ittan-momen rose from obscurity to national fame when Mizuki Shigeru used it as a main character in his comic *Kitaro* (1960s). Ittan-momen is an ally of the Yokai boy Kitaro, who often flies around on its back. Because of its nature as an animated piece of cloth, it has been described as a Tsukumogami in modern Yokai books.

Boroboroton Murderous Bedding

Lying down on a dirty, unknown mattress is probably not a good idea in the best of times, but you should be even more careful in the land of Tsukumogami. And should you find such a mattress, don't bother running away. The boroboroton will hunt you down.

Boroboroton are Tsukumogami of bedding. Discarded and left to fall apart, their resentment causes them to seek out sleeping people to kill. It will flip them out of their beds and wrap around their necks, strangling them to death.

Boroboroton is written **暮露暮露団**
暮露暮露 (boro boro) – ragged
団 (ton) – bedding

Boroboroton was created by Toriyama Sekien for *Gazu Hyakki Tsurezure Bukuro* (1781), his illustrated collection of Tsukumogami. While their name seems deceptively simple—ragged old bedding—it is based on complicated wordplay. Sekien's text references kamuso, a sect of mendicant Buddhist monks of the Fuke sect. Kamuso monks rejected ego, wearing iconic woven basket helmets that concealed their identity. They prayed by playing a flute called *shakuhachi* and lived entirely by begging. Sekien also references *Shokunin zukushi uta awase* (16th century), a theme of illustrated pictures scrolls featuring an imaginary poetry contest of seventeen artisans.

Much like *Hyakki Yagyo*, there are multiple versions along this same theme, each handwritten and illustrated. They feature various occupations and craftspeople along with verse about each of them. The entries for *kamuso* monks are labeled *boro*, an alternate name for practitioners. "Boroboro" is Japanese for ragged or tattered, and it was an easy pun to link these poor, wandering *boro* monks to a *boroboro* bedding they must have slept on. In his text, Sekien ponders that the *boroboro* bedding of these *boro* monks might have been discarded, as the monks discarded all worldly things, and become Tsukumogami.

While most modern descriptions of Boroboroton describe them as a mattress, that's not actually the case. The word futon can refer equally to a mattress that you lie on, or a *kake-buton*, meaning a futon you sleep under, like a duvet. Poor people couldn't afford to replace their futon, so they patched them as necessary. As cotton was not common in Edo period Japan, they would patch their futon with whatever scraps they could find. Over time these patches would take

over most of the original fabric, leading to a checkerboard appearance similar to what you see in Sekien's illustration. This style of folkcraft is known as *boro*. Sekien's Boroboroton is the ragged (*boroboro*) bedding in the *boro* style discarded by a *boro* (*kamuso*). Like I said, complicated wordplay.

Much of this is speculation, of course. An alternate view demonstrates that in the *Shokunin zukushi uta awase* scrolls there is a woven *tatami* mat with the same pattern as the Boroboroton. Some researchers believe Sekien intended for the Boroboroton to be a *tatami* mat, and not bedding at all. In that case, the checkerboard pattern would be from two

different woven grasses. As *kamuso* were known to carry rolled up *tatami* mats to sit on, this is equally likely.

If you are looking for a more straightforward haunted futon, Lafcadio Hearn told the story of the Futon of Tottori in *Glimpses of Unfamiliar Japan* (1894). It tells of two young brothers who freeze to death wrapped in a futon. The futon was sold to a hotel, whose guests complained about the voices of two small children crying about the cold.

Oi no Bakemono Animated Backpacks

General Ashikaga Tadayoshi, younger brother of Ashikaga Takauji, first shogun of the Ashikaga shogunate, sat in his bedroom. Before him appeared an inexplicable apparition. A wooden backpack that had sprung bird feet, a human head, and was breathing fire. Clinched in its teeth was a broken sword blade. Ashikaga knew who this was.

Oi no Bakemono are odd creatures. They are unlike any other Tsukumogami, being more of a chimera of parts than an ensouled object. And perhaps one with a singular history.

> **Oi no Bakemono** is written 笈の化け物
> 笈 (oi) – wooden backpack
> の (no) – of, possessive form
> 化け物 (bakemono) – changing thing

Oi are wooden backpacks. They could be simple, with vertical wooden supports on a bamboo frame bound by woven reeds. Or elaborate boxes with shoulder straps, and four legs on the bottom for when they were set down. *Oi* were originally used for transporting letters and books, but later became associated with people on pilgrimage. Eventually they became part of the uniform of *yamabushi,* mountain ascetics who followed the religion Shugendo.

An Oi no Bakemono confronts Ashikaga Tadayoshi in *Ehon musha biko.* (1749) Nishikawa Sukenobu.

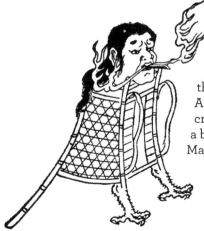

Oi no Bakemono appear in *Ehon musha biko* (1749) by Minamoto Orie and Nishikawa Sukenobu. The book says the Oi no Bakemono manifested before Ashikaga Tadayoshi in his bedchamber. The creature is described as having two legs like a bird, which is not unusual for Tsukumogami. Many, like the Kasaobake, have taloned feet like a bird of prey. The strange part is the head on top, clutching a broken sword in its teeth and breathing fire. Many describe this head as being of a *yamabushi*, but in

pictures it lacks the distinctive hat that characterizes the ascetics. The association is thin.

The most common response to this peculiar feature is to ignore it; Yokai are strange, after all. Oi no Bakemono are described as typical Tsukumogami, an *oi* backpack that was neglected and came time life after a hundred years, for some reason choosing to haunt Ashikaga Tadayoshi.

But there is another possibility. Ashikaga Tadayoshi defended the city of Kamakura during the Nakasendai Rebellion in 1335. Overcome, he was forced to flee. Tadayoshi was holding the son of Emperor Go-Daigo hostage, twenty-seven-year-old Prince Moriyoshi. Knowing that he would not be able to take the prince with him as he made his escape, Tadayoshi decided to behead Moriyoshi instead. Legend has it that even bound, Prince Moriyoshi fought back. Seeing the sword coming, he bit it in his teeth and broke off the blade. He died clutching a broken sword between his teeth.

If it was Prince Moriyoshi, that would make Oi no Bakemono an Onryo—a spirit of vengeance—rather than a Tsukumogami. But if so, he chose a bizarre and unsuccessful manner of vengeance. *Ehon musha biko* does not record the Oi no Bakemono attacking, just appearing. It seems more like Oi no Bakemono is a mix of Onryo and Tsukumogami.

Oboroguruma Cart Spirits

On misty nights on Kamo street in the old capital of Kyoto, the squeaking sounds of a cart were sometimes heard through the fog. Residents who stepped outside to investigate where confronted with a horrific site. The vengeful spirit of a cart battle.

Oboroguruma is the spirit of a cart battle. What is that? In the Heian period the aristocrats of the capital city were carried around in elegant carts. However, wherever there are vehicles in a crowded city there are parking problems. When two carts went for the same spot, a cart battle was on. The drivers would race for the spot, trying to physically bash the other cart out of the way. Oboroguruma is said to be the spirit of a cart that lost one of these battles.

> **Oboroguruma** is written 朧車
> 朧 (oboro) – misty
> 車 (kuruma) – cart, car

Stories of magical carts date back to *Uji Shui Monogatari* (1220). A story tells of a man encountering a mysterious cart on his way to see the Kamo festival in Kyoto. It is

むし朧鬼の大路とおがろよ
車のきしる音しくノ出くれば
異形のもの車争の
遙堀え車

朧車

thought stories like this inspired Toriyama Sekien to cre-
ate Oboroguruma for *Konjaku Hyakki Shui* (1781). He also
drew inspiration from a famous scene in *Tale of Genji* (11th
century), where Genji's wife Lady Aoi was defeated by his
mistress Lady Rokujo in a cart battle. This idea that a cart
may be so enraged that it transforms into a Yokai became
the basis for Oboroguruma.

Another potential influence comes from a famous haunt-
ing in the Edo period. Ino Heitaro, a 16-year-old samurai
living in the small town of Miyoshi in Hiroshima, chal-
lenged his friend Gonpachi, a sumo wrestler, to a game of
Hyakumonogatari Kaidankai on the haunted mountain of
Higuma. They played to the end and must have offended

Henge Shapeshifters

some spirit. Creatures appeared in the forms of various Yokai and haunted Ino relentlessly for the next thirty days. Apparently, it was such a ruckus that tourists came from all over Japan to witness the haunting. Eyewitness writers and artists wrote about it, in what are now known collectively as *Ino Mononoke Roku*. One of the Yokai that supposedly tormented Ino Heitaro was the face of a giant woman that blocked a door when he tried to leave. Pictures from *Ino Mononoke Roku* are similar to the giant face of Oboroguruma.

Scrolls from the Edo period show Oboroguruma in the *Hyakki Yagyo* parade. They are similar to Sekien's design, with the large face emerging from the cart. A key difference is in these scrolls the Oboroguruma is pulled by giant frogs. As with many things Yokai, no one knows why.

Tsunohanzo Living Washbins

The poet Ono no Komachi was not one to be trifled with. Her pen was power. Her will was strong. And when someone dared to challenge her authenticity, her rage extended even to the washbasin she held to prove the offense.

Tsunohanzo is a very specific Tsukumogami, the spirit of a handheld washbasin used by the Heian period poet Ono no Komachi. The washbasin's visual appearance merged with Komachi's elegance makes for a striking visual.

> **Tsunohanzo** is written **角盥漱**
> **角** (tsuno) - horn
> **盥漱** (kanso) – washbin for rinsing the mouth

Tsuno-darai are a type of lacquered bowl used for washing in the Heian period. They had four pointed handles so they could be gripped from any position, which gave them their name meaning horned tubs. A smaller vessel, called *tsunohanzo*, were used for rinsing the mouth. All *tsuno-darai* looked like creatures with four legs. It is small wonder they made their way into the ranks of Tsukumogami. A *tsuno-darai* appears in the oldest known Tsukumogami art, *Tsuchigumo Soshi* (14th century). It shows a small bowl standing on its handles as legs, with the bowl being its screaming mouth. *Tsuno-darai* Yokai also appear in *Hyakki no Zu* (Early Edo period) as a three-eyed monster clad in a simple tunic serving what appears to be soup from the head of a bowl-shaped Tsukumogami.

Toriyama Sekien created Tsunohanzo for *Gazu Hyakki Tsurezure Bukuro* (1781). He illustrated the Yokai as an elegant, Heian-period woman in an aristocratic junihitoe. These twelve-layered kimono were formal court dress worn by nobles

Tsunohanzo from *Gazu Hyakki Tsurezure Bukuro.* This is Sekien's original creation. Tsunohanzo was later renamed by Mizuki Shigeru as Tsunowansuki. (1781) Toriyama Sekien.

and ladies-in-waiting at the imperial court. He had a specific legend in mind when he created Tsunohanzo for It is a reference to the famed waka poet Ono no Komachi.

Once, Komachi was accused of plagiarism by fellow poet Otomo no Kuronushi. During a poetry contest, he declared that she had stolen her poem from the venerated book *Manyoshu.* Kuronushi then produced a copy of the book, with the poem clearly written on the page. To defend herself, Komachi produced her Tsunohanzo and poured water over the page. The freshly written ink ran, which should not happen in a book so ancient. Komachi proved that Kuronushi had broken into her house, read her poem, then copied it into the book hoping to declare her a fraud.

Henge Shapeshifters

Ono no Komachi (c. 825–c.900) was one of the Rokkasen—
the Six Immortals of Poetry. Renowned for her stunning
appearance as well as her poetry, in modern Japan Komachi
is a synonym for a woman of refined, elegant beauty. Almost
nothing is known about her besides her poetry. Sekien calls
her a "floating weed from unknown seeds." Floating weeds
is a poetic term for artistic people whose lives are moved by
currents. Unknown seeds are a reference to how little we know
of Komachi's life. Who was she? Where was she born? What
was her station in life? No one knows. Some surmise that there
were in fact multiple Komachis, as many as four different
women. Some think she was a low-ranking consort of Emperor
Ninmyo. Her poetry battle with Otomo no Kuronushi was
famous enough to be adapted into *noh* theater, as *Soshi Arai
Komachi* (15th century).

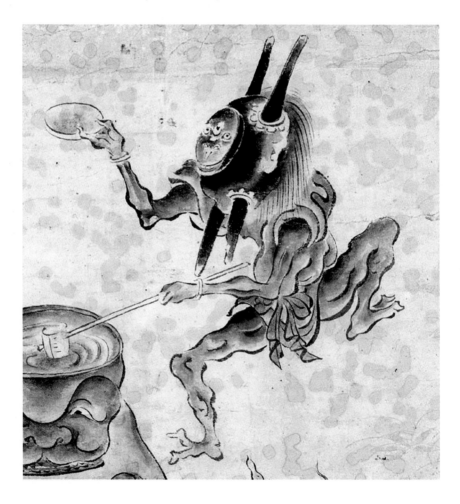

Seto Taisho Kitchenware Warriors

The kitchen staff shuddered in fear as they saw the plates shudder, clacking as they moved from the shelves and pulled together into a tiny shape. Grabbing a spare chopstick as a spear, the homunculus chased the staff around the cluttered kitchen. Seto Taisho was up to his hijinks again.

Seto Taisho is an unusual Tsukumogami in that he is not a single object come to life, but is instead an assemblage of cups, plates, chopsticks, and other ceramics pulled together to make a tiny person. As his name suggests, he is a warrior fighting a kitchenware war.

Seto Taisho is written 瀬戸大将
瀬戸 (seto) – Seto channel
大将 (taisho) – general

Japan has one of the world's oldest ceramic traditions, dating back to the Jomon period (10,500–300 BC). From the 4th century, Japan combined their native techniques with those learned from China and Korea. During the Kamakura period (1185–1333), six kilns refined their techniques to become defining producers. They are known as the Six Ancient Kilns of Japan. One of these, Seto in Aichi Prefecture, used a high-fired glazing technique that imitated Chinese ceramics. Called *setoyaki*, these domestic wares were a more affordable substitute for imported Chinese plates. Also known as *seto-mono*, they became so ubiquitous that *setomono* entered the Japanese language as a synonym for ceramics in much the same way "China" is used in English.

Toriyama Sekien created Seto Taisho for *Gazu Hyakki Tsurezure Bukuro* (1781). In it, he imagines a battle between *setoyaki* and rival *karatsuyaki*, a pottery produced in Karatsu, Saga Prefecture, on the island of Kyushu. *Karatsuyaki* was influenced by Korean design, opposed to *setoyaki*'s Chinese-influenced ceramics. Toriyama equates Seto Taisho with Guan Yu, a Chinese warlord and key figure in the epic *Romance of the Three Kingdoms* (14th century). Karatsuyaki is associated with Cao Cao, grand chancellor of the Eastern Han Dynasty. It refers to a scene in *Romance of the Three Kingdoms* when Cao Cao pours Guan Yu a cup of warm wine, which Guan Yu says he will drink after he returns victorious. Guan Yu then went to slay General Hua Xiong and returned so swiftly that the wine is still warm.

While having no folkloric provenance, Seto Taisho proved a popular character and appeared in other Edo period art. Tsukioka Yoshitoshi depicted him along with several other

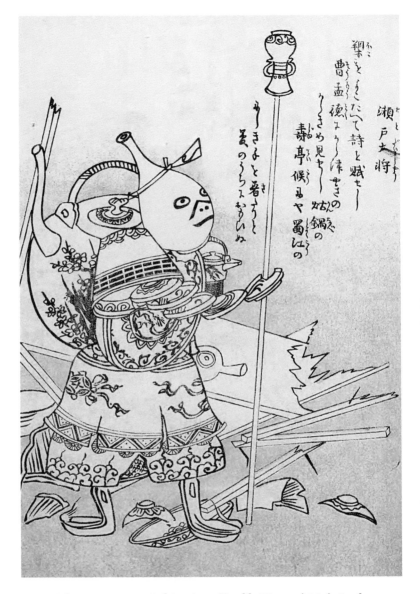

親としてたて詩と賦せー

瀬戸大将

曹孟徳ようく深きの

くきゝ見せー姑

くらぐと看ふと

の鍋の

寿亭候みや蜀江の

多きよと着ふと

美のうちえおりいぬ

Seto Taisho from
*Gazu Hyakki Tsurezure
Bukuro.* This is Sekien's
original creation. (1781)
Toriyama Sekien.

Sekien creations in his piece *Hyakki Yagyo* (1865). In the Showa period, (1926–1989) additional commentary was added saying that Seto Taisho defeated Karatsuyaki, which is how Setomono replaced Karatsuyaki as the most popular form of ceramics in Japan. He was eventually given a more traditional Tsukumogami origin, and Yokai encyclopedias from the Heisei period (1989–2019) often describe him as a mischievous figure that terrorizes kitchens. Smash Seto Taisho to pieces and he will reassemble to fight again.

Chochinobake Ghost Lanterns

The old lantern sitting in front of the bar had been there for years. The bar owner still lit it every night, even though it was starting to tear on the seams. She said it had been there for years, hung up by her grandmother. Why, the lantern must be almost a hundred years old. Then one night, the tear along the lantern spread all the way across, until the bottom half fell, looking like a gaping mouth. Out of the mouth lolled a gigantic red tongue. And on what was not clearly a face, an enormous eye opened. A Chochinobake was born.

Chochinobake are second only to Kasaobake in being the most famous of the Tsukumogami. They can be seen all

The Yurei of Oiwa manifests as a Chochinobake from the series *Hyaku Monogatari.* (1830) Katsushika Hokusai.

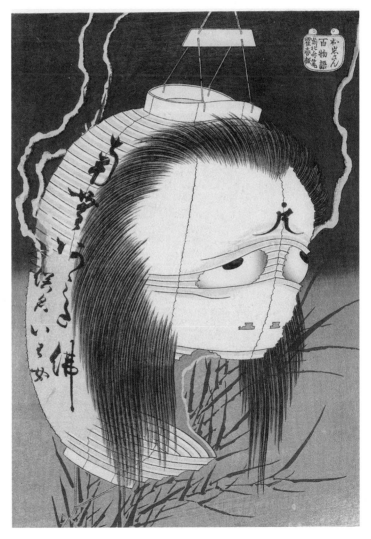

ぶらり／＼不二落に

山田もる机灯の
火とハえゆ
どともきとハ
南きよ
うくさまむ
狐ぶちぐ
ーしと
ゆものもちも
おうしぬ

over Japan, in every Yokai exhibition, haunted house, video game, toy collection, and anything else you can think to put a Yokai on and sell. And like Kasaobake, they were never Tsukumogami to begin with. They are a later creation.

Chochinobake is written 提灯お化け
提灯 (chochin) – lantern
お化け (obake) – changing thing

Chochin are paper lanterns consisting of a spiral frame of split bamboo covered with paper. They are round and long, different from the square *andon* and hexagonal *bonbori*. They have been used in Japan for centuries, with the earliest known usage being 1085. *Chochin* are hung outside of houses and businesses. Red *chochin*, called *akachochin*, are advertisements for restaurants and bars in the same way that a striped pole advertises a barber shop. *Chochin* are ubiquitous in Japan and would seem to be obvious candidates for Tsukumogami. However, they do not appear in any of the old *Hyakki Yagyo* picture scrolls.

Toriyama Sekien included a haunted lantern called Burabura in *Gazu Hyakki Tsurezure Bukuro* (1781) which is visually similar to modern Chochinobake. The key difference is Burabura has a tongue of fire from the candle within instead of Chochinobake's animal tongue. Sekien's burabura are not Tsukumogami, but Kitsune playing tricks, pretending to be lanterns strung along rice fields.

Another lantern spirit often misidentified as Chochinobake comes from the *kabuki* play *Tokaido Yotsuya Kaidan* (1825). In its most famous scenes, the vengeful spirit Oiwa haunts her murderer husband Iemon by manifesting in a temple lantern. This was a stunning special effect on the *kabuki* stage, with Oiwa's face projected onto a lantern. It was a favorite subject of Edo period artists. Many showed Oiwa emerging from a burning lantern, but Katsushika Hokusai made the definitive image showing Oiwa's head as a lantern, with a split seam as her gaping mouth.

Obakechochin appear in the picture scroll *Hyakki Yagyo-zu* (17th or 18th century) by artist Kano Enshin, the same scroll that has the first image of a Kasaobake. This creature is quite different, however, having the body of a Yokai and the familiar head of an Obakechochin. The familiar modern image comes mostly from popular Yokai children's games such as the table game e-sugoroku and the card game *Obake Karuta*. These continued to be popular in the Meiji period (1868–1912) and established the Obakechochin firmly in the pantheon of Yokai.

Burabura (facing page), a haunted lantern from *Gazu Hyakki Tsurezure Bukuro*. This is Sekien's original creation. (1781) Toriyama Sekien.

Kaibutsu
Creatures

What are Kaibutsu?

Kaibutsu are creatures. That doesn't mean they are evil. Or scary. Or dangerous (although some of them are). It only means that they have always been Yokai. Unlike Henge who were once normal creatures, people, or objects, Kaibutsu were never anything other than Kaibutsu.

Kaibutsu is written 怪物
怪 (kai) – strange, wonderous, supernatural, weird
物 (mono, butsu) – thing, object, evil spirit

Kaibutsu are generally thought to be powerful and terrifying. A more literal definition would be monster. However, even with the word monster, there is flexibility of nuance. The monsters of Sesame Street and Monsters, Inc., for example, are lovable and kind. While some of the creatures you will encounter in this chapter may not exactly meet the image of Kaibutsu/monster, think of them as more as folkloric creatures than horror movie monsters.

In Mizuki Shigeru's *Yokai Daihyakka* he labeled this category as Kaiju. This word means literally "strange beasts." However, the association has come to mean specifically the giant monsters of Godzilla and other films. Even though Kaiju is accurate in a folkloric sense, I thought this might be dissonant for modern readers. And changing things change.

A bloody Rokurokubi (facing page) surrounded by skulls (2019) Yoshi Yoshitani.

Kappa River Monsters

Swimming in the river with friends in a river, you see the current pull them ahead while you stay behind catching your breath. As your friends get further away, you move to rejoin them. In a panic you realize something has caught your foot. You can't move. Slowly, a slimy hand slips up your leg. A Kappa has found you and you are already dead.

One of Japan's most ubiquitous Yokai, Kappa are found across the Japanese islands. About the size of a child, Kappa appear as humanized turtles, complete with shell and beak. Even with their small size, they are stronger than normal humans. Their skin is green and mottled. Their hands and feet are webbed and studded with claws. They reek of fish. Kappa's most distinctive feature is the bowl-shaped indentation on their heads. This small bowl holds a reservoir of water that is said to be the source of their powers. If spilled, they must return to their river or die.

> **Kappa** is written 河童
> 河 (kawa) – river
> 童 (warashi) – child

Kappa folklore is vast and varied. It would be easy to write an entire book on Kappa, and many have. The study of Kappa was one of the first focuses of folklore studies when Yanagita Kunio founded the field in the Meiji period. For all this, the origins of Kappa are entirely unknown.

Kappa are considered to have ancient roots, yet there is very little record of them prior to the Edo period. They do not appear in the Muromachi period *Hyakki Yagyo* scrolls, nor are they mentioned in old folklore texts such as *Konjaku Monogatari*. There is a reference in *Nihon Shoki* (720) to a deity of the river called Kawa no Kami. Some, such as Yanagita Kunio, believed this was a reference to Kappa. The indigenous religion of Shinto had reverence for water spirits called sujin. Yanagita proposed that Kappa were fallen deities once worshiped. He connected stories of Kappa pulling horses into rivers with old practices of sacrificing a horse to river gods. Similar associations of water spirits and horses can be found across the world, such as the Irish Selkie and the Greek Poseidon. However, there is nothing beyond speculation linking Kappa to ancient Shinto deities.

The oldest known reference to Kappa appears in the dictionary *Kagakushu* (1444). It states that "aged otters transform into kawaro." They did not appear again for almost two hundred years.

A Kappa netsuke (below), a carved decoration worn on the obi sash of traditional kimonos. (mid-19th century) Artist unknown.

The hero Takagi Toranosuke (facing page) captures a Kappa in the waters of the Tamura river. (1834–1835?) Utagawa Kuniyoshi.

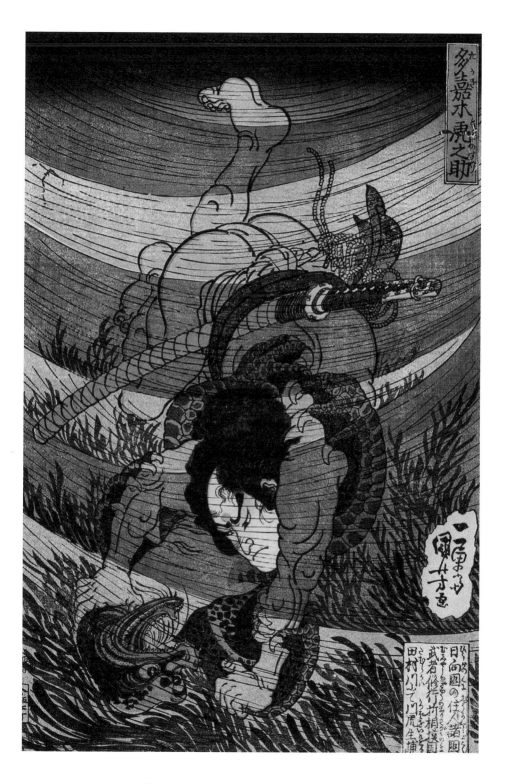

Kaibutsu Creatures

107

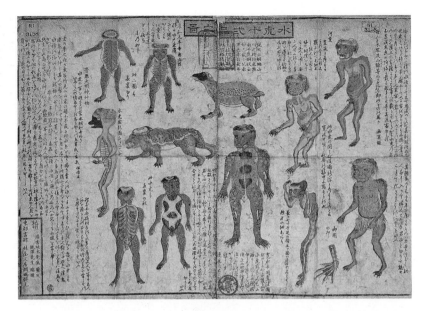

A Portuguese-Japanese dictionary, *Vocabulário da Língua do Japão* (1605), has an entry for "Cauaro" describing a beast similar to a monkey that lives in the river.

Clearly, myths of Kappa persisted for centuries even if they weren't written down. Japan's early written records are sparse at best. These dictionaries show Kappa were important enough to rate an entry. The earliest records are of a monkey-like creature. The oldest known image in *Wakan Sansai Zue* (1712) shows a hairy creature with a bowl on its head. There is a possible Chinese influence—a story of monkeys who tried to grab the moon's reflection in the water and drowned. Some also see Hindu influence; the Sanskrit word for monkey is *kapi*.

Similar water creatures were known by different names across Japan. Mizuchi in Aomori; in the Kansai region of Nara and Wakayama, Gawataro; Kawaranbe in Nagano and Aichi; Gawappa in Kagoshima; and Kappa in the Kanto region of Edo. Suiko, meaning water tiger, was another common name. As dictionaries and encyclopedias were written, Kappa became the accepted term, most likely because the compilers of these books were from Edo.

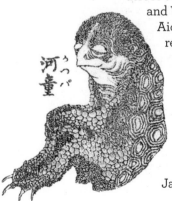

Kappa slowly transitioned from hairy river creatures to their modern amphibious turtle-like form. Researchers believe the transition from monkey or otter to turtle came from increased urbanization of Japan. As the populace left the mountains, contact with

monkeys became rarer. There is also a link between the rise of Kappa stories with the increased use of irrigation for rice cultivation. As cities spread, tales of Kappa spread with them.

A naturalist and food guide called *Honcho Shokkan* (1697) described Kawaro in the section on "Creatures with Shells." The book describes them as Mononoke transformed from soft-shelled turtle. About the size of a small child, Kawaro have tremendous strength and round depression on their head that is the source of their power. The books notes that some locals describe them as river otters transformed, and not soft-shell turtles at all.

Toriyama Sekien's entry for Kappa in *Gazu Hyakki Yagyo* (1776) is amphibious with textured skinned and webbed hands. It still has a hairy head and lacks the beaked face and shelled back of later depictions. Kappa were considered to be real animals, with different breeds. Books and illustrations explained the differences, such as Sakamoto Konen's *Suiko*

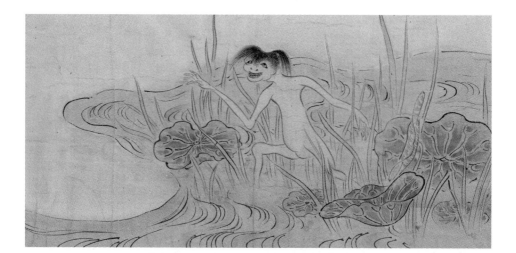

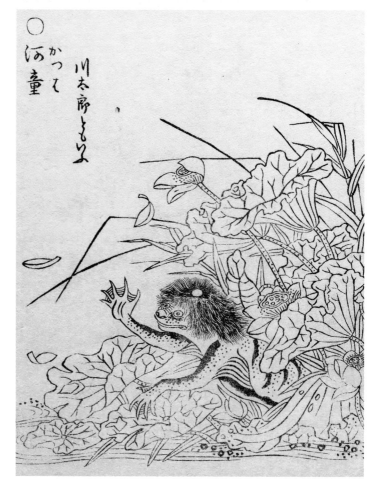

Kappa (top) from the *Bakemono no e* scroll illustrating various kinds of Yokai. (17th or 18th century) Artist unknown.

Kappa (bottom) from *Gazu Hyakki Yagyo.* (1776) Toriyama Sekien.

A type of Kappa called Suiko (bottom left) said to have been caught in Hida, Bungo province. (7th century) artist unknown.

A Kappa (bottom right) observed swimming in Ichibancho moats near Edo castle in the late 18th century. It was said to be over six feet long. From the multi-volume Ningawa Family Archives, a collection of records, poems, and other records of the Ningawa family starting from 1207. Appendix Nos. 136–142 are a collection of written reports on Kappa. (18th century) Artist unknown.

juni hin no su (19th century) showing 12 types of Kappa and Koga Toan's *Suiko Koryaku* (1820) detailing Kappa physiology and eye-witness accounts.

Kappa myths are myriad and show their changeable nature. Kappa are experts at sumo. They taught bone setting and medicine to humans. Their arms are detached from their bodies—pulling on one arm shortens the other. Their favorite food is cucumbers. Dropping a cucumber in a river with your name carved on it is said to gain the favor of local Kappa.

The most terrifying aspect of Kappa is that they crave the elusive *shirikodama*—a magical ball that resides in the human anus. Kappa forcibly rip out by sticking their hand up swimmers' anuses. No one knows exactly what they do with this ball. Some say they eat it. Some say they give them as tributes to the dragon king under the sea. The *shirikodama* has often been equated to the human liver. Either way, it is a painful way to die.

Some of the most unique Kappa legends come from Kyushu, where it is believed that they changed form during the winter and lived in the mountains. Kappa are the summer form, living in the rivers. But with the onset of winter, they transform into one-eyed Yokai called Yamawaro and migrate

to the mountains. They are Kawawaro, or river *waro* in summer, and Yamawaro, or mountain *waro* in winter.

Their level of civilization is also fluid. The 1910 *Tono Monogatari* portrays Kappa as barbarians who raid fishing villages and rape women. Other folklore describes them as civilized and intelligent; they are said to have taught medicine and bone-setting to humans and are masters of the strategy game *Shogi*. In Ryunosuke Akutagawa's 1927 book *Kappa*, they are portrayed as having a society based on radical capitalism, where poor Kappa are slaughtered as food for the wealthy class.

In Nakamura Teiris's exploration of the history of Kappa, *Kappa no Nihonshi* (1996), he disputes attempts to link Kappa to ancient deities. Nakamura states that Kappa are imaginary animals, based on encounters with monkeys and river otters, then transitioned into the world of Yokai. There was an escalation of Kappa stories in the Edo period, with characteristics and stories building on each other. Komatsu Kazuhiko has also done extensive research linking Kappa legends to ancient dolls and a clan of river folk who dwelled on riverbeds and sold medicine.

In modern Japan, Kappa experienced a renaissance. The terrors of the Edo period who yanked your liver out through your anus were replaced by cute, harmless mascots for sushi restaurants. Kappa are now friendly children's toys, joining the ranks of penguins and pandas as delightful stuffed animals to hug. They can be found everywhere in Japan today. But underneath the plastic smiles and friendly waves lie the brutal monsters of folklore.

A Kappa (facing page) in the shop of a merchant who designed stencil-dyed goods, with kappa being a pun on "stencil" in Japanese. From the series *Collection of Equipment of Merchants.* (1843–1847?) Issunshi Hanasato.

A Kappa is repelled by a man farting (right) at the lumber yard in Fukagawa. From the series *Comical Views of Famous Places in Edo.* (1881) Tsukioka Yoshitoshi.

Akaname Filth Lickers

The hotel was old and dilapidated, but you still wanted to take a bath. It was dark as you made your way to the outdoor tubs. The door creaked open, and as you switched on the light something skittered into a dark corner. It tried to hide in the shadows, but you could see glimpses of its long, red tongue.

Yokai come in many forms, from devolved deities to visual puns. Some even play a more traditional role, one found in every culture on earth—the bogeyman. Parents use Yokai to frighten children into good behavior. Do your chores, or a monster will come to get you. Akaname—the filth licker—scare children into keeping bathtubs clean.

> **Akaname** is written **垢嘗**
> **垢** (aka) – filth, grime
> **嘗** (name) – lick
> Akaname is also known as Akaneburi (**垢舐**) using
> a different kanji (**舐**; neburu) with the same meaning.

The bath is a venerated space in a Japanese home. More than just a place to clean, the bath is where you relax and carve out some much-needed privacy in a packed house. Families wash outside of the tub, then climb in to soak. Everyone uses the same bathwater, and traditionally the bath is entered by order of Confucian precedence—father first, then mother, then the children by birth order. This means the tub gets progressively dirty (and the water more lukewarm) by the time the youngest child climbs in. As an insult to injury, the youngest child is often responsible for cleaning the tub.

An **Akaname** from the Meiji period board game *Mukashi Banashi Bakemono Sugoroku*, a game that was similar to snakes and ladders. (1848–854?) Utagawa Yoshikazu.

Akaname are the cockroaches of Yokai. Born from accumulated skin, hair, mold, and lime scale left behind in baths, they scutter in the dark and lick scum from the bathtub. While this may seem like a free cleaning service, Akaname are pestilence bringers as well as just disgusting. Akaname come in a wide variety; they can be any color from filthy, moldy green to the bright pink of open sores. They can have one eye or two, and different counts of fingers and toes. The one characteristic all Akaname share is their long, sticky tongue that they use to lap up the grease, hair, and filth left behind in the family bath.

Akaname first appeared in *Kokon Hyaku Monogatari Hyoban* (1668) by Yamaoka Genrin. Published ten years after Genrin's death, the

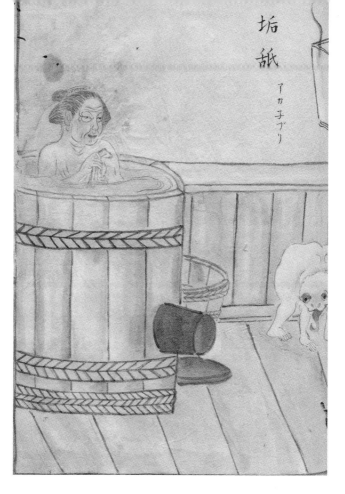

An Akaname lurks close by as an old woman bathes. (1780) Ueda Hiromitsu.

illustrated book is a collection of stories based on a game of *Hyakumonogatari Kaidankai* played at his house. Genrin's book is philosophical in nature, and the stories are told as dialogs. For Akaneburi, as it is called, Genrin philosophizes that all things eat what they are born from; fish born from water consume water, lice born of grime eat grime. So, it is only natural that a Bakemono born from filth should eat filth.

There are no other accounts of the Akaneburi until Toriyama Sekien's renamed it Akaname for *Gazu Hyakki Yagyo* (1776). It was then included in *Nitto Honzo Zusan* (1780), where it was described as child-like, with a large head, round eyes, and long tongue. *Nitto Honzo Zusan* describes an alternate form of Akaname as a beautiful woman who climbs into the bath with unsuspecting men, then licks them down to their bones.

Akaname became popular characters for Edo and Meiji-period games, appearing in *Sugoroku* and *Obake Karuta* with other Yokai.

Kaibutsu Creatures

Kurobozu Demonic Monks

If you wake up after a restless night, with reeking breath and gasping for air—beware! You might have had a visit from the breath-stealing Kurobozu, the black monk.

Kurobozu are vaguely human-like, shrouded in a pitch-black monk's robe. They are like living shadows. Their heads are round and featureless, except for the vague appearance of two eyes that sometimes reflect the light. The lack of face leads some to consider Kurobozu to be a type of Nopperabo.

Kurobozu is written 黒坊主
黒 (kuro) – black
坊主 (bozu) – monk

The "monk" part of Kurobozu does not have any religious meaning. During the Edo period, classes and traveling were highly restricted. Most were not permitted to leave their hometown and posted waypoints on the road rigorously checked passports to make sure everyone stayed put. Itinerant monks were one of the few classes allowed free travel. They were often the only unfamiliar faces who ever wandered into town. Bozu was thus used as a reference to strangers. Many Yokai have bozu as part of their name, such as Umibozu and Takabozu.

Kurobozu was one of the first new Yokai of the Meiji period (1868–1912). They entered the Yokai pantheon in the 663rd issue of the *Yubin Hochi Shinbun* newspaper (1875). A family living in the Kimata area of Tokyo reported a strange disturbance. Each night while they were sleeping a strange presence would appear in their bedrooms. The presence hovered over the wife, leaning close to her. It slobbered over her face and sucked her sleeping breath from her mouth. In the morning, the wife's breath and face would stink of rotting flesh. She fell ill. Unable to tolerate it any longer, the wife left to stay at a relative's house. The mysterious Kurobozu did not follow her there, and she was able to recover her health. After some time, she returned home and reported no further disturbance. The Kurobozu disappeared.

During the Meiji period, sensationalist newspapers ran illustrated stories of crime, Yokai, and other supernatural happenings. These stories were often very short, a bit of text accompanied by an eye-catching illustration. The Kurobozu illustration by Tsukioka Yoshitoshi, the last great master of the *ukiyo-e* style, ensured this new monster would not be forgotten.

There is another legend of a creature called Kurobozu, recorded as a local legend of Kumano in *Sankawa Kidan*

(18th century), by Bakushui Hori. The story tells of a hunter who encounters a large, black monster out in the woods, looking something like a black bear. When the hunter shot it with his rifle, the monster grew until it was several meters tall. Terrified, the hunter fired again, and the monster fled, moving over the difficult terrain at an incredible pace, almost as if it was flying.

In modern terms, Kurobozu seems like an obvious case of the phenomenon called sleep paralysis. Many who experience sleep paralysis report seeing attacks by shadowy monsters. Based on the two stories, images of Kurobozu are often merged into a bear-like monster wrapped in a monk's robes.

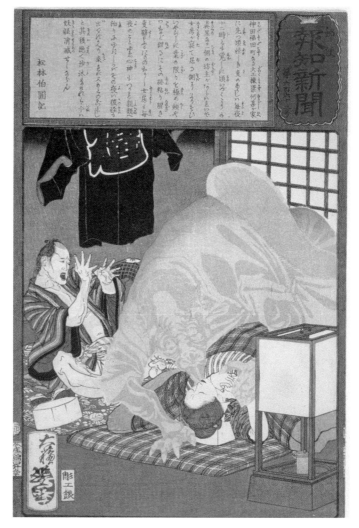

A Kurobozu attacks its sleeping victim, a carpenter's wife. From the series *The Postal News* illustrating true-life accounts. (1875) Tsukioka Yoshitoshi.

A terrifying **Dodomeki** (top) displays its eyes to its victim. (2011) Image courtesy Roberta Mašidlauskytė.

Dodomeki (bottom) from the *Modern Yokai Series*. (2020) Image courtesy Lili Chin.

Dodomeki Cursed Thiefs

A young girl covered entirely in a tattered robe creeps up to you on a darkly lit street. A poor beggar girl, she thrusts out a hand for alms, hoping that you will take sympathy on her plight. But just as you go to reach for your wallet to drop a few coins in her hand, the lamplight flickers exactly so and you see a site that will terrify you for as long as you live. For on that outstretched arm glitter hundreds of eyeballs, blinking in the reflected lamplight.

Dodomeki are women thieves cursed by their sin with arms covered in eyes. They look normal in all other aspects, until their arms are revealed.

> **Dodomeki** is written 百々目鬼
> 百々 (todo) – hundreds
> 目 (me) – eye
> 鬼 (ki) – demon, oni

Created by Toriyama Sekien in *Konjaku Gazu Zoku Hakki* (1779), He tells her story thusly:

"The Kankan-gaishi says a woman born with long arms constantly stole money. Her body was marked with hundreds of birds' eyes, the spirit of the money she stole. So, she was named Dodomeki. Gaishi refers to places beyond Hakone. A neighborhood in the Eastern capital is named after her."

Dodomeki has no other history or backstory. The book referenced, Kankan-gaishi, does not appear to exist. Dodomeki is one of Sekien's pun Yokai. He had several volumes to fill, and not enough Yokai to fill them. Sekien often took odd turns of phrases or puns and made Yokai out of them. It's the equivalent of creating a monster book filled with creatures like "Bird Brain" and "Slow Poke" with the creatures treated literally—in other words, like names of Pokémon characters.

Dodomeki are complex puns that would have been understood by people in the Edo period. Her "long arms" is a reference to a slang term for thieves. If someone was said to have "long arms" it meant something similar to saying they had "sticky fingers." For the spirit of money, Toriyama uses chomoku no sei, which means "bird's eye." That does not refer to actual birds. In old Japan, coins had a round whole hole stamped through them so they could be strung together and carried on a string. Resembling round birds' eyes, which became a slang term for coins. Some modern Japanese coins still retain this feature, mainly five- and fifty-yen pieces.

It is thought that Sekien was inspired by several places across Japan called domeki, with similar kanji meaning "hundred-eyed demon." Most of these reference Heian-period

Dodomeki from *Konjaku Gazu Zoku Hyakki.* (1779) Toriyama Sekien.

legends of Fujiwara no Hidesato, who slew several monsters including an Oni with a hundred eyes. Standing ten shaku tall, its hair was sharp like knives, and it had a hundred blazing eyes. Hidesato fired his bow into the eye that was shining the brightest and slew it. Another story comes from Hongan-ji in Utsunomiya, who says a hundred-eyed Oni prayed to Buddha to be released from hell. He came to the gates of Hogan-ji to worship and was reborn as a human. Hongan-ji claims to still have that oni's claws and crystal rosary.

Nurarihyon Yokai Bosses

An unknown man, well dressed, walks brazenly into your house. He sits down at your table as if he belongs there are begins barking out orders. Your best tea if you please. And the finest of whatever is in your cupboards. No, that won't do at all. His confident authority is so great you find yourself rushing to please him. Only after he has polished off your delicacies and left do you realize you have been paid a visit by Nurarihyon.

Nurarihyon is known by several titles. The Supreme Commander of Yokai. The Boss Bakemono. He is an old man in traditional dress, with a massive, veined head. Nurarihyon is said to possess an air of command. So confident is he in his authority that he wanders into houses and starts giving commands that are immediately obeyed.

> **Nurarihyon** is written **ぬらりひょん**
> **ぬらり** (nurari) – onomatopoeic word; slippery
> **ひょん** (hyon) – onomatopoeic word; bobbing
> up from the water

Nurarihyon's name is an onomatopoeia, representing the sound of something slippery bobbing in water. Some have used the kanji 滑瓢 meaning "slippery gourd" although this is a modern addition.

The history of Nurarihyon is as slippery as his name implies. The oldest known account is found in *Koshoku Haidokusen* (1703), humorous and spicy novel of a married man who falls in love with a prostitute. There is a brief passage describing Nurarihyon as a catfish-like creature with no face, who is the spirit of deception. He next shows up in *Masumi Sugae's Travelogues* (1801–22). In an entry on Sae no Kamisaka, Musami writes that on misty days the *Hyakki Yagyo* appears which lends its name to Bakemono-zaka. Masami lists Notsuchi, Otoroshi, and Nurarihyon as members of this parade. Sadly, we have no idea where this Bakemono-zaka was.

Nurarihyon (left) from the *Bakemono no e* scroll. An imitation of Sawaki Sushi's design from *Hyakkai Zukan.* (17th or 18th century) Artist unknown.

Nurarihyon (right) from *Gazu Hyakki Yagyo.* (1776) Toriyama Sekien.

The dictionary *Rigen Shuran* (18th century) defines Nurarihyon only as "a Bakemono painted by Kano Motonobu." This is possibly a reference to the Shuinu-an *Hyakki Yagyo-zu* (16th century), believed to have been painted by artist Kano Motonobu. However, nothing resembling Nurarihyon appears in this scroll or its copies. Another clue lies in the late Edo period *Kiyushoran* (1830). An encyclopedia of manners, customs, and performing arts by Kitamura Totei, *Kiyushoran* says that Bakemono paintings were begun by Kano Motonobu, and that copying these was a training exercise for the Kano school. A list is given of these Yokai, among which is Nurarihyon. If these Kano school Bakemono-e were real, no copies survived.

The oldest known image of Nurarihyon comes from some consider a copy of the Kano school Bakemono-e, Sawaki Sushi's *Hyakki Zukan* (1737). The Yokai listed in *Kiyushoran* appear in Sawaki's scroll, except an unknown creature called yume no seirei, or dream spirit. There is no way of knowing if these are Sawaki's inventions or if he was truly copying Kano Motonobu. *Kiyushoran* was written almost a century after Sawaki painted his scroll and may have been repeating legends instead of facts.

Sawaki depicts Nurarihyon as old man in a somewhat slovenly kimono with an enormous, gourd-shaped veined head. As with all Sawaki's Yokai, there is no description, only a name accompanying the image. This became the template image for all others to follow. Toriyama Sekien dressed up Nurarihyon for *Gazu Hyakki Yagyo* (1776), showing him alighting from a kago palanquin giving him an aristocratic feel. Sekien most likely intended this as a pun, as "nurarin" meant disembarking from a vehicle. Some researchers see Sekien mocking Edo period elites visiting the lowly pleasure

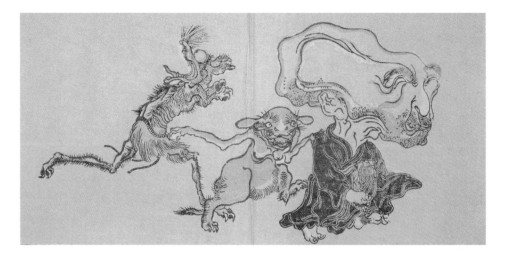

quarters. He titled his creature Nurarihyon, but this is thought to be an error instead of a variation.

From there, Nurarihyon received a succession of promotions. In *Yokai Gadan Zenshu* (1929), Fujisawa Morihiko wrote "In early evening light comes visiting the Yokai leader Nurarihyon." This is the oldest known instance of Nurarihyon having any sort of prominence in Yokai society. In fact, Edo period books such as *Bakemono Shiuchi Hyobanki* (1779) identify Mikoshi-nyudo as the supreme commander of Yokai. Most researchers agree this interpretation of Nurarihyon comes from his elegant portrayal in Sekien's *Gazu Hyakki Yagyo*. It is also thought that from this one sentence developed Nurarihyon's powerful air of command and the legends of the uninvited guest. Mizuki Shigeru built upon this further when using Nurarihyon for his Yokai comic *Kitaro* (1960s). For the third season of the animated series, they needed a main villain and introduced Nurarihyon as the Supreme Commander of Yokai. Modern stories often call Nurarihyon the leader of the *Hyakki Yagyo*, the night parade of a hundred demons. Yet a glance at the original *Muromachi* scrolls shows that not only is Nurarihyon not the leader, but he did not even appear.

To further complicate things, there is another legend of a creature called Nurarihyon from Okayama Prefecture. It is said to be something that floats on the sea like a blob of goo and is thought to be a reference to the jellyfish called the Portuguese Man o' War. However, as with all things Nurarihyon, it is not clear which came first. Did the Supreme Commander of the Yokai begin as a blob on the ocean or as a funny-shaped old man in design books used to train artists? An excellent question regarding the spirit of deception.

Nurarihyon,
Yamabiko, and an unknown bestial creature run in fear in *Kyosai Hyakki Gadan,* a late Edo period *Hyakki Yagyo* scroll. (1889) Kawanabe Kyosa.

Jakotsu Baba Old Snake Women

If you are wandering through the woods at night and stumble upon something that looks like a carved stone stamped with the symbol of a snake—run! Maybe it's nothing. Or maybe you have stumbled across the hidden grave of the long-dead Jagoemon. And that means that you are seconds away from an encounter with his wife, The Old Snake-Bone Woman called Jakotsu Baba.

Jakotsu Baba is an old woman holding two snakes: a blue snake in her right hand and a red snake in her left. She is said to eternally guard the tomb of her husband Jagoemon.

Jakotsu Baba is written **蛇骨婆**
蛇 (ja) – snake
骨 (kotsu) – bone
婆 (baba) – old woman

The word Jakotsu Baba appears in Edo period *kabuki* plays and picture books. Edo period picture books were color-coded with different colored covers showing the targeted readership. *Akazoshi* (red books) were fairy tales for children, *Aozoshi* (blue books) and *Kurozoshi* (black books) for teens, and *Kiboshi* (yellow books) aimed at adults. The oldest known use of Jakotsu Baba comes from the *Kurozoshi Inui-no-tsubone* (1768) where it is used as a derogatory term for an elderly woman. It's used similarly in the *kabuki* play *Sanmon Gosanno Kiri* (1778). There is no supernatural connotation to its usage. Most likely it was common slang at the time.

Toriyama Sekien included Jakotsu Baba in *Konjaku Hyakki Shui* (1781). There is no record of her before this, and most likely Sekien created her as a pun referencing the slang term. Sekien established Jakotsu Baba as a non-Japanese Yokai, from Wuxian, north of the cattlewomen. This is an allusion to the Chinese classic text *Shanhai jing* (4th century?), an encyclopedia and bestiary of that mixes the mundane and fabulous. The mythological Wuxian is to the west of China and described as a land of shaman and mystics. The cattlewomen references a horrific practice of staking young women to mountaintops as ritual sacrifices and leaving them to die. Sekien describes a land where people bear blue snakes in their right hands and red snakes in their left, and wonders if Jakotsu Baba came from such a land. He says she is the wife of Jagoemon, or Snake Goemon, and lives in a place called Snakemound. Sekien went all-in on the snake puns.

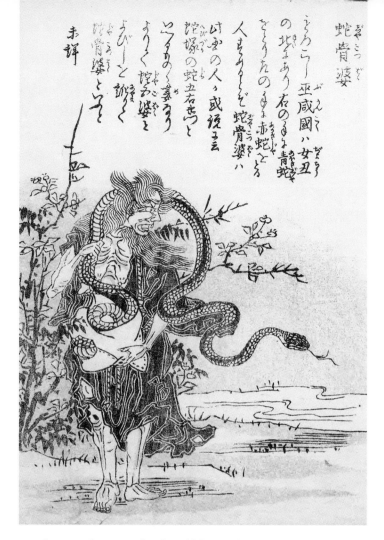

蛇骨婆

The significance of red and blue snakes is unknown.
The colors appear in other tales, like the red and blue Oni
of Hamada Hirosuke's *The Red Oni Who Cried* (1933) and
the 1930s urban legend *Aka Kami/Ao Kami*, or red paper/
blue paper. In Sato Arifumi's *Nihon Yokai Zukan* (1972) he
describes the blue snake as being able to freeze and the red
snake to burn. There are no earlier records of this and is most
likely Sato's invention. Showa period (1926–1989) Yokai books
relocate Jakotsu Baba from the mystical Asian provenance of
Wuxian to the mountains of Japan. Modern versions recast
her husband Jagoemon as a great serpent trapped in the
snake mound, over which Jakotsu Baba stands guard.

Mizuki Shigeru included Jakotsu Baba in his comic *Kitaro*
(1960s) where she teamed with Nurarihyon. She became a
popular antagonist in the series.

Nopperabo Faceless Creatures

Late one foggy night you stumble across a roadside soba stand. Ordering a bowl, you sit down and start to eat the delicious noodles. Looking up to complement the chef, you are startled to see a face as smooth as an egg, with no eyes, mouth, or nose. Spilling your soba, you run fleeing into the night. Seeing someone on the street, you grab them to warn them about the faceless person. After hearing your story, they ask if the chef looked something like this. And with a wave of their hand, the Nopperabo wipes off their own face.

Nopperabo are some of the most iconic Yokai. They are regular humans except for a featureless face. Nopperabo are not fearsome but love to surprise people. They often work in pairs. Their usual modus operandi is to lure in unsuspecting wanders at night, shock them by revealing their featureless face, then send them running into the second shock of the next Nopperabo.

Nopperabo does not use kanji and has no inherent meaning: のっぺらぼう

Nopperabo come in two types. They are either a distinct species of Yokai, or one of the Henge shapeshifters playing a joke on humans. The culprit is most often Mujina or Tanuki. There are several variations on the Nopperabo theme, all with the same mischievous intention.

The oldest known Nopperabo story comes from the Edo period kaidan collection *Sorori Monogatari* (1663), telling of a mansion haunted by an unnamed faceless monk in a white kimono, standing close to seven feet tall. In a later collection, *Shinsetsu Hyakumonogatari* (1767), there is a story of attacks by a creature called nupperiho, with a featureless face. The story says that those who encountered the nupperiho found dark strands of hair on their clothing, implying that the monster was a transformed animal of some sort.

Similar stories of faceless creatures appear in China during the period. Supernatural story collection *Yuewei caotang biji* (1789) tells of encounters with women in the dark of the night who, when approached from behind by men, suddenly turn around to reveal their featureless faces. The affect is

Nopperabo (left) from the *Kiboshi* yellow book *Bakemono Shiuchi Hyobanki.* The Nopperabo is described as a transformed Henge weasel. (1779) Koikawa Harumachi.

Nopperabo (right) from *Kyoka Hyaku Monogatari*, an Edo period collection of comedic Yokai-themed *kyoka* poems. (1853) Ryukansai.

the same as with Japanese tales, of a startled man fleeing into the night.

The most famous Nopperabo story comes from Lafcadio Hearn's book *Kwaidan: Stories and Studies of Strange Things* (1904). It tells the now-classic tale of an encounter with two Nopperabo late at night and the double-surprise. Instead of Nopperabo, however, Lafcadio Hearn called his tale *Mujina*. While not explicitly stated, it is implied the faceless jokesters are transformed Mujina.

Kage Onna Shadow Women

A lingering shadow cast against a wall when no one is there. The silhouette of a woman in a window coming from an empty room. These are all signs of one of the shyest, most elusive Yokai of all—Kage Onna, the shadow woman.

Very little is known about the Kage Onna. It is said she appears on moonlit nights, and that the shimmer of moonbeams reveals her true form. She is never seen in detail, only the outline of a woman cast against an illuminated surface. What she wants, who she is—nobody knows.

> **Kage Onna** is written 影女
> 影 (kage) – shadow
> 女 (onna) – woman

Kage Onna first appear in Toriyama Sekien's *Konjaku Hyakki Shui* (1781). Sekien described the Kage Onna as shadows of women cast by the moonlight in Obake-haunted mansions. He makes a poetic reference to an ancient Taoist book *Tzuangzi* (3rd century), that uses the word moryo to describe a penumbra, the thinner edge of shadows. Moryo are also a type of Yokai that live in graveyards. In the book, the penumbra questions the shadow why it moves uncontrollably, and the shadow answers that it has no will of its own and only reflects the caster. With Kage Onna, Sekien most likely started with an evocative name, then imagined a Yokai to match.

In a later book, *Tohoku Kaidan no Tabi* (1974), Yamada Norio said that the Kage Onna is a traditional Yokai from Yamagata Prefecture. She tells the story of a man visiting his friend's house and seeing the shadow of a women in the garden. When asking his friend who this mystery woman is, the friend laughs it off, saying he must have seen the Kage Onna who haunts the place.

Kage Onna from *Konjaku Hyakki Shui,* the third book in Toriyama Sekien's Edo period Yokai collections. (1780) Toriyama Sekien.

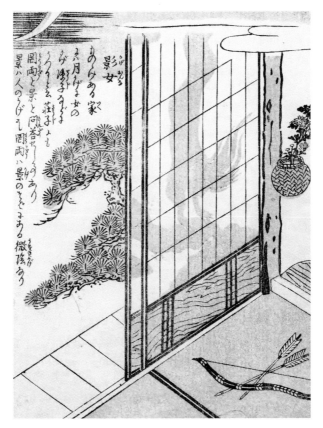

Moryo Fearsome Ghouls

Strolling through a graveyard—as one does—you stumble upon what looks like a small child tearing into food. Looking closer, you see the child is dark red in color, with long ears like a rabbit. Its hair is beautiful. And it feasts on the liver of a fresh corpse dug from its grave.

Moryo are both a Yokai category and a Yokai themselves, although the two have little connection. More are sometimes a child-like eater of human innards and sometimes a generic term for Mononoke of mountains and trees, rivers and rocks.

> **Moryo** is written 魍魎
> 魍 (mo) – spirits of mountains and streams
> 魎 (ryo) – spirits of trees and rocks

Moryo were originally a Chinese nature spirit. They appear in *Huainanzi* (139 BC), an ancient Chinese collection of debates attempting to define a perfect societal order. *Huainanzi* covers broad topics such as the beginning of reality, military strategy, and patterns of heaven. An entry describes Moryo as looking like reddish-black, three-year old children with long ears, red eyes, and beautiful hair. It says they are born from water.

According to *Shiji* (2nd century BC), the first of China's great histories, Confucius said spirits of water were dragons and Moryo. *Zuo Zhaun* (4th century BC) uses the term chimi-moryo to describe all spirits of earth and water, mountains and trees. Chimi were creatures of the mountains. Moryo were monsters of the rivers. Chimi were born from the supernatural mists of mountains, and Moryo from the life energy of water. A later book, *Bencao gangmu* (1596), known in English as *Compendium of Materia Medica*, claims moryo feast on the innards of the dead. The entry says that *The Rites of Zhou* (2nd century BC) states you can expel Moryo by sticking a spear into grave mounds. It also says Moryo are afraid of tigers and oak trees.

Moryo enter the Japanese record in the *Wakan Sansai Zue* (1712), looking very much as described in earlier Chinese texts. It describes moryo as a water spirit, contrasting it with Chimi, as a mountain spirit. The two together, chimi-moryo, was used as a generic term meaning. When Toriyama Sekien included moryo in *Konjaku Gazu Zoku Hyakki* (1779) he placed them opposite jami, a type of chimi that was the counterpart of moryo in chimi-moryo. Artist Iseya Jisuke also combined them in his Yokai collection *Hyakkiyako Bakemonogatari* (1802).

Moryo feasting upon its victim from *Konjaku Gazu Zoku Hyakki.* (1779) Toriyama Sekien.

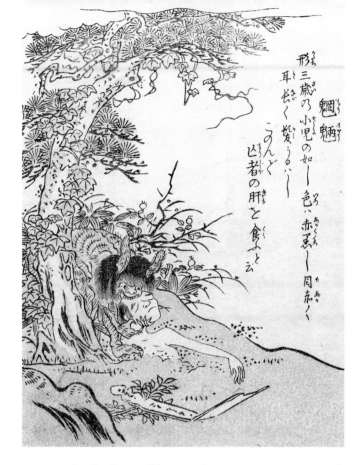

Later books focused less on the water-spirit nature of moryo and more on their corpse eating. In the storybook *Mimibukuro* (1814), the servant of a government official declares himself a moryo and steals the corpse from the coffin at a village funeral. This mixes the story of moryo with legends of the corpse-eating cat demon Kasha.

Honengyo Fortune Fish

The crowds of Osaka gathered watching the creature float through the waters of the Yodo River. A massive beast almost six feet long, ridged with black spines, covered in black moss, and with eyes like mirrors. As the monster pushed forward with its long tail and flicked its long tongue, the crowd broke into a cheer. They knew it was going to be a good year.

Honengyo are auspicious beasts said to have been sighted in the Yodo River of Osaka. While they look fearsome, as their name suggests they were omens of a bountiful harvest. An obscure Yokai, there has been a resurgence of Honengyo in modern times due to their resemblance to the movie Kaiju Godzilla.

Kaibutsu Creatures

Honengyo is written 豊年魚
豊年 (honen) – bountiful year
魚 (gyo) – fish

Honengyo come from a single recorded observance in 1866. A strange creature washed up on the shores of the Yodo River in Osaka, attracting crowds. According to the description, it was 7.5 feet (2.3 meters) long and weighed about 72.5 kilos (160 pounds). Its body was covered in scales like a snake, and it had black, ridged dorsal fins. Articles described its body as bellow-shaped and weasel-like, with stubby limbs like a turtle. It had a long, fish-like tail and tail fins and a long tongue. Moss grew on its body. Its eyes were like mirrors. While described as a fish, its description sounds more like an amphibian, perhaps a Japanese giant salamander. Algae can grow on turtle shells, giving the appearance of moss, so that is perhaps another candidate.

Unknown artists illustrated Honengyo for local newspapers. The most famous is an 1866 woodblock print split with an illustration of thunder on the top of the page and the Honengyo below. To modern eyes the depiction looks like an ancestor of the modern-day Godzilla. Others look much less lizard-like. However, it does show a heritage of mysterious, large creatures appearing from the sea.

Kawaraban **of a Honengyo** that appeared in the Yodo River of Osaka at the late Edo period. It was 7.5 feet (2.3 meters) long and its appearance was followed by a bountiful harvest. This is the image most commonly associated with modern day Kaiju. (1866) Artist unknown.

The Honengyo (right) that appeared in the Yodo River of Osaka. (1866) Artist unknown.

The Honengyo (below) shown here is a particularly hairy version. (1866) Artist unknown.

Legends said that similar creatures were omens of a bountiful year, so it was named Honengyo—fish of the bountiful year—in hopes this would fulfill the prophecy. Alas, it did not work. 1866 was one of the worst rice harvests in decades and lead to countrywide famine. It would not be long before this famine led to a revolt and overthrow of the Tokugawa shogunate and an end to the Edo period. So, while perhaps not a bountiful harvest, the arrival of the Honengyo was certainly the harbinger of an eventful year.

Kaiju Enormous Monsters

The huge beast rose from the harbor. As water poured from its back, ships were smashed by its wake. It let out a great roar and Tokyo screamed in fear. The Kaiju had returned.

Kaiju today are a genre of movie monster. Usually titanic and often linked to atomic energy, they are the most modern addition to Japan's pantheon of fearsome creatures. But are they Yokai? That is still up for debate.

> **Kaiju** is written **怪獣**
> **怪** (kai) – strange, wonderous, supernatural, weird
> **獣** (ju) – beast, animal

Kaiju is an ancient word. It is first found in the Chinese text *Shanhai Jing* (4th century?), a mythological geography of pre-Qin China. Kaiju is used to refer to supernatural creatures, much in the same way we use Yokai today. Kaiju appeared in Chinese poetry at the time and seems to have been in relatively common usage.

Kaiju was adopted into Japanese in the late Edo period (1603–1867). In Abe Masanobu's 50-volume topography of Suruga province called *Suruga no Kuni Fudoki* (1843), a collection of regional industries, fashions, geography, animals, plants, and mythology, a local legend was recounted of a baboon-like winged creature called a Kaiju that was captured in the mountains of Oshika village. In *Mikkyoku Nichijo* (1819), Kaiju is used to describe an animal that washed up on the beach, shaped like a boar and covered in hair like a rat.

During the Meiji period (1868–1912), as Japan opened to the West, Kaiju was repurposed to refer to fabulous beasts of foreign countries. In *Kisekai: Chindan Kiwa* (1908), Suzuki Eishiro used the term with an alternate pronunciation of *"kowaiju"* or "scary monsters" to describe phenomena such as the sighting of a living Ceratosaurus in Partridge Bay, Yukon Territory, Canada. This was most likely the usage when *The Beast from 20,000 Fathoms* (1953) was translated into Japanese as *Genshi Kaiju Arawaru*, or *The Atomic Kaiju Appears*. A passion for giant monster movies followed, led by special effects artist Ray Harryhausen in the U.S. and Eiji Tsubaraya in Japan. In 1954 the film *Gojira* (*Godzilla* in English) appeared and a new genre of Kaiju films was born. Two film companies, Toho and Daiei came to define the genre.

Kaiju forms a distinct genre in Japan and has been widely adopted in Western media. In English the term has come to mean giant monsters, although in Japan massive size is not required. There are many small Kaiju, from the human-sized

Three massive Kaiju (facing page) rampage through a city sowing devastation in their wake. (2023) Image courtesy Kewber Baal.

Kaibutsu Creatures

Minira to the cat-sized Fairy Mothra. The big ones can either be called Kaiju or Daikaiju, with *"dai"* meaning giant.

Mizuki Shigeru adopted Kaiju as antagonists for his Yokai comic *Kitaro*. In his officially licensed *Kaiju Raban* (1958) Mizuki created a human-Kaiju hybrid developed from Godzilla's blood. He invented Raban-17, a mechanical counterpart created to fight Raban. This inspired robots such as Mechani-Kong in *King Kong Escapes* (1967), Mechagodzilla in *Godzilla vs. Mechagodzilla* (1974), and the Jaegers in *Pacific Rim* (2013). Mizuki used the idea again in *Daikaiju* (1966), without the trademarked Godzilla elements, pitting his plucky hero Kitaro against the massive South Sea monster. Mizuki also combined Yokai and Kaiju in *The Great Tanuki War* (1968) for his monstrous Yokaiju. The media franchise *Yokai Watch* (2013) also has Kaiju alongside well-known Yokai and its own version of a Yokaiju. The film *The Great Yokai War: Guardians* (2021) mixes Kaiju and Yokai, incorporating the Daiei films' Kaiju Daimajin to battle their Yokaiju version.

Are Kaiju Yokai? That depends on who you ask and, I suspect, when you ask. Some point to the commercial nature of the Kaiju. They have no folkloric provenance and were created solely to sell entertainment media. But so were many Yokai. Muromachi period artists invented visually splendid Yokai with the intention of marketing and selling hand-painted picture scrolls. Toriyama Sekien invented volumes of creatures now accepted as Yokai, specifically to sell books. Monsters created for movies don't seem all that different.

And while Kaiju tropes are unique to the films, Japan has a history of monsters emerging from the sea, such as Honengyo, Ushi Oni, and Bake Kujira. Ushi Oni perhaps bear the closest resemblance to modern Kaiju. They could be huge creatures with the head of an ox on the body of a whale or massive spiders with horned ox heads. Tales of the period pitted warrior heroes against these giants. Another gigantic monster was the massive *namazu* catfish that lives under the islands of Japan and causes earthquakes when it writhes.

In the first Godzilla film, the monster is briefly referred to as a Yokai. And given the fact that new creatures from multiple sources have historically been adapted into Japan's pantheon of monsters, it would seem Kaiju could easily become a new kind of Yokai. Yokai creation has largely been driven by artists, and few artists can resist the fun of introducing a massive Kaiju into their stories. I have no doubt that given enough years, when copyrights expire and origins are forgotten that future Yokai encyclopedias will feature a new entry labeled "Kaiju." I am happy to be among the first.

YOKAIOLOGY
Nihon San Daiaku Yokai
Three Great Evil Yokai

Lists have been popular in every culture, in every era across human history. The Seven Wonders of the World. The Twelve Treasures of Spain. Japan in particular is fond of lists. In 1643 Hayashi Gaho created the Nihon Sankei, or Three Views of Japan celebrating the country's most picturesque spots. Other lists include the Three Holy Mountains, encompassing Mt. Fuji, Mt. Haku, and Mt. Tate, and the Three Great Gardens of Japan, showcasing Kenroku-en in Kanazawa, Koraku-en in Okayama, and Kairaku-en in Mito.

And of course, at various periods of time there have been lists of Yokai. In his book *Genso Sekai no Junin tachi* (1990) researcher Tada Katsumi listed the Three Great Yokai of Japan as oni, Kappa, and Tengu. Another list that has become widespread is the *Nihon San Daiaku Yokai*, the Three Great Evil Yokai of Japan.

> **Nihon San Daiaku Yokai** is written
> 日本三大悪妖怪
> 日本 (nihon) – Japan
> 三 (san) – three
> 大悪 (daiaku) – great evil
> 妖怪 (yokai) - yokai

The list of evil Yokai seems to be a modern creation. It corresponds to the Three Great Medieval Yokai outlined by Komatsu Kazuhiko, with only a title change. No one is exactly sure where it came from. It appeared as a Wikipedia article in 2005 and was removed in 2012 due to a lack of sources. By then the list had spread. Several Yokai books were published with list, but all were post-2005. It is now an accepted and established part of the Yokai world. Folklore is, of course, the lore of the folk, and a website like Wikipedia is as good a place as any for new folklore to be created.

The list is three specific characters rather than species of Yokai. All come from the Heian period (794–1185) and directly threatened the emperor of Japan. All three continue to haunt Japan to this day, appearing in comics, films, and video games as figures of dread.

Shuten Doji – Demon King of the Sixth Heaven

Few monsters have been more perfect villains than Shuten Doji. He first appeared in *Oeyama Ekotoba* (14th century) in a tale of an Oni king and his band living on Mt. Oe, on the outskirts of the capital of Kyoto. They raided the capital, taking people back to their stronghold to eat. The heroes of the day, such as the onmyodo sorcerer Abe no Seimei, the legendary warrior Minamoto no Raiko, and his four lieutenants called the Four Heavenly Kings assembled to stop him. Raiko led his warriors to Shuten Doji's lair, where they disguised themselves as priests. Bringing powerful sake as a gift, they were invited in. Raiko poured out the

specially brewed sake, until the entire band of Oni were passed out drunk. Raiko and his lieutenants then went one-by-one, killing the Oni. When they at last got to Shuten Doji, they cut off his head. But Shuten Doji was too powerful and his head flew around the room. Finally subdued, Shuten Doji cried his final words "It is priests who lie! There is nothing false in the words of an oni!"

Raiko took the head of Shuten Doji to Byodo-in temple in Uji, where it remains to this day.

(There are multiple variations and multiple "real" locations of Shuten Doji's head. Another is Oeda shrine in Oeda Kutsukake, outside of Kyoto.)

Tamamo no Mae—The Nine-tailed Fox
Stories of Tamamo no Mae appeared during the Muromachi period (1336–1573). She was a wily transformed Kitsune who used her powers to captivate rulers of three countries and bring them to ruin.

She was said to have first possessed the body of Daiji, concubine of King Zhou, last ruler of the Shang dynasty of China. She ensorcelled the King and ruled over a reign of terror that brought about the end of the Shang dynasty. She then fled to India where she became Lady Kayo, concubine to crown prince Banzoku. Again, she oversaw a reign of terror, causing Banzoku to cut off the heads of a thousand men. She then returned to China, possessing Bao Si, concubine of King You of the Zhou dynasty. This time she was exposed and chased away.

Traveling across the Sea of Japan (East Sea), she manifested as Tamamo no Mae, courtesan of Emperor Toba. After Toba fell ill, *Onmyoji* sorcerer Abe no Yasuchika exposed her. Fleeing again, she was hunted to the plains

of Nasu, and in 1653 her spirit was trapped in a stone called the Sessho-seki. The stone was said to cause death to all who touched it.

In 2022, the Sessho-seki split into two parts. Many speculated that Tamamo no Mae was now free from her prison and able to sow her seeds of discord again.

Emperor Sutoku – The Great Tengu

Sutoku was never more than a pawn in the game of thrones. Placed on the throne when he was a child, he was controlled entirely by his grandfather, retired Emperor Shirakawa, who was actually his father. His official father, Emperor Toba, resented his bastard son, and when Shirakawa died Sutoku was replaced by Toba's real son, Konoe. After a brief and futile succession war, Sutoku was banished to Sanuki province where he would live out the rest of his life as a monk.

Sutoku attempted to find solace and a purpose in life by hand-copying holy sutras which he sent to the imperial temple as an offering. New Emperor Go-Shrirakawa feared they might be cursed and rejected them. That was too much for Sutoku. He bit off his own tongue and laid a curse on all of Japan with his dying breath. He was reborn as a vengeful Great Tengu with power to fulfill his curse. For years death and disaster struck the imperial court. Emperor Nijo died at 23 years old. Storms, droughts, fires, and earthquakes blasted the imperial capital. Clans rose in rebellion and finally open civil war erupted in 1180. The imperial court was overthrown by the Kamakura shogunate and was never to wield power over Japan again. They were reduced to mere figureheads.

It appears that Sutoku's curse

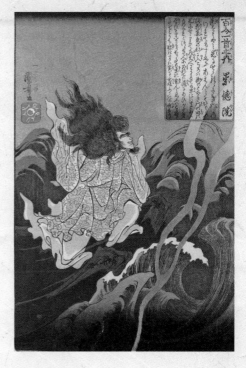

remains upon Japan. In 2012, when a historical drama that retold his story was broacast, an earthquake struck at the very moment the scene when he laid his curse was shown.

The severed head of Shuten Doji (facing page left), the demon of Mt. Oe, attacks Minamoto no Raiko. (1843) Katsukawa Shuntei.

Tamamo no Mae (facing page right) stands by the Sessho-seki. From the series *New Forms of Thirty-Six Ghosts*. (1891) Tsukioka Yoshitoshi.

Emperor Sutoku (above) stands on a rocky outcrop above a stormy sea. (1842) Utagawa Kuniyoshi.

Tengu Divine Birds

You have devoted your life to the study of martial arts, to improving and disciplining your body. You know that you have learned all that a human master can teach you. So, you must seek something else. You cast aside all worldly belongings and undertake a pilgrimage deep into the mountains. Half-starving and weak, you hear the beating of mighty wings. An imposing being stands before you, radiating might. If you can meet its challenge, it might take you as a disciple. Then and only then will you learn the secrets of the Tengu.

Few Yokai straddle the sacred and the profane like Tengu. Perhaps only the demonic Oni and the fluid Kitsune are as immersed in the triple worlds of Buddhism, Shinto, and folklore superstitions. Disruptor and bringers of war. Impious anti-Buddhas who lead people into temptation and ruin. Mighty warriors who taught the secrets of martial arts to the famed Minamoto no Yoshitsune. Deities and spiritual focus of the mountain ascetics known as Shugendo. Tengu have played many roles over the centuries.

> **Tengu** is written 天狗
> 天 (ten) – heaven
> 狗 (gu) – dog

Tengu are one of the most ancient of Japan's Yokai. Like many things that comes from before Japan started keeping written records, the actual history and evolution of Tengu is unknown. Tengu are generally thought to have arrived in Japan along with Buddhism and contain elements borrowed from other faiths. There is much speculation with little established facts. Tengu have taken several forms over the centuries, and Japanese scholars have devoted multiple books attempting to rationalize Tengu tales into a cohesive mythology. Some of these books have been claimed to be written by Tengu themselves.

The oldest known reference to Tengu comes in *Nihon Shoki* (720). It mentions a large shooting star, and names it Tengu. The kanji characters come from a Chinese demon called *tiāngou*, a dog-shaped meteor that heralds war and misfortune. However, the characters are accompanied by phonetic characters identifying it as a "heavenly fox." It seems that at the time Tengu and Kitsune were not separate creatures but a conglomerate representation of evil spirits.

Tengu appear extensively in *Konjaku Monogatari* (12th century), serving as foils to Buddhist monks.

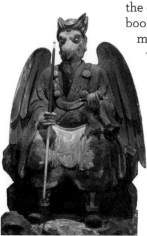

Statue of a Tengu, resembling Hindu statues of Garuda. (19th century) Artist unknown.

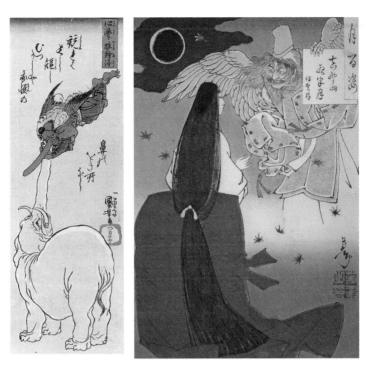

A Tengu and an elephant in combat (left). A poem is presented about the fight between the two long nosed creatures. (1842) Utagawa Kuniyoshi.

Iga-no-Tsubose (right) encounters the ghost of Sasaki no Kiyotaka as a Tengu, after he was forced to commit suicide for giving Emperor Daigo bad advice. From the collection *One Hundred Aspects of the Moon.* (1886) Tsukioka Yoshitoshi.

Tengu used their powers to attempt to lure them from a righteous path. They were able to transform, taking on the appearance of monks and nuns and even Buddhist figures. Though their name meant "heavenly dog," Tengu were avian in appearance. Depicted as the bird of prey known as a kite, they are speculated to have been influenced by the Hindu garuda, winged people also identified with kites. One of the earliest depictions of Tengu, *Tenguzoshi Emaki* (c. 1296) parodied high-ranking priests as fallen Tengu with beaks. Toriyama Sekien illustrated this version in *Gazu Hyakki Yagyo* (1776). His Tengu looks exactly like an angry bird. This avian Tengu is known today as Karasu Tengu, or Crow Tengu.

By the 13th century, Tengu were seen as heretical monks and vengeful spirits. Those who observed the tenants of Buddhism walked the Way of the Buddha, or Butsudo. Heretics strayed into the Tengu Path, or Tengudo, a middle realm between heaven and hell. The most famous was Emperor Sutoku, who died laying a curse on all of Japan as was said to have been reborn as an O-tengu, a Great Tengu. Tengu were also thought to possess people, as Tsukimono, and drive them to madness.

By the Kamakura period Tengu stratified. The idea spread of two types of Tengu, good and evil. *Shasekishu* (1283),

Kaibutsu Creatures

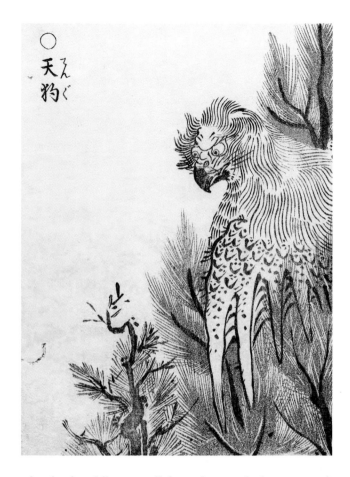

○
天えん
狗ぐ

Tengu from *Gazu Hyakki Yagyo*. This is the bird design of the Tengu. (1776) Toriyama Sekien.

a book of Buddhist parallels said instead of enemies of Buddhism, Tengu were protectors of the Dharma. It was pride or ambition that caused priests to fall to the Tengudo, yet they remained the righteous people they were in life. *Genpei Josuiki*, an extended version of *Heike Monogatari* (14th century) introduced Daitengu (greater tengu) or Kotengu (lesser tengu). Some said Daitengu were spirits of honorable warriors whose could not go to heaven because the violent lives they lead but could also not go to hell.

Tengu later became associated with the long-nosed Shinto deity Sarutahiko, altering their form into red-faced, long-nosed, winged goblins. Sarutahiko was a monkey deity of the mountains. A further association with the religion of mountain aesthetics Shugendo, fixing their modern appearance. Shugendo is an esoteric religion of natural magic and exorcists called yamabushi that contrasted the court sorcerers of Onmyodo. Tengu's costume incorporated the small

hats and robes of these mountain dwellers. They adopted fans of bird feathers with which it was said they could create mighty winds.

Tengu legends expanded over the centuries. The book *Tengu Meigiko* (1754) lists seventeen Daitengu in order of power. The most powerful, Sojobo, was said to have mentored the legendary warrior Minamoto no Yoshitsune in skills of battle. Other Tengu, such as Doryo Daigongen, became associated as guardian deities and Kami. Guhin, or dog Tengu, were a lesser species associated with mischief in the woods, such as the sound of a falling tree when there was none around. *Sozan Chomon Kishu* (1850) tells of woodcutters putting out special mochi cakes to placate Tengu when they went to forests to work. Inoue Enryo collected myriad Tengu tales in his book *Tenguron* (1916). Tengu stories are too many to tell and remain a vital part of modern Japanese storytelling and society.

Sketch of a Tengu, labeled number 61 in the collection *Album of Sketches by Katsushika Hokusai and His Disciples.* (19th century) Katsushika Hokusai.

Aobozu (facing page) from *Gazu Hyakki Yagyo*. (1776) Toriyama Sekien.

Aobozu (bottom) from a deck of *Obake Karuta* cards. Each card features a Yokai and kana character from the hiragana syllabary. (early 19th century) Artist unknown.

Aobozu Blue Priests

Wandering in the woods one day, a strange apparition appears. A blue, one-eyed creature towers over you, draped in a monk's robe. It asks you casually "Would you like to be hung by your neck?" Desperately you think of the right reply, as you are trapped by the Aobozu.

Aobozu appear in multiple regional variations, sometimes as a mountain deity and sometimes as a Tanuki or weasel playing tricks. They are often whimsically vicious, issuing minor challenges such as riddles or sumo matches. The consequences of failing an Aobozu's challenge is often death.

> **Aobozu** is written 青坊主
> 青 (ao) – blue
> 坊主 (gu) – priest

Aobozu first appeared in Toriyama Sekien's *Gazu Hyakki Yagyo* (1776). His illustration shows a solitary priest in a mountain hut. The priest is large, heavy set, and sports a single eye in his round head. The single eye is reminiscent of minor mountain gods, and he wears the robes of a Buddhist priest. The name Aobozu could have multiple meanings. *Ao*, or blue in Japanese, also means young or unskilled. Aobozu could be a novice priest; or perhaps a pretender who wears the garments of a holy person while knowing nothing of the sacred teachings. Aobozu could be a sly dig at a corrupt priesthood. As Aobozu appeared in the earliest of Sekien's Yokai catalogs it is unlikely to be an original creation.

Since then, several regional variations have been recorded. and many tales merge the monster with older myths. Many do not follow Sekien's depiction, showing two eyes instead of one. But they are usually large and blue.

In *Ise Minzoku* (1957), there is an Aobozu who challenges those it meets to sumo matches. This Aobozu is small, and those who underestimate him soon find themselves in danger of their life as they are flung into the air. *Okusabe no Minwa Densetsu* (1965) tells an odd tale from Nagano Prefecture of a pine tree, where if you circle it seven times while holding your breath, an Aobozu will appear and ask you not to step on stones or break the tree. More brutal legends are told in *Kagawa Minzoku* (1958) of Aobozu who peeked in on a nursemaid and asked if she would like to be hung by her neck. After refusing, the Aobozu reached through the window and hung her anyway. The crying of the baby alerted a neighbor who found the nursemaid's body.

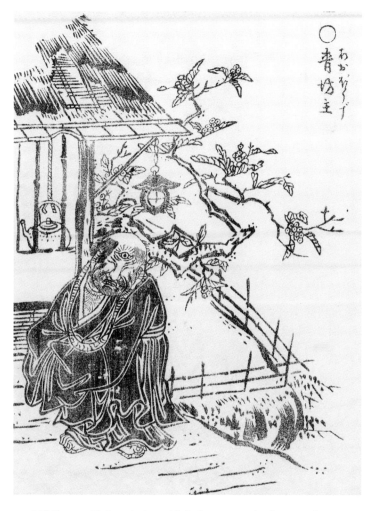

While terrifying, it is said Aobozu can be kept at bay by woven baskets or other objects with multiple holes. The appearance of many eyes is said to drive away the single-eyed Aobozu, either from fear or jealousy.

Sunakake Baba Sand-throwing Hags

Walking through the forests of Nara at night, you pass by an ancient, abandoned shrine. Fearing an attack by a Yokai, you turn to flee. Suddenly, you are hit by a bit of sand. You breathe a sigh of relief, for you realize the only creature lurking nearby is Sunakake Baba.

While some Yokai are terrifyingly deadly, and some are amusing, Sunakake Baba is little more than a nuisance. She hides in forests and flings a little bit of sand at you.

Unnerving, perhaps, but of no consequence other than having to brush off the debris.

> **Sunakake Baba** is written 砂かけ婆
> 砂かけ (sunakake) – sand-throwing
> 婆 (baba) – old woman

Sunakake Baba was first recorded by Dr. Sawada Shirosaka in *Yamato Mukashitan* (1931). A collection of folktales of Nara Prefecture, Sawada described a creature that sprinkled sand on passer-byers in the shadows of lonely forests and ancient shrines. An obscure regional Yokai, folklorist Yanagita Kunio spread knowledge of Sunakake Baba by including her in his book *Yokai Dangi* (1954). There are regional variations although these are usually attributed to prankster Tanuki throwing sand at travelers while remaining out of sight.

It is speculated that the origins of Sunakake Baba are birds dropping sand from their feet when they fly overhead. An island country, Japan is surrounded by beaches. Birds hunting the shores get wet sand sticking to their bodies. It's not impossible to think some of it might land on someone as it dries from birds flying through the sky.

Sunakake Baba throwing sand in the forest. (2023) Image courtesy Cat Farris.

There are no visual depictions of Sunakake Baba, or period illustrations. She was always described as unseen. Mizuki Shigeru designed a character for her when including Sunakake Baba in his comic *Kitaro*. Mizuki modeled his "heroic" Yokai on the ones in Yanagita Kunio's books, and his "villainous" Yokai from the works of Toriyama Sekien. Mizuki cast Sunakake Baba as the manager of the Yokai apartments. Thanks to *Kitaro* (1960s), Sunakake Baba is one of the most well-known Yokai in modern Japan.

Kuchisake Onna Slit-mouthed Women

Wandering the streets of Tokyo one night, you encounter a young woman. She has a mask across her face, but you can still see the loveliness of her eyes. The woman lures you into a quiet alley, and pulls you close. She asks you a simple question. "Am I beautiful?" No matter what your answer, you will face the vengeance of the Kuchisake Onna.

Kuchisake Onna are women Yokai who stalk the streets of modern Japan. A medical mask covers their horrific face, a mouth slashed from ear to ear. Finding a victim, they ask their fatal question. There is no correct answer. If you say no, they stab you with scissors. If you say yes, they remove their mask to show their horrific face and ask you again. Say no and they will cut you in half. Say yes again and they slit your face to match their own.

Kuchisake Onna is written 口裂け女
口 (kuchi) – mouth
裂け (sake) - split
女 (onna) – woman

Kuchisake Onna follow the tradition of Yokai such as Aobozu, asking questions for which there is no answer that does not lead to death. Kuchisake Onna play on fears of medical masks, a common site in modern Japan. Masks are worn by people with colds and other illnesses as a courtesy not to infect those around them. Wearing them is a sign of good manners, which adds to the fear of a Yokai hiding behind the mask. Folklorist Komatsu Kazuhiko considers Kuchisake Onna to be a continuation of Yamauba legends, a mythical hag of the mountains.

Similar Yokai to Kuchisake Onna appeared during the Edo period. In *Kaidan Ou no Tsue* (19th century?) there is the story of a man out for a walk one night in the rain. He spies a woman caught in the storm and offers to share his umbrella with her. She reveals her fearsome face, a mouth spread from ear to ear. This story is recorded as a mischievous Kitsune playing pranks. In *Ehon Sayoshigure* (1801) a story is a told of a man visiting a courtesan who reveals herself to have the same terrible grin. The man never visited a courtesan again.

An account of the Kaijo of Yoshiwara, from *Ehon Sayoshigure*. This story was later associated with Kuchisake Onna. (1801) Shungyosai Hayami.

Urban legends arose in Gifu Prefecture in December 1978. One of the oldest accounts is of an old farmer's wife who was startled by seeing a disfigured woman standing by her outhouse. In January 1979, the Gifu Nichinichi Shimbun reported on the sightings. A local radio station did a special on the sightings, and the national newspaper Asahi published an article in June 1979. In less than six months stories of Kuchisake Onna had spread across Japan. Kuchisake Onna was a form of mass hysteria. Police were mobilized to hunt her down. Children were organized into groups and escorted to and from school by teachers. Some said Kuchisake Onna was a psychotic woman escaped from a mental institution who drew a mouth on her face with lipstick. In June 1979, a woman was arrested in Himeji for dressing up in a mask and walking around with a kitchen knife scaring children.

By August 1979, stories of the Kuchisake Onna had disappeared. She was gone as quickly as she arose. Many noted that this corresponded with summer vacation for school children. With children no longer gathered to spread rumors, the stories swiftly faded.

Pop culture Japan was quick to embrace the new monster. In 1979, the disco song *Kuchisake Onna o Tsukamaeru* by Pomade and Kompeito. Enterprising women at Ginza hostess bars took to wearing masks and asking their patrons if they were beautiful. Apparently, customers had to answer either "pomade" or "hard candy." The *tokusatsu* television show *Battle Fever J* (1979) had a Kuchisake Onna episode. Manga, anime, and all other forms of entertainment soon followed.

Legends of the Kuchisake Onna resurged in the 1990s. She accumulated new legends, incorporating scissors and sickles and other cutting devices. With the popularization of cosmetic surgery, stories were told that Kuchisake Onna was a victim of plastic surgery gone bad. Multiple regional variations arouse, mostly based on the consequences of the answer to her perpetual questions, "Am I beautiful?" Some attempt to link her story to a Heian period samurai who slashed his wife with a sword, but these are examples of what is known as backlore; invented historic roots of modern folklore stories in an attempt to give them ancient provenance.

In truth, Kuchisake Onna are the first Yokai of the modern age. She arose as an urban legend and spread through modern methods of communication. Mizuki Shigeru designated her an official Yokai by including Kuchisake Onna in one of his Yokai collections. Kuchisake Onna is evidence that new Yokai can and will continue to be born.

Tofu Kozo Tofu Boys

On a dark and stormy Edo night, if you should happen to turn around and see a giant baby dressed in an enormous bamboo hat and carrying a wiggly block of tofu festooned with a maple leaf, don't panic. Despite the strange appearance, it is only Tofu Kozo, one of the most harmless of all of Japan's bizarre Yokai tribe.

Tofu Kozo look like children dressed in fancy kimono, with large heads and oversized straw rain hats. Their kimono are often adorned with daruma figures, red rockfish, horned owls, and taiko drums, all of which were thought to be talismans against smallpox during the Edo period. Tofu Kozo carry a platter with a single block of tofu, often adorned with a maple leaf. This is a dish known as koya tofu, or maple leaf tofu, and was popular during the Edo period. Tofu Kozo are urban Yokai who rarely appear outside of cities.

Tofu Kozo is written 豆腐小僧
豆腐 (tofu) – tofu
小僧 (kozo) – young boy

Tofu Kozo drawing from *Ojidai Morokoshi Bakemono*, a collection of ancient Chinese Yokai stories. He wears the usual straw hat and kimono. (1816) Katsukawa Shuntei.

Little is known about Tofu Kozo. They mysteriously manifested sometime around the late Edo period where they started to appear in everything, from illustrations to ornaments to cookbooks *kabuki* plays. They were one of the first of what we would now call viral characters.

Tofu Kozo first appeared in kusazoshi and kibyoshi books, illustrated works of popular fiction. Kibyoshi, known as yellow books, were identified by their bright yellow covers. Equivalent to modern comic books, kibyoshi were usually ten pages long, and featured satirical and comedic illustrated stories. Several kibyoshi featured Yokai stories. The oldest known appearance of Tofu Kozo is in *Bakemono Shiuchi Hyobanki* (1779), by artist Koikawa Harumachi. It showed a creature with a large head like a baby carrying a plate of tofu. In the book, Tofu Kozo is identified as the child of Mikoshi-nyudo, the supreme commander of Yokai, and Rokurokubi. In the illustration Tofu Kozo is noticeably missing his large rain hat.

A few years later, Tofu Kozo appeared in a tofu cookbook, *Tofu Hyakuchin* (1782) by Hitsujun Ka. The kibyoshi *Bakemono Chakutocho* (1788) shows him with his oversized hat and two-toed clawed feet. *Kyoka Hyaku Monogatari* (1853), depicts

Tofu Kozo (right) from *Kyoka Hyaku Monogatari*. Notice the single maple leaf on the block of tofu. (1853) Ryukansai.

Tofu Kozo (facing page) hides behind a woman and rabbits in a modern Yokai painting. (2023) Image courtesy Peach Momoko.

Tofu Kozo as a human boy carrying tofu. He is usually shown as friendly and cheerful. Tofu Kozo is often depicted as an errand boy for Yokai, rushing messages back and forth between more important creatures.

In *Yokai Kusazoshi* (2001), Adam Kaba speculates that Tofu Kozo may have originally been a mascot character for a tofu seller. Street scene illustrations such as *Edo Meisho Zue* (1835) show tofu dealers moving through the bustling streets of Edo wearing the same iconic conical bamboo hat. Other illustrations from the time show Yokai such as Kappa and Tanuki carrying tofu. Tofu Kozo may have been created as an advertising character for a shop, only to see their mascot's popularity run away from them. An alternate idea is that Tofu Kozo may have been created as a story for the game *Hyakumonogatari Kaidankai*. What is in general agreement is that there are no roots to Tofu Kozo beyond the late Edo period when he was suddenly everywhere. Given Japan's propensity for cute characters, I favor the mascot theory.

Showa period (1926–1989) books claimed the tofu he carried was poisonous and would kill any that touched it. Others said it had a mold growing in it that infected human bodies. Yokai researchers Kyogoku Natsuhiko and Yamaguchi Bintaro trace this legend as having been invented for children's books to give the Tofu Kozo more of an edge for modern readers.

Kaibutsu Creatures

Yamauba Cannibalistic Witches

A Yamauba mountain witch from the *Hyakkai Zukan,* an early Edo period Yokai scroll. Sawaki's depiction was used as a guide for many Yamauba images to follow. (1737) Sawaki Sushi.

Coming home from a good day of fishing, your cart is full of your catch. As you lead your horse home, you see an old woman begging on the side of the road. She smiles at you and asks for a fish. Feeling pity, you give her a fish. Swallowing it in a single bite, she demands another. Then another. You are unable to move, caught in her spell. After she finishes off your fish, she digs into your horse. When the horse is done, she turns her eye to you.

Yamauba are cannibalistic old women of the mountains. They are described as having long unkempt white hair, wearing tattered clothes of bark. At the same time, they are voluptuous mothers raising legendary heroes. They have served both roles at different times in Japanese folklore. But always in the mountains.

> **Yamauba** is written 山姥
> 山 (yama) – mountain
> 姥 (uba) – elderly woman

Yamauba appear sometime around the Muromachi period (1336–1573). They did not emerge fully formed but merged Oni legends with mountain deities. They have been called multiple names, from Yamahime (mountain princess) to

やまうば
山姥

Yamababa (mountain mother). At times they are part of a family, complete with Yamajiji (mountain old man) and Yamawaro (mountain child). More often they are solitary, living in mountain cabins hunting for prey. Yamauba encounters are most often with lonely travelers and merchants crossing mountain paths.

Origins of Yamauba are equally varied. Some say they stem from the mythological—but not historical—practice of *ubasute*, abandoning elderly women in the mountains to die. Others see them as creatures of obsession and jealousy, essentially the hungry ghosts of Buddhism transformed by

Yamauba from *Gazu Hyakki Yagyo.* (1776) Toriyama Sekien.

Kaibutsu Creatures

151

their own negative emotions into Oni. And still others associate them with Shinto practices of shrine maidens who lived in sacred mountains serving the Kami. Most likely they are a mix of all of these.

One of the oldest known Yamauba comes from the *noh* play *Yamanba* (16th century) by Zeami Motokiyo. It features a young courtesan famous for her dance of the Yamauba, and thus is called Hyakuma Yamanba. The courtesan and her two attendants embark on a pilgrimage to Zenkoji. On their way, they take a mountain pass where they run into a mysterious old woman who offers them lodging for the night. In payment, she asks Hyakuma to dance the dance of the Yamauba. Realizing their host is a real Yamauba, they are terrified. The old woman then dances the dance herself, asking for salvation from obsession that led her to become what she is. The dance over, it is suddenly daylight again, and Hyakuma Yamanba and her attendants find themselves outside. The core of the play is dualism, with the Yamauba singing lines such as "Good and evil are not two, right and wrong are the same." Hyakuma then performs the dance for the old woman as a memorial, so that she might be freed.

Many other stories tell of similar encounters, but with more vicious endings. Yamauba's defining trait is cannibalism. They often invite in weary travelers or appear in a variety of guises all with the ultimate goal of gaining a meal. In the most famous story, *Ushikata to Yamauba* (?), a Yamauba stops an ox-cart driver with a wagon of fish and feasts on all three. Toriyama Sekien's Yamauba in *Gazu Hyakki Yagyo* (1776) shows a ragged old woman, the bones of her ribs showing through her chest.

Yanagita Kunio's *Tono Monogatari* (1910) told varied stories of yamabito, mountain dwellers. Sometimes these were madwomen, married to mountain deities and birthing the various monsters of the mountains. This maternal aspect of Yamauba would feature in other legends.

Some stories tell of kinder, gentler Yamauba. They nurse children lost in the woods. The folk hero Kintaro was said to have been raised by a Yamauba. Edo period depictions of Kintaro and his Yamauba mother show young, buxom women. *Kitagawa Utamaro's Yama-uba Nursing Kintoki* (1802) shows a beautiful, full-breasted woman with her young, red-faced charge.

In perhaps the oddest twist on a Yokai legend, Yamauba became a fashion subculture during the early 2000s. Young women tanned themselves dark and painted their eyes and lips white, while wearing colorful stickers and hair accessories.

Okka Mysterious Blobs

There's a blob in front of you. A strange blob. With feet! What's it doing? Nobody knows. That's Okka.

Okka are blobby creatures. They are usually red. Sometimes white. They generally have two feet. Sometimes one. Sometimes they have an odd little tail. There is almost nothing distinctive about them other than they are one of the few Yokai to never have been given a story.

> **Okka** is written 大化
> 大 (o) – great
> 化 (ka, bake) – change

Okka are some of the oldest Yokai yet are entirely unknown. They appear on the oldest known *Hyakki Yagyo* scroll, the Shinju-an scroll, held in Daitokuji temple in Kyoto. Okka are usually in the same position, being beaten by the hammer-wielding Yokai Kanazuchibo. Why is he beating this clearly weaker Yokai? We don't know. They were diligently painted across the centuries without explanation. Okka are the most important Yokai we know nothing about.

The name Okka comes from a single scroll, *Bakemono Emaki* (18th century?) held at the Kawasaki City Museum. There is a creature that looks similar enough to the familiar blobby, labeled Okka. That association was enough to name this lost Yokai. The word Okka is thought to be a childish corruption

of *obake*, a form of baby talk. Whether this was a common name for the creature, or something added by the scroll's artist to name the one unnamed Yokai, we can never know.

There have been many suppositions about Okka. Many attempts to give them stories. Some say they are Yokai frogs, because of their vaguely amphibious appearance. Some call them Yokai babies. Which is slightly horrifying considering they are usually being beaten with hammers.

The best thing about Okka, and why those of us who love Yokai love it so much, is that Okka represents the mystery that remains in the world. There are questions we will simply never have the answers to, enigmas we will never unravel. Okka is one of them. And that delicious feeling of unknown, is Yokai.

Oni Ferocious Demons

The red giant towers before you, a tanned tiger skin stretched across its broad chest. Horns spring from its head. A massive, studded iron club is in its hands. Standing before you is the fiercest, most destructive of all Yokai—the Oni.

What are oni? Massive, red-skinned demons dressed in tiger skins, wielding studded iron clubs? Mysterious, invisible bugs that lodge in your organs causing illness and imbalance? Servitors of Hell, meeting out just punishment to the dammed by command of Enma Dai-O, Judge of Hell? Guardians of the gates of Heaven? Embodiment of the destructive powers of nature, wielders of thunder and

Okka, in a detail from the *Hyakki Yagyo Emaki* scroll. (16th century or 17th century) Artist unknown.

lightning? Savage, hairy foreigners gorging themselves on human flesh? A cute alien girl with green hair, horns, and a tiger-skin bikini? With Oni, the answer is always "yes."

Oni is written 鬼
鬼 (oni, ki) – oni

Oni are the ill will, the noxious. They are darkness, the evil that lurks inside every soul. They are harbingers of health and fortune. They are Shinto. They are Buddhist. They are Onmyodo geomancy. They are native to Japan. They are Chinese. They are Indian. In any time, in every place, across all of Japan Oni have played a role. Many books have been written exploring Oni. In *Japanese Demon Lore: Oni from Ancient Times to the Present* (2013) scholar Noriko Reider spends thirty pages attempting to answer the question "What are Oni?" Ultimately, she determines any definition will fail to encapsulate the full idea of the creatures.

Oni appear first in *Nihongi* (720) described as evil entities. Spirits of people and nature were believed to be double-souled, possessing both an *ara-mitama* (rough or violent soul) and *nigi-mitama* (the gentle soul). These twin souls were embodied as Kami and Oni and influenced nature. Kami was bountiful crops and health. Oni was thunder and lightning. In *Oni no Hanashi* (1975), researcher Orikuchi Shinobu says this energy had three aspects: energy that was worshipped became Kami; energy that was unworshipped became Yokai; energy that was feared or despised became Oni.

Oni next appears in *Izumo fudoki* (733) where it defines "People with different customs who live beyond the reach of the emperor's control." This could mean barbarian tribes living in the mountains, or rival clans. Orikuchi saw in Oni the abstruse concept of *marebito*, the foreign god. Marebito was a belief in ancient Japan, representing a concept of the Other who comes from over the seas, entities of awesome power that bring either blessings or curses. Unlike Kami, Marebito had physical form and may be the oldest known Japanese concept of incarnate deities.

The Heian period (794–1185) saw the rise of *onmyodo*, yin-yang geomancy practiced in the imperial court. In Onmyodo, Oni were microscopic bugs that swam in the human body, negatively influencing personalities and fortunes. Much of medicine from the time focused on cleansing Oni from the body to allow for healthful energy flow. *Onmyodo* was also concerned with directions. Precursors to modern Feng Shui, *onmyodo* divined fortuitous directions and placement. The

An Oni (left) chants the *nenbutsu*, a prayer to obtain rebirth in the Pure Land of Amida Buddha. The Oni priest comes from Otsu-e folk art, with a double meaning that the truth of the Buddha can redeem even an Oni, or that priests are hypocrites who hide their evil in religious robes. (19th or 20th century) Suzuki Shonen.

An Oni (right) writing in an account ledger, accompanied by a verse from the poet Akera Kanko "Though the name of Buddha is hidden from me I can see it in the eyes of an Oni." (19th century) Totoya Hokkei.

most inauspicious direction was northeast, called the *kimon* or *Oni gate*. Based on the twelve zodiac animals, this direction was also called *ushitora*, meaning Ox-Tiger. It is thought this influenced the Oni's appearance of horns and tiger skins.

Around the 12th century, Oni were recast as demons in Buddhist hells. But formless energy cannot mete out divine judgment. They needed bodies. Gathering bits and pieces along the silk road, Oni were merged with Hindu rakshasa and yasha. Their mottled forms were black, red, blue, or yellow and their heads decorated with an assortment of horns and fangs.

Stories of a different kind of Oni came from northern Japan. Villagers told of huge, red-faced, hairy men coming down from mountains wielding implements of iron. Some researchers speculate these were shipwrecked sailors, possibly Dutch or other Europeans. Their large size, hair, and red skin might be exaggerated accounts from Japanese people who had never encountered foreigners. While no physical evidence supports this supposition, these stories live on in Namahage traditions of northern Japan.

Modern Oni blend all these traits together. They are temporal chimeras, reflecting Japan's belief of evil and wearing

whatever mask society needs them to wear. Yet not all Oni are evil. Renowned children's author Hamada Hirosuke wrote *Naita Akaoni* (1933) about a red Oni and blue Oni who were friends. The blue Oni sacrificed his own happiness for the red Oni. This book gave rise to the concepts of red and blue oni, as well as Oni exhibiting kindness. Like many of Japan's Yokai, Oni have entered the realm of cuteness. Rumiko Takahashi remade Oni in her comic book *Urusei Yatsura* (1976). She mixed folklore and science fiction in her character Lum, a green-haired Oni girl in a tiger bikini who wielded lightning. Lum has become a beloved character for generations.

I have only scratched the surface here. Oni are complex and defy analysis. Whatever you think you know about oni—they are so much more.

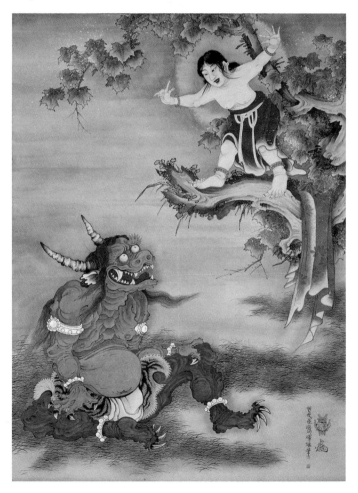

A blue-skinned Oni is shown from a story from the lives of the Buddha, where Sessen Doji offers his life in exchange for knowledge of a sutra. (1764) Soga Shohaku.

Oni girl as a sukeban, a type of girl gang delinquent popularized in 1970s and 1980s Japan. (2017) Image courtesy Emi Lenox.

Hannya Possessed Women

You watch in horror as her face twists in rage. Her anger builds and builds until her entire body seems to transform. Horns spring from her head. Her mouth splits wide, showing dripping fangs. You realize you made your last mistake as you stare into the face of a Hannya.

Hannya are the souls of women possessed by strong emotions. Jealousy, rage, obsession... any of these are powerful enough. The woman transforms into a living Oni, horns springing from her head and mouth gapping. While Hannya has become a popular name for this type of Yokai, in actuality it refers to a mask, not a monster. Hannya is the name for the traditional *noh* mask used to portray the Oni women known as Kijo.

Hannya is written 般若
般若 (hannya) – wisdom required to attain enlightenment

Kijo is written 鬼女
鬼 (ki, oni) – oni
女 (jo, onna) - woman

Kijo are women consumed by jealousy, rage, and other powerful emotions. They originated in the Muromachi period (1336–1573), appearing mostly in *noh* theater plays. They are Buddhist in nature and represent the ability of strong emotions to manifest as demons, such as Gaki, or hungry ghosts. Most Kijo tales were didactic, meant as warnings to not let emotions control you. They were also exciting, scary tales that made for dramatic theater.

One of the most famous Kijo stories is *Momijigari* (15th century), a *noh* play believed to have been written by Nobumitsu Kanze. In *Momijigari*, the warrior Taira no Koremochi is deer-hunting when he comes across a beautiful, high-ranking woman and her attendants having a maple-leaf viewing party. She lures Koremochi to drink and puts him under a sleeping spell. In his dream, a divine being

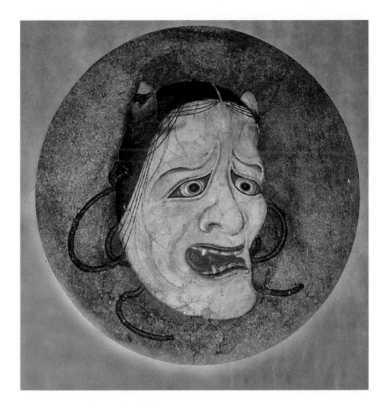

grants Koremochi a sword to vanquish the demon disguised as a woman. Awakening, he slays the Kijo with the sword.

Noh uses traditional masks to indicate roles. The Hannya mask is used to represent Kijo. The name of the mask, "Hannya," is a phonetic transcription of the Sanskrit "prajñā" meaning "the wisdom of Buddha needed to achieve enlightenment." No one knows how this came to be associated with the mask. One theory comes from the play *Aoi no Ue* (14th century), where the Kijo Lady Rokuju cries "How horrific is the voice of wisdom!"

The Hannya mask is thought to have been created in the 16th century. It first appears in the works of Shimozuma Nakataka. *Aoi no Ue* (14th century), a play based on the jealous wife of the unfaithful Genji in the book *Genji Monogatari* or *The Tale of Genji* (11th century), uses the Hannya mask to dramatic effect and has made it one of the most famous symbols of Japan. (Interestingly, *Momijigari* was written before the development of the Hannya mask. Traditionally it uses the *shikami* mask which lacks horns.)

Toriyama Sekien illustrated Hannya in *Konjaku Gazu Zoku Hyakki* (1779), describing the story of *Aoi no Ue* (14th century)

Head of a Hannya (above). (18th century) Artist unknown, in the style of Ogawa Haritsu (Ritsuo).

Hannya (facing page) from *Konjaku Gazu Zoku Hyakki*. (1779) Toriyama Sekien.

and referencing the *Hannya-kyo* sutra, or *Prajnaparamita* as it is called in Sanskrit. Others, such as *Tosa Obake Zoshi* (18th century?) show a Kijo.

In modern Japan, Hannya has come to refer to the Oni-woman Kijo as well as the mask itself. In traditional Shinto weddings, brides wear a large box hat meant to hide their horns just in case. Swept up in the powerful emotions of the day, they might transform into Hannya.

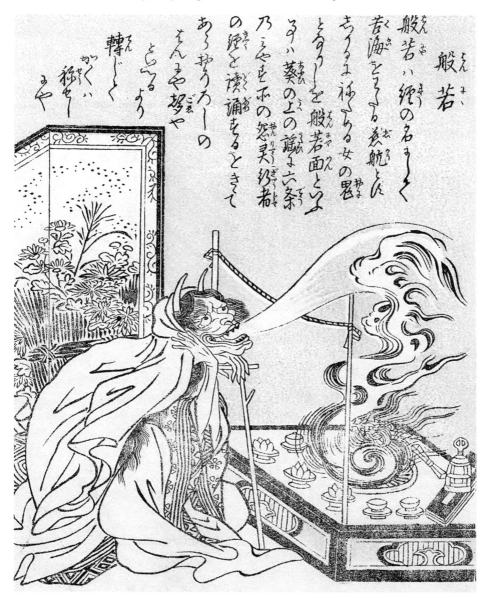

YOKAIOLOGY
Yogenju
Prophetic Yokai

In 1805, a strange creature was sighted in the ocean off Etchu province. It was described as having the head of a long-haired young woman, a pair of golden horns, a red belly, three eyes on each side of its torso, and a carp-like tail. It was said to be about thirty-five feet long. The creature, called Kairai, or sea lighting, was killed by shots from four hundred and fifty rifles. It's said that anyone who sees the strange creature will enjoy longevity, protection from disasters, and good fortune and virtue.

Kairai was the first of the Yogenju, prophetic creatures that appeared from the late Edo period to the early Meiji. Yogenju predicted disaster but that sharing their image would avert catastrophe and ensure prosperity. This disaster was often unspecified but was most likely famine. The Great Tenmei famine (1782–1788) devastated the country. Famine was a very real fear. Yogenju also appeared in a time of instability and increasing contact with the West. They represent the transition from traditional to modern Japan.

> **Yogenju** is written 予言獣
> 予言 (yogen) – prophecy
> 獣 (ju) – beast, animal

The use of supernatural creatures as talismans against disaster has a long history. The Daibutsu of Nara was raised in 743 to provide divine protection against smallpox. During the Heian period (794–1185) images of a fierce

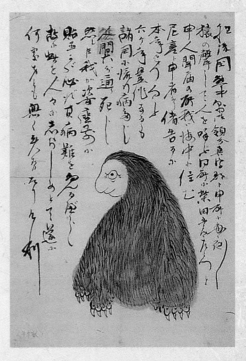

folkloric figure called Shoki the Demon Queller was hung over doorways. Called gofu, these images are magical talismans of warding meant to terrify any noxious sprits from entering.

Yogenju sightings were often printed in *kawaraban*, single-sheet broadside newspapers popular at the time. *Kawaraban* were half real news, half sensationalism. *Kawaraban* printed anything that sold papers, including crimes, executions, and

Kawaraban of the Yogenju Amabiko (above), showing mountainous traits rather than aquatic. (1852?) Artist unknown.

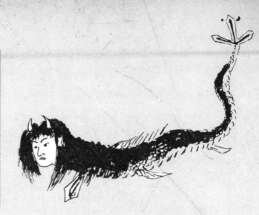

supernatural sightings. They were accompanied by illustrations of varied quality, with some by superb artists of the era and others clearly scratched out by amateurs. Yogenju also follow the pattern of modern chain emails, warning horrific things will happen if their image is not shared widely. This causes people to replicate the image and share it with as many people as possible. There was also clearly a commercial incentive for these sightings; the *kawaraban* said that posting the image of the creature would ward off disaster while simultaneously selling you an image of said creature.

Timeline of Yogenju

1619 – Kameonna – A sea turtle with a woman's head appeared off the coast of Echigo province, prophesying a good harvest followed by plague. The Kameonna said copying its picture and praying to it day and night would protect you.

1818 – Jinjahime – A long fish with a horned face of a beautiful woman and

a sword tail appeared in the sea. It prophesized "For the next seven years there will be a bumper crop. After will be an epidemic of *corori*. However, those who see my picture will avoid hardship and have long life."

1827 – Kutabe – A cow with a human face was encountered on Mt. Tate, in Etchu province. It spoke essentially the same prophecy as the Jinjahime and disappeared. Other sightings of Kutabe were recorded in local newspapers and *kawaraban*.

1836 – Kudan – A creature with a human head on a bull's body appeared during the Tempo famine of 1830–1844. The legend of the Kudan spread rapidly.

1844 – Amabiko – Appearing in Echigo province, an illustration of the creature was of a crude dark blob of a head with three legs. It prophesized that 70% of Japan would die that year if not shown this image. Obviously, that did not happen.

1846 – Amabie - Many speculate that Amabie is simply a misheard version of Amabiko. The illustration of this sighting has much improved artistry. Amabie gave a vague prophecy of

The Kudan (top left) that appeared in Yosa, Kyoto, to deliver a prophecy of good harvest followed by an epidemic. (1836) Artist unknown.

A Jinjahime (top right) from the book *Waga Koromo*, describing an eyewitness account in Hirado, Hizen province. (1819) Kato Ebian.

doom and promise of reward. Amabie's three fins are a reference to the three-sword tail tip of the original Jinjahime.

1849 – Hitokai – A shellfish mermaid that appeared near Shibata castle in Echigo province, apparently, a popular place for Yogenju. Also called Umidebito.

1852 – Amabiko - Hikozaemon Shibata heard a monkey's voice every night, and eventually tracked it down to the source. He encountered an Amabiko who delivered the usual dire warning. This version is simian rather than aquatic, covered in fur with a bald face.

1857 – Yogen no Tori – A two-headed bird, with one head black and one head white, appeared near Mt. Haku in Kaga province and predicted the death of 90% of the world's population if its image was not shared.

1875 – Amahiko no Mikoto - Said to have appeared in a rice field, the illustration shows something like a four-legged version of a daruma doll. This version carries the name of "Mikoto" identifying it as something holy, and it professed to be a servitor of the heavenly gods.

1876 – Arie – This last of the Edo period Yogenju, this version is peculiar indeed, looking like a rounded, modern cartoon character with a huge belly and nose. It has four legs and a dark mane of hair.

1882 - Amabiko Nyudo - A Meiji period return, it's illustrations were sold as protection against Cholera. Looking more like a bird man than the other aquatic creatures, and instead of the usual tripod of legs, Amabiko Nyudo sports a stunning nine limbs below, looking somewhat like thin heron legs.

Amabie (top left) as a modern day protection amulet. tukinoto/Shutterstock.com.

Kawaraban of the Yogenju Arie (top right). This version has four feet instead of the usual three. (1876) Artist unknown.

Jinjahime Fish-Women Harbingers

The Jinjahime appearance in Hirado, Hizen province in 1819 shown in this *kawaraban* broadsheet. (1919) Artist unknown.

From the beach you saw the giant fish swimming through the waves. Its crested back breaks the surface and you know this is no normal fish. A gasp escapes your lips as a human face appears, attached to the giant fish. You are stunned in amazement as the bizarre creature speaks the prophecy of the Jinjahime.

Jinjahime is a serpent-like fish with a face of a beautiful woman crowned with horns and a three-bladed sword tail. She is about 20 feet (6 meters) long, with a belly as red as crimson. Jinjahime is considered a type of mermaid as well as one of the Yogenju, the prophecy beasts.

> **Jinjahime** is written 神社姫
> 神社 (jinja) – Shinto shrine
> 姫 (hime) - princess

Japan has a history of Honengyo, fish of fortune, and Honenkame, turtles of fortune, which appear from the sea and are omens of bountiful harvest. They often are chimera, mixing aquatic, and human features. Reported sightings began in the Edo period and continued through the Meiji period. They were often associated with the underwater kingdom of Ryugu, a magical place ruled by the dragon god Ryujin. Sightings were popular subjects for artists, who could create images of the creatures along with the stories and sell them to a hopeful public.

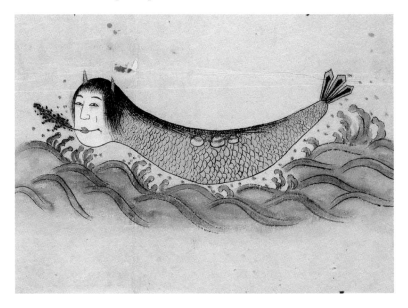

On April 18, 1819, scholar Kato Ebian recorded in his diary *Waga koromo*:

"I am a messenger from Ryugu-jo (The Dragon Palace), called jinja hime. For the next seven years there will be a bumper crop. After that, there will be an epidemic of *corori*. However, those who see my picture will be able to avoid hardship, and instead will have long life."

It is unknown exactly what disease *corori* is. Many often translate this as cholera due to similar pronunciation, but cholera did not enter Japan until much later. Going by symptoms, *corori* is most likely dysentery. But whatever the disease, spreading Jinjahime's picture could help. Judging from the amount of Jinjahime prints that survive, the public was only too happy to spread her image. She was a popular subject for artists.

In appearance, the Jinjahime is eerily similar to an oar fish. One easily imagines Kato Ebian seeing one of these swimming offshore in the ocean and his imagination filling in the details. Except for the prophecy, of course. Oarfish are not known to be verbose.

Kudan Bovine Soothsayers

The farmer looked in horror at the thing that lay in his barn. The horror was not such much at the creature itself, but at what it meant. A time of trouble was coming. A Kudan had been born.

Kudan are bovine born with human faces. Usually bulls, Kudan are born from normal cows. Upon birth, they speak a prophecy and die. Whatever their prophecy, it is guaranteed to come true. Kudan are considered harbingers of societal upheaval.

> **Kudan** is written 件
> 件 (kudan) – Kudan
> The kanji for Kudan is a mix of that for humans (人) and cows (牛).

The origin of the word Kudan is unclear. The phrase "kudan no gotoshi," meaning "As the matter in question," appears as far back as the Heian period. It is used in Sei Shonagon's *The Pillow Book* (1002). During the Edo period it began to appear on credentials, permits, and legal contracts. "Kudan no gotoshi" would have been familiar to anyone who dealt with official documents. Some claim that this is meant to be "As certain as a Kudan" referring to the accuracy of Kudan prophecies. But more likely the creature was invented as a reference to cow + human characters that make up the word.

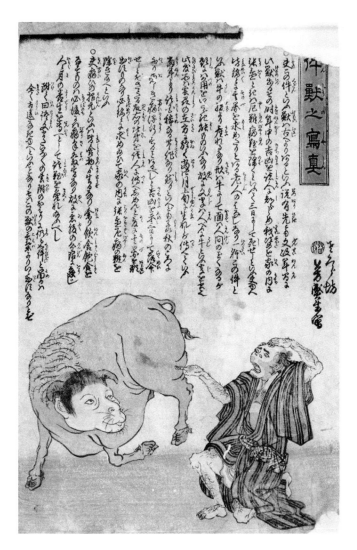

The oldest known mention of Kudan as a creature comes from *Mikkyoku Nichijo* (1819). A diary of a servant of the Hagi clan, it mostly records daily activities and political movements within the clan but occasionally notes rare and bizarre events. In 1800 it noted a strange beast called a Kaiju that washed up on the ocean. And in 1818, the diary writer mentions a rumor of a cow gave birth to a cow with a human face that spoke a prophecy. The creature said "I am three days old. Call me Kudan. Although I am freakish, do not kill me out of fear. Since my birth there will be seven years of bounty. But on the eighth year, war will break out." The diary writer finishes the entry with "I do not know if this is true."

Another creature, called Kutabe, made an appearance in 1827 on Mt. Tate. Some see this as a type of Kudan, but its body is more feline than bovine, with sharp claws.

Kudan next appears in 1836, towards the end of the Edo period. A *kawaraban* was published saying a Kudan had been discovered on Mount Kurahashi. It states that if you hang up a picture of the Kudan, your home shall flourish, misfortune shall be diverted, and a great bumper harvest is guaranteed. "Truly a propitious beast," the *kawaraban* proclaims. The *kawaraban* also says the last such magnificent monster appeared in 1705, recorded in an ancient document. No such document exists. Nothing particularly notable happened in Japan in 1705.

The Kudan legend spread rapidly from the 1835 *kawaraban*. There were copies made, including hand-drawn copies by people who wanted the magical protection of the Kudan but without wanting to pay the price of buying an official version. Kudan legends persisted well into the Meiji (1869–1912) and Showa periods (1926–1989). Lafcadio Hearn wrote about exhibits of Kudan mummies in *Glimpses of Unfamiliar Japan* (1894). One of the last known Kudan sightings was in 1943, when a Kudan born in a geta shop in Iwakuni predicted Japan would lose World War II. And a Kudan's prediction always comes true.

Amabie Bird–Fish Prophets

Out on the seas comes upon a strange vision. A three-finned half-fish person rises from the water and speaks a prediction; this year shall bring a great wealth of crops followed by a devastating plague. However, the fish creature says, show my picture to anyone stricken down by the disease and they shall be healed.

Amabie are a bird-fish chimera, with fish scales on a cylindrical body, a beaked mouth with diamond shaped eyes, and long flowing hair. Their three fins evoke the triple sword tail of Jinjahime. They are considered a species of mermaid, and are one of the Yogenju, the prophetic beasts of Japan. Amabie were obscure Yokai, all but forgotten until a resurgence during the Covid pandemic of 2020.

> **Amabie** is written **アマビエ**
> Amabie is thought to be a contraction of Amabiko (**海彦**) meaning "water boy."

There is only a single account of an Amabie. It appeared in the Edo period, in mid-May 1846, in Higo province, modern

肥後國海中ニ毎夜光物出ル所ニ役人行

足をづの如く浪頭札ノ海中ニ住アマビヱ中

者や當年より六ヶ年諸法豊年別ニ候

病流行すると写し人く見せ候へなると

申し海中へ参り有写し役人より江戸

中写し遣し也

弘化三年四月中旬

day Kumamoto period. Locals reported a strange, glowing light appearing in the sea each night. Finally, a government official was sent out on a boat to investigate.

When they arrived at the glow, a strange creature appeared. It spoke, saying "I am an Amabie, who lives in the sea. For six years hence crops will be abundant across all provinces. But a horrible plague shall spread. For those who succumb, show them my image as soon as possible and they will be cured." With that said, the creature sank back into the sea.

The official drew an illustration of what he saw, showing a chimeric creature with a bird's beak, fish scales, long hair, and three finned feet. The story and illustration were printed in *kawaraban* woodblock-printed broadsides and disseminated across Japan. There is no evidence that Amabie was distributed beyond this initial *kawaraban*. Unlike other Yogenju like Kudan and Jinjahime, there are no supporting artworks. A single copy of the initial *kawaraban* survived to the modern period, held by Kyoto University.

While the Amabie is the best known, there are multiple variations on the same story, some of them older. It has been suggested that the Amabie is a misheard or mistranscribed versions of earlier stories, mixed with mermaid legends. Folklorist Yamato Koichi identified seven variations of Amabie. Nagano Eishun later expanded this to nine.

No one really knows what sparked the proliferation of Amabie stories at the time. In 1846, Japan was still recovering from the Great Tenpo famine (1833–1837), the Fires of

Edo (1834), and the Sanriku earthquake (1835). These disasters were followed by political and societal instability that would lead to the end of the Edo period. Speculation is that the stories of disaster and salvation played on people's fears and made for a good sales pitch for *kawaraban* broadsides. Households would have not wanted to take the risk by not buying a picture of the Amabie when offered. As there was little contact between towns at the time, they would have been unaware of the other variations of the legend. Enterprising traveling salesmen could have encountered the stories and then concocted their own legends.

The modern resurgence of Amabie was sparked on January 30th, 2020, when a Mizuki Shigeru fan account posted about Amabie on the social media platform Twitter. The world was only beginning to understand that they were in the grips of a pandemic. Facing an uncertain future, people took solace in a forgotten Yokai whose promise of protection still held. Amabie posts began to be shared and on March 6th, 2020, Kyoto University Library posed an image of the 1846 *kawaraban*. On March 17th, the family of Mizuki Shigeru posted his version of the Yokai. From there, Japan's artists' imagination was sparked and images of the healing Yokai began to spread across the internet. Soon, the world joined in and Amabie became the most famous Yokai of modern times.

Mikoshi Nyudo Towering Monks

Walking along a mountain path, you encounter a monk on pilgrimage. The monk is very tall, and as you look up at him, he grows taller and taller. Soon, he looms over you like a giant. Unable to look away, you fall flat on your back, now staring at the massive monster reaching to the sky. The foot of the Mikoshi Nyudo lifts to stomp you flat.

Mikoshi Nyudo appear as Buddhist monks or priests, usually bald headed but sometimes described as having hair. Their robes are usually tattered. And they are tall. The normal reaction to a tall person is to look up at them. But if you look up at a Mikoshi Nyudo they will grow to impossible heights. And usually kill you. But if you look down instead of up, you can turn the tables and shrink them down. So, if you encounter a tall monk walking down a lonely road in Japan, cast your eyes downward.

> **Mikoshi Nyudo** is written 見越し入道
> 見越し (mikoshi) – looking over (e.g. a fence)
> 入道 (nyudo) - priest

As with Yokai named bozu, the *"nyudo"* part of Mikoshi Nyudo has no particular religious associations. During the Edo period, classes and traveling were highly restricted. Most were not permitted to leave their hometown and posted waypoints on the road rigorously checked passports to make sure everyone stayed put. Itinerant monks were one of the few classes allowed free travel. They were often the only unfamiliar faces who ever wandered into town. Many Yokai have nyudo as part of their name.

Mikoshi Nyudo appeared in *Wakan Sansai Zue* (1712), described as 20 feet (6 meters) tall, with dark complexion and red eyes, and yellow hair. The accompanying illustration shows Mikoshi Nyudo in their usual bald state. They seem to have been a well-known Yokai, and there are myriad regional variations with different names. Sometimes known as Miage Nyudo (looking-up priest), in Tottori they are called Shikadaidaka (depends on height), in other places they are called Taka Nyudo (tall priest) or Taka Bozu (tall monk). Some offer a chant you can use to protect yourself, such as saying "I have seen past the Mikoshi Nyudo!" or simply "I saw past you." Usually these involve keeping your cool and summoning up your courage in the face of a dangerous Yokai. In one legend, you have to calmly walk by smoking tobacco as if nothing of amazement happened.

In *Enka Kidan* (1773), Nishimura Hakucho says Mikoshi Nyudo is a plague spirit called Yakubyogami. An encounter with him resulted in fever and death. *Bakemono Shiuchi Hyobanki* (1779), by artist Koikawa Harumachi declared

Mikoshi Nyudo (top left) from the *Hyakkai Zukan*, an early Edo period Yokai scroll. (1737) Sawaki Sushi.

Mikoshi Nyudo (top right) from the *Kaidan Ektoba* scroll profiling thirty-three Yokai and human oddities from Japan and overseas. This Mikoshi Nyudo was encountered by a peasant late at night in Naka, Fukuoka. (mid-19th century) Artist unknown.

Mikoshi Nyudo to be the supreme commander of Yokai. His wife was the Yokai Rokurokubi and their child was Tofu Kozo. In other stories, Mikoshi Nyudo are not portrayed as individual Yokai at all, but merely Henge Yokai like Kitsune, Tanuki, and Mujina up to their usual tricks.

Artists over time portrayed Mikoshi Nyudo as having a long neck instead of growing tall. In *Hyakkai Zukan* (1737) by Sawaki Sushi, he is a large, bald man with swirling eyes. Toriyama Sekien portrays him as a somewhat lumbering, hairy man with an extended neck in *Gazu Hyakki Yagyo* (1776). This was unusual for Sekien to depart so much from Sawaki's designs. In *Tanomian Bakemono no Majiwari* (1796), artist Ikku Jippensha portrayed Mikoshi Nyudo has having a long, elastic neck, like the male version of a Rokurokubi.

Mikoshi Nyudo from *Gazu Hyakki Yagyo.* (1776) Toriyama Sekien.

Rokurokubi Long-necked Women

The woman sleeping next to you at the inn looks innocent enough. She slumbers peacefully, but something about her makes you wary to fall asleep. Lying on your futon, keeping one eye open, you see her stir, her head rising from her pillow. Terrifyingly, her body remains prone. You watch in horror as her neck extends like a snake. Then you realize you share a bedroom with a Yokai woman called Rokurokubi.

Rokurokubi are normal seeming women until they stretch out their necks. By many accounts, this happens when they sleep. The women may be unaware of their Yokai nature. Later stories present the Rokurokubi as entirely Yokai, a beautiful woman with her head languidly stretched on an impossible neck, casually smoking a *kiseru* pipe.

Rokurokubi is written ろくろ首
ろくろ (rokuro) – potter's wheel
首 (kubi) - neck

The *"rokuro"* part of the Rokurokubi's name is a bit of a mystery. Most assume it is a reference to a lathe or a potter's wheel. Traditional Japanese's potter's wheels were a long, thin spindle turned by a crank. It is this spindle thought to inspire the Rokurokubi's name. Another possibility is a reference to the long ropes of clay that are spun off the wheel. Other thoughts are umbrella handles, which elongate on opening.

Rokurokubi appeared during the Edo period. It is generally agreed they are an evolution of another Yokai, Nukekubi, whose head can detach entirely. In some stories when the Nukekubi head detaches, it trails a long thread, like the string on a balloon. Over time, pictures of the Nukekubi with the string attached to its body were misinterpreted as a long, skinny neck. New legends emerged of women whose necks stretched, and thus a new Yokai was born.

Rokurokubi were originally described as a condition affecting sleeping women. In *Tosei Buya Zokuden* (1756), author Baba Bunko wrote that women's necks sometimes unconsciously stretched as they slept. In *Kanden Koshitsu* (1801), by *kokugaku* scholar Ban Kokei and illustrated by Nagon Tanaka, there is a story of a geisha whose neck stretched at night, "dropping one foot from her pillow." This was attributed to sleeping relaxing the mind which stretches the neck. Still others cited the usual suspects of karmic retribution and divine punishment.

By contrast, in *Bakemono Shiuchi Hyobanki* (1779), artist Koikawa Harumachi claimed Rokurokubi was the wife of Mikoshi Nyudo, supreme commander of Yokai. Together they had a child, Tofu Kozo.

The image of Rokurokubi as an independent Yokai was largely driven by artists who found her a fascinating subject.

In *Gazu Hyakki Yagyo* (1776), Toriyama Sekien portrayed her as an elegant woman of fashion, casually reaching for a comb to fix her hair as her head floated above a folding screen. In *Hokusai Manga* (1814) Katsushika Hokusai showed her also as an elegant woman, lounging on her cushions while her head smoked a *kiseru* pipe, the smoke drifting far away from her body. Edo and Meiji period performers also created illusions of Rokurokubi, using stage magic to show a woman whose neck stretched dramatically, presenting her a real life Yokai. Film magic was equally fascinated with Rokurokubi. She became a major character in the *Yokai Monsters* (1968–1969) film series directed by Yasuda Kimiyoshi and Kuroda Yoshiyuki.

Rokurokubi (above) from *Gazu Hyakki Yagyo*, the first of Toriyama Sekien's Edo period Yokai collections. (1776) Toriyama Sekien.

Rokurokubi acting as kaishaku (facing page) for a Kitsune's seppuku ritual suicide. (2013) Image courtesy Eleonora D'Onofrio.

Nukekubi Headless Women

The woman sleeping next to you at the inn looks innocent enough. She slumbers peacefully, but something about her makes you wary to fall asleep. Lying on your futon, keeping one eye open, you see her stir, her head rising from her pillow. Terrifyingly, her body remains prone. You watch in horror as her head detaches from her body and starts to fly around the room Then you realize you share a bedroom with a Yokai woman called Nukekubi.

Nukekubi are older versions of Rokurokubi, whose heads entirely detach from their bodies. As with Rokurokubi, this often happens when asleep. The woman may not even be aware of the nocturnal activity of her head. Sometimes the head is described as attacking victims and even drinking their blood. Some stories say moving the body of a Nukekubi prevents the head from returning by daytime and destroys the Yokai.

> **Nukekubi** is written 抜け首
> 抜け (nuke) – come loose
> 首 (kubi) - neck

Nukekubi are a manifestation of the belief that a soul can escape from a sleeping body. This is a form of somnambulism. The next morning, the actions of their head are attributed to bad dreams. Nukekubi is treated as an illness afflicting the innocent rather than an independent Yokai. In older stories,

Nukekubi from *Sorori Monogatari*, where a woman whose "wrong thinking" causes her head to fly off at night. (1660) Artist unknown.

both Rokurokubi and Nukekubi are used interchangeably. Rokurokubi only became established as a separate Yokai in the middle Edo period.

Tales of Nukekubi most likely originated from the Chinese fēi tóu mán, whose head flies freely separated from its body. There are several Chinese folktales of women whose heads separate from their sleeping bodies. There are similar stories across all of Asia, such as the penanggalan of Malaysia and kurasue of Thailand. One of the oldest Japanese Nukekubi stories comes from *Sorori Monogatari* (1663). The story is based on Buddhist thought. A woman's "wrong thinking," meaning a Buddhist idea of having convictions based on incorrect ideas, causes her head to detach from her body at night. This is typical of early Yokai stories when needed to have a Buddhist moral to pass censors. But the stories also needed to be entertaining. The woman's husband sees her head transform into a chicken. He chases it with a sword, but the head flees. The next morning, his wife talks of a terrible dream of being chased through the house by a man with a sword.

Other stories followed this pattern. *Shokoku Hyaku Monogatari* (1677) adds that the Nukekubi manifestation was due to shame over a crime the woman committed. She later repented, shaved her head, and committed suicide. *Kokon Hyaku Monogatari Hyoban* (1668) adds the detail that the flying head had a thin cord attached to the body, like a string on a balloon. This can be found in illustrations such as Nukekubi in *Bakemono no e* (17th or early 18th century). The string eventually was drawn as a neck, which eventually separated into a unique Yokai, the Rokurokubi,

Perhaps the most famous Nukekubi story was written by Lafcadio Hearn in his book *Kwaidan: Studies and Stories of Strange Things* (1904). Although titled *Rokurokubi*, it tells the story of an encounter between vassal Isogai Heidazaemon Taketsura and four Nukekubi in a woodcutter's cottage. At night, their heads detach, and they try to eat Isogai, but the quick-thinking warrior moves their bodies, so they are unable to return. This story was adapted by Mike Mignola into his comic *Hellboy* as the story *Heads* (1998).

Yuki Onna Snow Women

Seeing the firelight dance over the face of your wife, you are reminded of something that happened in your youth. Reminiscing, you tell her of an encounter with a supernatural creature on a snowy night in the forest, who let you live if you promised to never tell a soul. Finishing, you stare in terror as your wife's face changes before your eyes. Enraged, she rises before you, asking how dare you break your promise? Only then do you realize who your wife is. You married that same Yuki Onna.

Yuki Onna have snow-white skin and a white kimono, usually described as a thin, summer kimono far too light for the cold weather. There is no single story of Yuki Onna. They are one of Japan's most well-known and yet unknown Yokai. Yuki Onna are as ephemeral as a windblown mist of snow, and as impossible to hold.

> **Yuki Onna** is written 雪女
> 雪 (yuki) – snow
> 女 (onna) - woman

Not surprisingly, most Yuki Onna tales come from Tohoku and Japan's frozen north. However, they are not restricted to those areas. Yuki Onna appear as far south as Ehime, Tottori, Nara, and Toyama Prefectures. There are few Prefectures in Japan without at least one Yuki Onna story—except maybe Okinawa (and, strangely, Hokkaido).

The oldest known Yuki Onna tale comes from *Sogi Shokoku Monogatari* (1685). Written by Rakushita Ryokan, *Sogi Shokoku Monogatari* features Muromachi renga poet Sogi as the main character. It says Sogi went out one snowy morning and saw a beautiful woman. She was huge; almost 10 feet tall, with skin whiter than any human being. Although her face was young and beautiful, her hair was stark white and hung loosely about her shoulders. Her kimono was white to the point of being translucent and was made of some magical gossamer fabric that clung to her body. Sogi attempted to speak to her, but she vanished into the snow. Discussing the vision with a friend native to the region, Sogi was told that she was the Spirit of Snow (Yuki no Seirei). She normally appeared during heavy snowfall. Appearing at the cusp of spring was rare.

Because it is written as a first-hand account, some claim this shows Yuki Onna legends stretching back to the Muromachi period (1336–1573). But in fact, there are no records of Yuki Onna prior to the Edo period (1603–1867).

However, from the Edo period, there are more stories of the Yuki Onna than it would be possible to tell. Many are so different it seems they are talking about completely different Yokai. In one, Yuki Onna goes from house to house asking for water. If you give her hot water, she melts. If you give her cold water, she swells in size. In another, Yuki Onna is a princess from the Moon who came to earth. Unable to return, she pines for her old home on snowy nights. In tales from Nigata, Yuki Onna haunts snowy forests looking to feed. She freezes her victims, then sucks their souls through their mouths. She prefers the souls of children and more—hundreds more.

But the variation that most know—in Japan or elsewhere—comes from Lafcadio Hearn's book *Kwaidan: Stories and Studies of Strange Things* (1904).

In Hearn's story, two woodcutters—a father and son—were trapped in the forest when a sudden blizzard arose. They took shelter in an abandoned cabin. In the middle of the night, the son awoke when the door banged open, and an ethereally beautiful woman came in from the blizzard. The woman crept over the father and blew her breath on him, then sucked up his soul. As she turned to do the same to the son, she paused. Captivated by his youth and beauty, the Yuki Onna said she would let him live, but only on the condition that he never speak of this night. The following winter, the young man met a beautiful woman traveler. Offering her refuge from the elements, the woman accepted. They quickly fell in love. She married the young man, and they lived happily for years and had several children.

Yuki Onna from the *Bakemono no e* scroll illustrating various kinds of Yokai. (17th or 18th century) Artist unknown.

One night, the man looked up at his wife and a memory surfaced that he hadn't thought about in years. He told her of his encounter with the snow spirit years ago. The smile fell from his wife's face, as she revealed herself to be that very same Yuki Onna. She was livid that her husband had broken her promise and would have killed him there were it not for the children. She left instantly, leaving the husband behind with regret and sorrow.

No one knows exactly where Hearn got this version of the Yuki Onna tale. People have searched for years but are unable to find the original. According to Hearn's preface, it was taught to him by a local man. Researchers tracked that down to potential candidates, a father and daughter who worked as servants in Hearn's house in Tokyo. However, Hearn

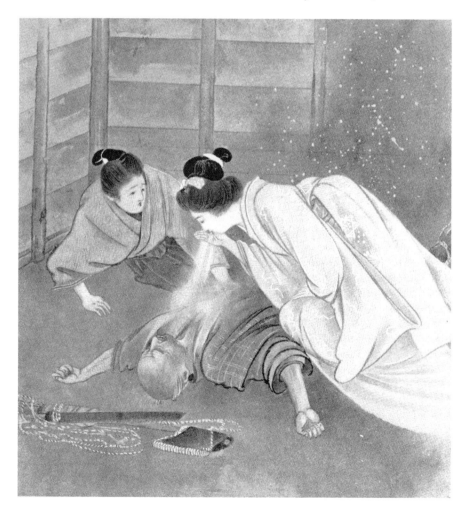

embellished whatever tale he was told. He never faithfully recorded stories and worked them into something he thought was better. There is no way of knowing what portions are original, and what are additions.

Ever since Hearn published his version, it superseded all other versions of the Yuki Onna. No more Moon princesses or water beggars. With Hearn's story there was a marked shift to a different kind of Yuki Onna story, one that blended romance with loss and melancholy.

Ushi Oni Ox-spider Demons

Standing on the shore, you see two massive horns breaking the surface of the waves. This is soon followed by six spindly spider legs and a massive black body. Last of all emerges the head of a dread bull. Gripping your sword, you stand to defy the monster, the brutal Ushi Oni.

Ushi Oni is a general name for many monsters across Japan. They can be creatures of the forest or the ocean. Often, they are a mix of traits, such as an ox head on whale's body, or an ox body with an Oni head. The most common appearance is an ox head on a giant spider body. Ushi Oni are the boss level monster of several samurai adventure tales. The slaying of an Ushi Oni marks a true hero.

Ushi Oni (bottom) is shown with the body of a spider in this modern illustration. (2011) Image courtesy Roberta Mašidlauskytė.

Ushi Oni (facing page) from *Gazu Hyakki Yagyo*. Sekien's version lacks the spider legs. (1776) Toriyama Sekien.

> **Ushi Oni** is written 牛鬼
> 牛 (ushi) – cow
> 鬼 (oni) - oni

Oxen have supernatural qualities in Japan, although rarely as shape changers like the Henge Yokai. The association is with the Hour of the Ox, between 1–3 A.M. in the ancient method of counting time in Japan. The Hour of the Ox is the traditional Witching Hour in Japan, a time when Yurei and Yokai and other evil spirits come haunting. In Onmyodo, the court geomancy of the Heian period, the most inauspicious direction was Ox-Tiger, called ush-itora. Oni and other negative forces entered from that direction.

One of the oldest mentions of Ushi Oni comes from *The Pillow Book* (1002). Author Sei Shonagon compiled lists, and Ushi Oni appears on her list of Fearful Things. She says it is far

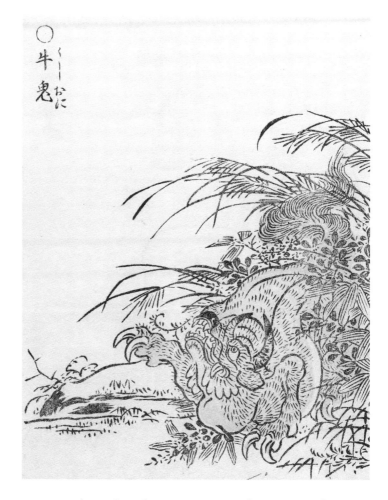

more terrifying than the name suggests but gives no further explanation. In *Azuma Kagami* (1266), there's a story of an ox suddenly appearing at Senso-ji temple in Edo. Twenty-four monks fell ill and seven died by being in its presence. Many stories of Ushi Oni follow this trait. The Ushi Oni is a type of Yakubyogami, a bringer of disease that kills those it encounters. In the epic *Taiheiki* (14th century), the great hero Minamoto no Yorimitsu faces off against an Ushi Oni. Yorimitsu would later kill the Oni king Shuten-doji and was quite the monster slayer in his time.

Ushi Oni tales vary wildly by location. In Ehime Prefecture they have the head of an ox and the body of a whale. In the Yoshida Matsuri festival, there is a huge Ushi Oni costume manned by ten or more people to march in a parade. In Wakayama Prefecture, a waterfall empties into the Wado river,

Ushi Oni (right) from the *Bakemono no e* scroll. (17th or 18th century) Artist unknown.

Statue of a bear-like Ushi Oni (bottom) at Neko-ji, Takamatsu city, Kagawa Prefecture. Local legend says the archer Yamada Takakiyo killed an Ushi Oni here during the Edo period. The horns of the monster are still on display. (2021) Dokudami/Wikimedia Commons.

it was said an Ushi Oni lived there. If it licked your shadow, you would fall ill and die, but it could be placated by offerings of booze. They were said to have catlike bodies that moved without sound. In Okayama Prefecture, they call it gyuki and say that it is a spirit that possesses people. Yanagita Kunio cites this as a former mountain god who devolved into a Yokai.

Ushi Oni have the unusual trait of partnering with another Yokai. In some stories, they pair with Nureonna, a woman who walks along beaches and asks strangers to hold her baby. Holding her baby—which is not a baby at all—freezes you to the spot. The Ushi Oni then emerges from the ocean to kill, and the two split the feast.

Sawaki Sushi painted Ushi Oni in *Hyakki Zukan* (1773) as an oxen head crowned with dual horns on a spider-like body. Its legs are boned spikes. It is thought this was inspired by earlier illustrations of Tsuchigumo, another monster slain by the busy Minamoto no Yorimitsu. *Bakemono no e* (17th or early 18th century) shows both Tsuchigumo and Ushi Oni looking almost identical, with the key difference three eyes on Tsuchigumo. Toriyama Sekien's Ushi Oni in *Gazu Hyakki Yagyo* (1776) shows an oxen head on a cat's body, inspired by the Wado river legends.

Mizuki Shigeru solidified the Ushi Oni's appearance as an antagonist in the story *Gyuki* (1968) in his comic *Kitaro*. Mizuki mixed the *gyuki* curse with the spidery Ushi Oni. This was made into an animated story in 1972 and has remained the prominent version of Ushi Oni ever since.

Chapter 2

Amefuri Kozo Rainy Children

Walking down a dry street without a cloud in the sky, you are confused at being hit by sudden rain drops. In moments, it is pouring rain. You see a small boy with a bamboo umbrella for a hat rushing by as if on some errand. When he passes, the rain passes with him. It is then you realize you had an encounter with Amefuri Kozo.

Amefuri Kozo is a small, childlike Yokai who wears an oversized bamboo umbrella for a hat. More than just a hat, it covers most of his body with his face sticking through an opening. He carries a little lantern and wears tall geta sandals. As his name foretells, he makes it rain.

Amefuri Kozo is written 雨降小僧
雨降 (amefuri) – falling rain
小僧 (kozo) – young boy

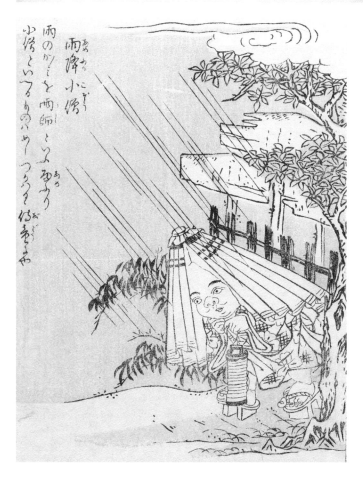

Amefuri Kozo, with his umbrella hat, is sheltered from the rain. From *Konjaku Gazu Zoku Hyakki.* (1779) Toriyama Sekien.

Amefuri Kozo are one of three messenger Yokai, along with Hitotsume Kozo and Tofu Kozo. They are sometimes illustrated as the same Yokai, with some illustrations of Amefuri Kozo and Tofu Kozo having a single eye like the hitotsume kozo.

Amefuri Kozo first appear in Toriyama Sekien's *Konjaku Gazu Zoku Hyakki* (1779). It is unknown if he is an original creation of Sekien. The entry describes Amefuri Kozo as a servant of Yǔ shī, an ancient Chinese god of rain. One of Sekien's students, Utagawa Toyokuni, illustrated Amefuri Kozo in *Gozonji no Bakemono* (1792), saying that on rainy nights Amefuri Kozo pass by carrying something in their hands. Like Tofu Kozo, the large bamboo hats leave their hands free to run errands in the rain.

Modern Yokai stories expanded on Amefuri Kozo, treating him as a mischievous prankster who delights in raining on people hoping for sunny skies. In *Tohoku Kaidan no Tabi* (1974), novelist Yamada Norio has Amefuri Kozo responsible for the rain during Kitsune weddings.

A one-eyed Amefuri Kozo from the book *Gozonji no Bakemono.* (1792) Utagawa Toyokuni.

Tenjoname Ceiling Lickers

Coming out into your living room on a cold winter morning, you see streaks of grime on your ceiling. Sighing, you get out the stepladder and cleaning bucket. It looks like you've had another visit from the Tenjoname.

Tenjoname are strange looking creatures with mottled bodies and long tongues. For unknown reasons, they sneak into houses at night and lick ceilings as their name implies. But their filthy tongues dirty the ceiling instead of cleaning it.

> **Tenjoname** is written 天井嘗
> 天井 (tenjo) – ceiling
> 嘗 (name) – licker

Old Japanese houses often have high ceilings that allowed smoke to gather from central cooking fires. In winter, moisture and dust would gather. Sometimes this would stain the rafters and even the pillars and walls. These marks were said to be the work of Tenjoname.

Tenjoname were created by Toriyama Sekien in *Gazu Hyakki Tsurezure Bukuro* (1781). He referenced a line from the classic work *Tsurezuregusa* (1332), which says high ceilings in winter are cold and dark. Sekien says this coldness and darkness are caused by Tenjoname.

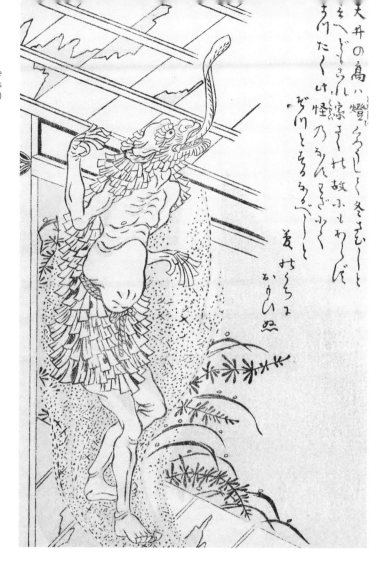

Tenjoname from *Gazu Hyakki Tsurezure Bukuro.* This is Sekien's original creation. (1781) Toriyama Sekien.

The visual design was taken by a Yokai that appeared in *Hyakki Yagyo Emaki* pictures scrolls from the Muromachi period (1336–1573). This blue creature running frantically with its tongue sticking out actually spawned two Yokai. Toriyama Sekien used it to create the Tenjoname, and another anonymous artist labeled it isogashi in an Edo period copy of *Hyakumonogatari Emaki* (1780). Other artists used both creations, and Isogashi and Tenjoname entered the Yokai pantheon.

As with most Sekien creations, people continued to expand the Tenjoname and add to their story. Folklorist Fujisawa Eihiko recorded a later tale from Tatebayashi castle, where it said they captured a Tenjoname to help with the cleaning.

Futakuchi Onna (top left), forever hungry, enjoys an ice cream cone from the Modern Yokai Series. (2020) Image courtesy Lili Chin.

Futakuchi Onna (top right) attacks a man eating dinner. (2011) Image courtesy Roberta Mašidlauskytė.

Futakuchi Onna Two-mouthed Women

The woodcutter's new wife was perfect. Beautiful. Charming. And never ate more than a few grains of rice. The mystery was where all his rice was going? One day he decided to spy on her and found horror beyond expectations. His dainty wife was sitting before bales of rice, her snakelike hair feeding her second mouth hidden in her head. In shock, he realized he had married a Futakuchi Onna.

Futakuchi Onna look like regular women until their secret gets out. They have a second mouth hidden in the back of their heads. Their long hair is able to feed this second mouth, which gorges on shocking amounts of food.

> **Futakuchi Onna** is written 二口女
> 二 (futa) – two
> 口 (kuchi) – mouth
> 女 (onna) - woman

Futakuchi Onna are one of various magical wife tales in Japanese folklore. Most of these involve a human married to a Henge Yokai, like a Kitsune, or a crane, taking human guise. These wives are usually perfect and wonderful, and all the husbands must do is respect their privacy. But inevitably the husband can't resist and breaks his promise, destroying his own happiness. Futakuchi Onna is a clever twist on these tales. A wife who doesn't eat and doesn't need the expense of food sounds like a dream to a poor peasant. However, in this case when the husband peaks the dream becomes a nightmare.

Futakuchi Onna first appear in *Ehon Hyaku Monogatari* (1841). Created by artist Takehara Shunsensai, the book was

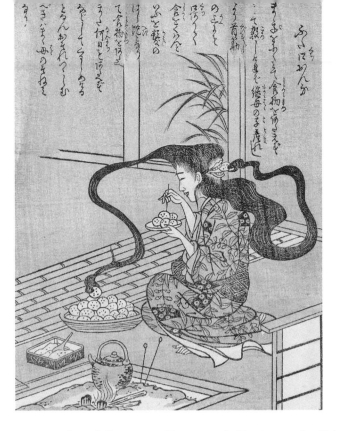

A Futakuchi Onna eating from both sides of her head. From *Ehon Hyaku Monogatari.* (1841) Takehara Shunsensai.

meant to be a follow-up to Toriyama Sekien's popular Yokai books. Like Sekien, Takehara took some popular stories and legends and created art for them. The Futakuchi Onna illustration is a classic image of a two-mouthed woman tucking into a giant plate of rice, eating both from the front and back. Her snakelike hair grasps balls of rice to feed. The story, oddly enough, does not connect with the image. It tells of a woman who married a woodcutter with a daughter. The woman also had a child, and neglected her stepdaughter, ultimately starving her to death. One day the woodsman accidentally cut his new wife in the back of the head with his ax. The axe wound split into a mouth, which confessed the guilt at killing the stepdaughter.

The more common Futakuchi Onna story is actually a completely different tale later connected to Takehara's image. The story "The Wife who Didn't Eat" is a folktale found all over Japan. The story is the familiar tale of a perfect wife who works hard and doesn't eat. Suspicious, the man's mother spies on this amazing wife. The mother-in-law sees the woman feasting her second mouth. The truth revealed, the wife reveals herself as a Yamauba or transformed animal like a spider, and then flees into the mountains.

Umashika Ridiculous Creatures

What are you even looking at? There's no way to tell. But whatever it is, it sure is stupid. That's the Umashika.

Umashika are twisted creatures, with a single eye popping from their heads, a single horn, a long face, and entirely unworkable arms and legs. They look ridiculous, which is exactly the point.

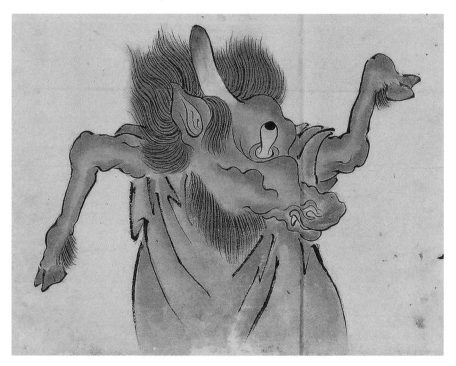

Umashika is written 馬鹿
馬 (uma) – horse
鹿 (shika) – deer

The characters used for Umashika have an alternate pronunciation, *baka*, which is an insulting term in Japanese meaning "stupid." Umashika can also be pronounced Mumashika.

Not all Yokai have fascinating stories. Some are just artists messing around. These emakimono Yokai have only names and images, usually combining amusing bodies with pun-based names. They are essentially visual gags.

That's the case with Umashika. First appearing in Oda Gozumi's *Hyakumonogatari Emaki* (1780) Umashika was just a picture and a name. Oda's painted scroll had 58 Yokai,

Umashika from *Bakemono Zukushi* showing a visual pun of the word "idiot" in Japanese, imaging a horse mashed with a deer. (18th century) Artist unknown.

nearly double those in precursor Sawaki Sushi's *Hyakki Zukan* (1737). In order to fill out the ranks Oda probably created an abundance of new Yokai. Some of these were picked up by other artists.

We have no idea what Oda intended. Was Umashika supposed to be a personification of the kanji for baka, a twisted amalgam of a horse and a deer? Or was it a visual representation of what a stupid person was. Or was it just funny? We'll never know. Later writers added that Umashika was a type of tsukigami possessing Yokai that possessed people and made them act stupid.

Up until the 1990s, it was thought that *Hyakumonogatari Emaki* was the sole appearance of Umashika. However, other scrolls were discovered with their own versions of Umashika.

Konaki Jiji Weeping Old Men

Deep in the woods you hear the cry of a baby. Running towards the sound, you find an infant wailing in fear. As you bend to pick it up, you are horrified to see the baby has the face of a wrinkled old man. It stops crying and smiles. Getting heavier and heavier, you topple backwards as you are crushed under the weight of the Konaki Jiji.

Konaki Jiji look like babies, but when you get closer you see they have the faces of old men. Their attack is to be picked up, then suddenly increase their weight until they crush their kind helper to death.

Konaki Jiji is written 子泣き爺
子 (ko) – child
泣き (naki) – cry
爺 (jiji) – old man

Konaki Jiji is another famous Yokai that may not exist, at least not in a folkloric sense. Konaki Jiji was first recorded by Yanagita Kunio in his book *Yokai Dangi* (1954). He said that it could be seen on roads at night and looked like an old man that cried like a baby. When passersby picked up what they thought was a baby, Konaki Jiji would get heavier and heavier until he killed the good samaritan. Yanagita notes that there are several Yokai with similar stories, including Ubume and Obariyon. Konaki Jiji tales are said to come from the mountains of Tokushima Prefecture.

Tokushima historian Takita Masahiro researched these legends and concluded Konaki Jiji never existed. However, he did discover legends of a mountain creature that cries like a baby. Takita also found that there was supposedly an old man who lived in the region who cried like a baby. The villagers hated him and used him as a boogieman for scaring children. Parents would say that he would get them if they were bad. When Yanagita collected his legends, somehow these stories merged with the heavy baby motif of existing Yokai to form Konaki Jiji.

As with many of Yanagita Kunio's Yokai, there were no accompanying visuals. When Mizuki Shigeru used Yanagita's *Yokai Dangi* to create a cast of supporting characters in his comic *Kitaro*, he designed Konaki Jiji for the first time, drawing him in the red bib of another folkloric hero, Kintaro. Through *Kitaro*, Konaki Jiji became one of the best known Yokai in Japan, appearing in multiple Yokai books and encyclopedias referencing Yanagita's origin.

Nurikabe Invisible Walls

Wandering home late at night, you find your path blocked by a wall, a wall that shouldn't be there. You've walked this path a thousand times and never encountered a wall here before. You try to walk around it, but it never seems to end. With a sigh, you sit down and wait for daylight as you know you are trapped by the mysterious Nurikabe.

Nurikabe are theoretically invisible. They appear as walls in the dark that you cannot see and cannot go around. But if you could see them, they would appear either as a large, blocky grey wall with eyes, or a huge, noseless three-eyed elephant creature.

> **Nurikabe** is written 塗壁
> 塗 (nuri) – plastered
> 壁 (kabe) – wall

Nurikabe is one of the Yokai collected by folklorist Yanagita Kunio. It appears for the first time in *Yokai Meibo* (1932), a glossary of Yokai with brief descriptions. He describes Nurikabe as found on the coast of Onga in Fukuoka Prefecture, He says that if you take a stick and strike the base of the wall Nurikabe will disappear, but if you strike the top nothing happens. Yanagita notes that Nurikabe is feared.

Similar tales appear in Kyushu and other places. Often they are described as the work of trickster Henge Yokai. In Oita Prefecture they are called Tanuki Nurikabe and are described as Tanuki playing tricks with luckless travelers.

Nurikabe illustration discovered in 2007 in the *Bakemono no e*. Until then, it was thought there was no surviving period illustration of this Yokai. (17th or 18th century) Artist unknown.

As with all of Yanagita Kunio's Yokai there were no visual records. As with Sunakake Baba and Konaki Jiji, Mizuki Shigeru designed Nurikabe using Yanagita's stories to create a cast of supporting characters in his comic *Kitaro*. This became the default appearance of Nurikabe for decades. Then in 2007 a new Yokai scroll was discovered, the *Bakemono no e* (17th or early 18th century). On it was a strange, white elephant shaped creature with three eyes and no nose clearly labeled Nurikabe. This creature had appeared on other scrolls unnamed, but it was only now its true identity was known. There is some debate among researchers as to whether this is the same Nurikabe as collected by Yanagita Kunio. The name could be a coincidence or signifying another unknown Yokai with the same name.

Nurikabe have the rare distinction of a true-life encounter recorded in modern times. During World War II, when Mizuki Shigeru was stationed on the isle of Rabaul, he claims to have encountered a Nurikabe walking through the jungle one night. Terrified and on the run from enemy troops, he smacked into a wall in the pitch-black night. Unable to find a way around he, he surrendered to

exhaustion and slept at the base of the wall. Waking up the next morning, he found himself on the edge of a cliff. There was no wall there, but only the existence of the wall had prevented him from running straight off the unseen cliff in the middle of the night.

Daidarabotchi Earth-moving Giants

You stare up at a giant so large as to defy impossibility. It towers above the mountains, blotting out the Sun. With hands large enough to squash entire villages, it casually scoops up a mountain and deposits it miles away. You have met the earth-moving giant, Daidarabotchi.

Daidarabotchi are the largest by far of the Yokai. They are large enough to pick up Mt. Fuji in their hands. Their footprints formed lakes across Japan. Daidarabotchi are a race of giants thought to have lived in ancient Japan and helped shaped the landscape as it exists today.

> **Daidarabotchi** is written **ダイダラボッチ**
> Yanagita Kunio speculated the name was a combination of *daitaro*, meaning "big taro" and *hoshi*, a term for Buddhist priests.

Daidarabotchi are known by many regional names. They can be Deidarabotchi or Dairabo or Reirabotchi or Okibochabocha or Onyudo or other variations. They form legends of prehistoric giants who raised the mountains and dug the lakes that formed the Japanese geography. Many of Japan's most famous geological features are attributed to the works of Daidarabotchi.

One of the oldest accounts comes from *Hitachi-no-kuni Fudoki* (8th century). The deity Yatsukamizu Omitsuno looks across the sea at Silla, modern day Korea, and finds his domain too small by comparison. So, he grabs a garden hoe and reaches across the Sea of Japan (East Sea) to hack a chunk of Silla off and drag it to his own domain of Izumo. Another story in the same book tells of a Daidarabotchi eating clams from the sea and piling them up to what is known to archeology as the Ogushi Shell Mound. This is a Jomon period (14,000–300 BCE) dump for domestic waste and is indeed made of discarded shells, bones, and other artifacts of daily life from the time. Located in Mito, Ibaraki Prefecture, to this day there is a massive statue of the supposed Daidarabotchi who made the mound.

Another ancient record, *Harima-no-kuni Fudoki* (8th century), tells of a Daidarabotchi who comes to Japan and likes it

A massive **Daidarabotchi** climbs over a mountain. (1790) Katsukawa Shunei.

because the sky is high enough for him to easily stand and walk. His footprints became lakes and swamps as he took a stroll.

There are many similar legends. The city of Koshu became a bay when huge chunks of earth were dug up from it to make Mt. Fuji. Or perhaps it was Lake Biwa, also said to have been excavated to build Japan's most sacred mountain.

Daidarabotchi are rarely illustrated, however artists Katsukawa Shunei and Katsukawa Shunsho included one in their Yokai collection *Imahamukashi* (1790). They call their illustration Onyudo, one of the many names for Daidarabotchi. This illustration was copied for *Rekkoku Kaidan Kigaki Zoshi* (1802) and has become the template for Daidarabotchi.

Many in modern times became familiar with Daidarabotchi from the film *Princess Mononoke* (1997). The deity of the forest has two forms; a sacred deer called shishigami during the day, and Daidarabotchi at night. In the film, Daidarabotchi was translated into English as Night-Walker.

YOKAIOLOGY
Densetsu no Seibutsu
Sacred Legendary Creatures

In the realms of the supernatural there are gods and monsters. And then there are those that are a little bit of both. Folklore is full of creatures that defy easy categorization. The line between folklore and religion is often a question of time and place. And devotion.

Japan has several sacred supernatural creatures. They are found at Shinto shrines and Buddhist temples and appear in rituals and festivals. Sacred creatures are guardians, healers, bestowers of wishes. Dictionaries define them as *densetsu no seibutsu*, or "legendary creatures." They can also be called *genju*, or "mythical beasts."

But are they Yokai?

As always, that depends on your interpretation. Researcher Orikuchi Shinobu makes a distinction between that which is worshiped (Kami) and unworshipped (Yokai). Yet there are shrines to Kitsune, Kappa, Tanuki, and Tengu across Japan. People pray at these shrines the same as they would at any other. People carry talismans of protection with an image of Amabie in the same way they would an image of a Baku.

When it comes to Yokai, you either narrow or broaden the definition. Inoue Enryo sought to narrow it, to draw a solid line between the sacred and the profane, between the true mysteries of religion and the invented creatures of folklore. Yanagita Kunio believed that line was blurred, and that modern monsters were gods of the past. Toriyama Sekien seemed to see little need for separation. His influential Yokai collections included deities like Amanozako alongside monsters like Ushi Oni. All Sekien required was for it to be mysterious—and sellable. Mizuki Shigeru takes

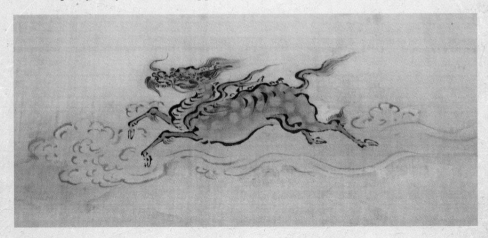

A Kirin flies among the clouds. (1666) Artist unknown.

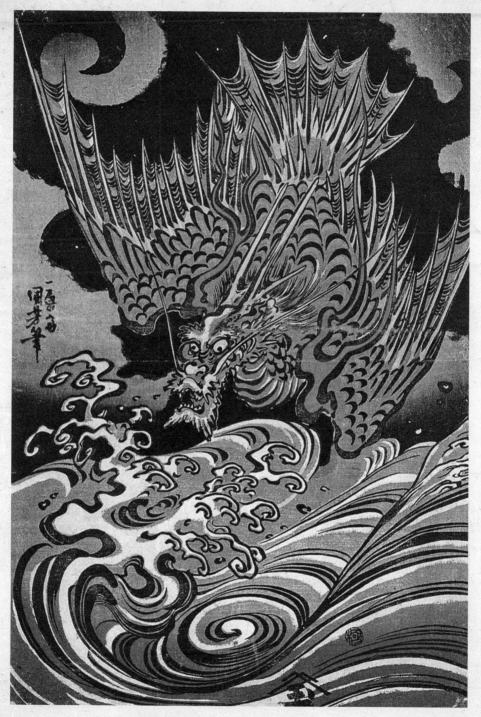

A dragon above a stormy sea. (1831?) Utagawa Kuniyoshi.

Kaibutsu Creatures

Yatagarasu leading Emperor Jinmu to his kingdom. (1891) Ginko Adachi.

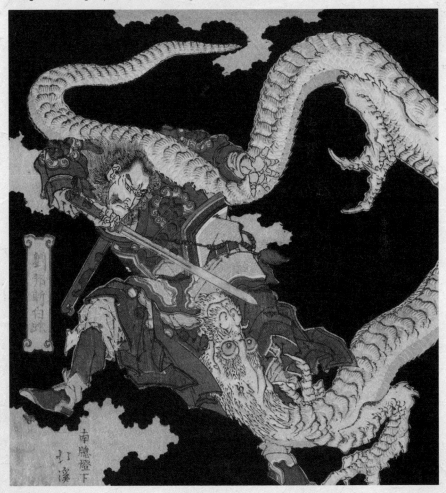

Ryuho (Liu Bang) battles a Hakuja. (1832) Totoya Hokkei.

the broadest approach in his Yokai collections. To Mizuki, it is all Yokai. How you define it is up to you.

Here's a few of these sacred creatures of legend:

Kirin – Called Qilin in Chinese, this auspicious, chimerical creature is said to appear at the imminent births or deaths of sages and illustrious rulers. They have bodies like oxen covered in scales, with cloven hooves, and a face like a Chinese dragon. They date to 11th–7th BCE first appearing in the Chinese poem *Chūnqiū*. Kirin became the word for giraffe in Japanese as well as the mascot for the popular Kirin beer.

Komainu – Sacred guardian lion-dogs that stand watch, repelling evil. Mostly found at Shinto shrines, they date back to the Nara period (710–794). Komainu are adapted from Chinese guardian lions that originated during the Tang dynasty (618–907).

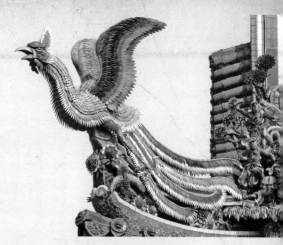

A Fenghuang (Hoo) at the Mengjia Longshan Temple in Taipei. (2011) Wikimedia Commons – Bernard Gagnon.

Yatagarasu – A three-legged crow that assisted Japan's legendary first emperor, Emperor Jinmu, to found his kingdom. The three legs stand for the Earth, the sky, and the people.

Ryu – Dragons. While dragons are found in mythologies across the Earth, Japanese dragons are generally aquatic, living in lakes or under the ocean. Ryugu-jo is the undersea palace of the dragon king Ryujin. They are similar to Chinese dragons, but where Chinese dragons have four to five claws, Japanese dragons have only three.

Hakuja – A white snake, sacred to the goddess Benzaiten. Snakes in general are thought to be auspicious and bring good luck and fortune.

Hoo – A type of phoenix, originating from China where it is called fenghuang. Hoo are a chimera made up of several kinds of animals including the back of a tortoise and the body of a mandarin duck. One of the most powerful of Japan's sacred creatures, it is a symbol of immortality and longevity. The temple Byodo-in in Uji city deifies the Hoo, with its famed Phoenix Hall.

A Komainu guards Ikuta Jinju shrine in Kobe. (2019) Ethan Doyle White/Wikimedia Commons.

Baku Dream Eaters

The young girl woke screaming. A terrifying nightmare, but she knew what to do. Hugging her face in her pillow, she whispered three times "Baku, I give you this dream. Baku. I give you this dream. Baku, I give you this dream."

Baku are classic chimera, the body of a bear, the nose of an elephant, the feet of a tiger, the tail of an ox, and the eyes of a rhinoceros. One legend says that when the gods were finished creating the animals, they took the odds and ends lying around and put them together to make the Baku. According to Japanese legend, Baku are eaters of bad dreams.

> **Baku** is written 獏
> 獏 (baku) baku, tapir

Baku are both mythological creatures and real animals. While wildly stylized, Baku resemble the Malayan tapir. In Japanese they share the same name. This association has its own strange history. In 1824, French sinologist Jean-Pierre Abel-Remusat mistakenly identified the newly discovered Malayan tapir by the Chinese name *mo*. In fact, *mo* was used for both the giant panda and the mythological Baku. The mistake entered scientific literature, forcing giant pandas to be renamed. And tapir have been Baku ever since.

Baku have been known in China since ancient times, although portrayed with some inconsistency. The oldest surviving Chinese dictionary, *Erh-ya* (3rd century BC), says Baku are like bears, with small heads, short legs, and black and white spots. They are said to eat copper and bamboo. This is a clear reference to giant pandas. *Bencao Gangmu* (1596) describes Baku as having an elephant's trunk, rhinoceros' eyes, cow's tail, and tiger's paws. This is a clear reference to tapir. But there are no tapir in China. Some speculate there was once an ancient species of tapir in mainland Asia, but no physical evidence supports this.

Whatever the animal, in China Baku pelts were said to be magical wards against illness and the malice of evil spirits. An image of Baku provided equal protection. Baku were popular decorations for folding screens based on their protective power. However, the Chinese Baku makes no mention of dreams. That is a Japanese addition.

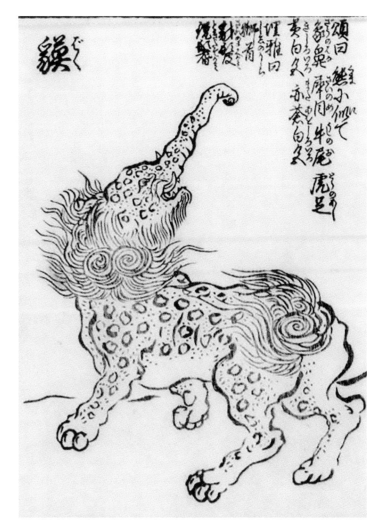

By the end of the Muromachi period (1336–1573), Baku were being used in Japan as talismans of protection. Baku appeared in *Kinmozui* (1666), the first Japanese encyclopedia and the *Wakan Sansai Zue* (1712). *Sankai Ibutsu* (17th century) describes Baku as living in the mountains to the south and eating only copper and iron. Sleeping on its pelt prevents pestilence, but if that is not possible sketching Baku protects you from evil. Its efficacy as a protective ward led to its incorporation into temple architecture as *kibana* from the from the 17th century, an honor they share with dragons and lions. Many *kibana* clearly use elephants as models.

A 1791 woodblock print describes a Baku as an eater of dreams. No one really knows how or when the association

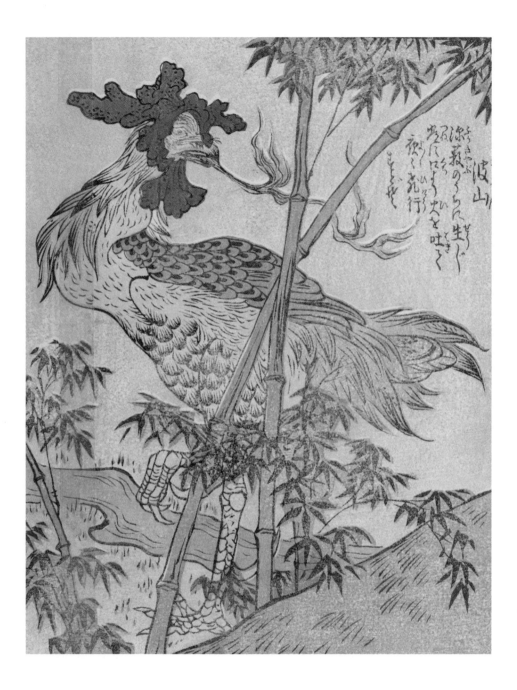

波山
　深きやぶ
　藪のうちに生じ
　　　　と
　をりふ
　るには必ず火を吐く
　　　いふ
　夜るにも光行
　　　　なり

with dreams began but it appears to have started during the Edo period. The Chinese book *Hou Hanshu* (5th century) speaks of a shrine maiden named Hakui who practiced dream divination and was said to be able to swallow nightmares. It is possible these legends blended to create the Baku. Whatever the case, Baku would become popular decorations for pillows. Baku also became associated with hatsu yume, the first dream of the new year. Japanese customs said your first dream of the year showed what fortune you would have, and sleeping with a picture of a Baku under your pillow was thought to ensure prosperity. Equally effective was a picture of the treasure ship of the Seven Lucky Gods, which had Baku written on its sail.

In *Kotto* (1902), Lafcadio Hearn wrote "The name of the creature is Baku, or Shirokinakatsukami; and its particular function is the eating of Dreams." In *Sandman: The Dream Hunters* (1999), comic writer Neil Gaiman and artist Yoshitaka Amano introduced Baku into their story of the dream king Morpheus.

Basan Fire-breathing Chickens

Walking through the forests you stumble upon a flock of chickens. It is very unusual, you think, for chickens to be out in nature like this. Then they open their mouths and start to breathe fire. You realize these are no ordinary chickens. These are Basan.

Basan are legendary birds from stories passed down in Ehime Prefecture. They are said to resemble chickens with bright crests. They breathe flame, but it is a cold flame without heat.

Basan is written 波山
波 (nami) wave
山 (san) mountain

Basan are mysterious creatures. They live in bamboo groves deep in the mountains and rarely appear in public. They are occasionally spotted in villages late at night, where the flapping of their wings makes an eerie, rustling sound. They are also called basa basa based on the sound of their wings. It's said that if someone hears their wings and goes to look, the Basan will disappear.

Wakan Sansai Zue (1712) has an entry for hikuidori, described as a chicken that eats wood left over from burning fires. It's thought this is the prototype for Basan. Takehara Shunsen illustrated Basan in *Ehon Hyaku Monogatari* (1841).

Nue Nightmarish Hybrids

The black cloud floated ominously overhead, slowly making its way towards the palace. Everyone looked in fear, then fear turned to terror when from the cloud emanated the sound of hyoo hyoo. The sound of the Nue was the sound of death.

One of Japan's most ancient folkloric beasts, Nue are chimeric monsters. Their bodies are usually described as having the head of a monkey, the torso of a Tanuki, the legs of a tiger, and a snake for a tail. In other accounts, they have the torso of a tiger, the legs of a Tanuki, the tail of a fox, and the head of a cat. In some versions, they even have the body of a chicken. Nue bodies are thought to symbolize animals in the Chinese Sexagenary cycle of directional magic. A snake represents southeast, a monkey for southwest, a Tanuki for northwest, and for the northeast, a tiger.

> **Nue** is written 鵺
> 鵺 (nue) scaly thrush

Whatever menagerie of beasts, Nue are shapeshifters and bringers of nightmares. They take the form of black clouds, floating overhead, issuing a mournful cry, and causing illness and bad dreams to all below. They are said to have the cry of the scaly thrush, a bird species with which they share a name. Hearing the cry of "hyoo hyoo" was said to be inauspicious. If you heard it, you should immediately head to a Temple to pray for protection. Early depictions identified them as "a monster who cried like a Nue." Eventually this was shortened to calling the Yokai itself Nue.

The oldest known account of Nue comes from *Heike Monogatari* (1330), a record of the Genpei Wars between the Taira and Minamoto clans. The story says that in 1153, Emperor Konoe fell ill and was tormented by nightmares. After all medicine and prayers failed, the emperor summoned the legendary samurai Minamoto no Yorimasa to help him. Sensing an evil spirit, Yorimasa stood guard at night. He heard the cry of a Nue bird and saw a black cloud over the palace. He shot an arrow into the cloud and slew the beast, its body dropping to the ground. Yorimasa placed the monster's body in a boat and floated it down the Kamo river to rid the emperor of its curse. Several villages say it floated ashore, and to this day there at least three burial mounds around Western Japan called Nuezuka, each claiming to house the true body of the Nue.

Zeami Motokiyo wrote the *noh* play *Nue* (16th century) based on *Heike Monogatari*. In the play, a traveling monk

Nue (facing page) from *Konjaku Hyakki Shui.* (1780) Toriyama Sekien.

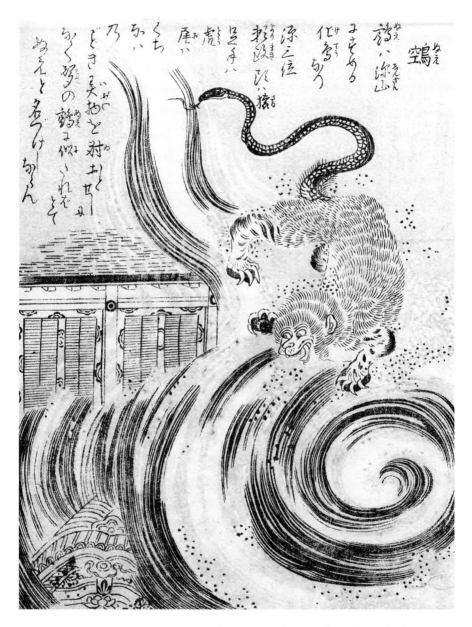

meets a mysterious boatman. The monk realizes the boatman
is not human, and he reveals himself to be the ghost of the
Nue. It tells his story of being slain and repents, asking the
monk to pray for its soul.

Toriyama Sekien illustrated Nue in *Konjaku Gazu Zoku
Hyakki* (1779). The fantastic body of Nue proved to be
irresistible to artists, and it became a popular topic for Edo

Kaibutsu Creatures

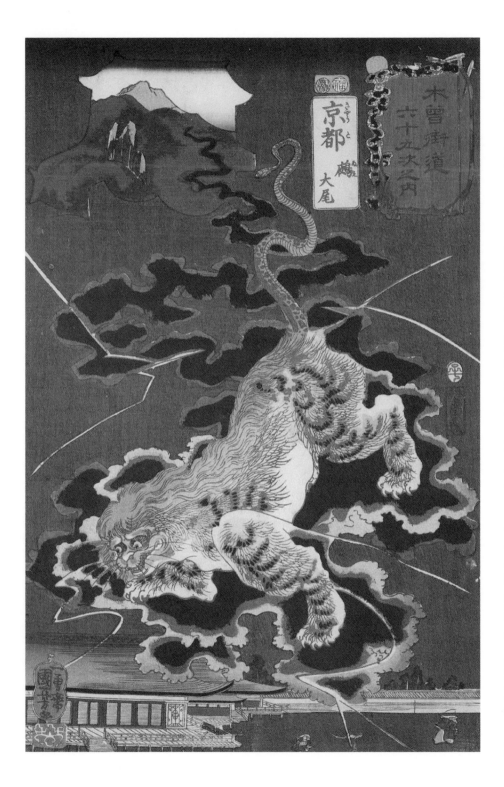

Chapter 2

period woodblock prints. Acclaimed artists such as Utagawa Kuniyoshi and Yoshitoshi Tsukioka all did illustrated versions of battles with Nue.

Nue took on a new role in the Meji period (1868–1912). Contact with the West brought new diseases, one of the most horrible of which was cholera. Nue was adopted as a physical representation of cholera and used in medical advertisements. The battle against cholera was personified as a battle against Nue.

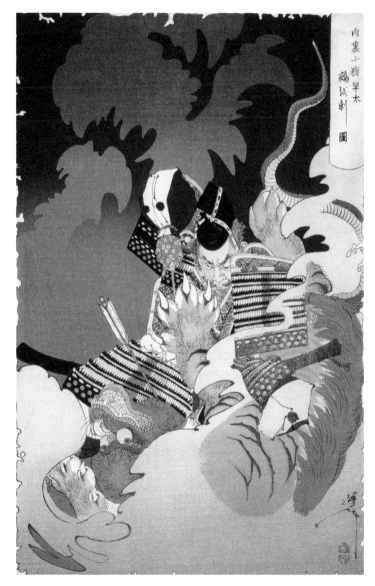

A Nue (facing page) attacks the imperial palace in a piece showing the famous sixty-nine stations along the kiso kaido as well as local legends and events from each. In the upper right, you can see the final station, the imperial capital of Kyoto, from which the Nue descends. (1852) Utagawa Kuniyoshi.

Yorimisa's servant Ino Hayata battles the Nue (right), from the series *New Forms of Thirty-Six Ghosts*, depicting famous Yokai stories. "Ino Hayata and the Nue." (1891) Tsukioka Yoshitoshi.

Hakutaku Wise Beasts

One the slope of a mountain you encounter the strangest creature you have ever seen–a cow's body with nine eyes and six horns with eyes running all along its body. The beast looks at you calmly, then with a bemused smile asks, "So what do you want to know?" You have found the Hakutaku, the wisest of all Yokai.

Hakutaku are mixed up beasts with a strange mix of body parts put together in no logical order. Sometimes it has the body of a lion, a human face, and sets of three eyes running down its flanks, with multiple horns on its head. Sometimes it is a cow body. Sometimes it has only one eye. There is very little agreement on what Hakutaku looks like. But there is agreement on what they know—everything.

Hakutaku painting at Dairyuji temple in Gifu. Said to have been painted by the Zen priest Hakuin when he visited the temple, and now designated as an Important Cultural Property of Japan. (1758?) Hakuin.

Hakutaku is written 白沢
白 (haku) white
沢 (taku) wetlands

黄帝東巡
白澤一見
避怪除害
靡所不徧
摸捫窩賛

白澤

Hakutaku are a type of auspicious beast. These were known
to appear only when the right conditions were met on earth
for a creature of such purity to manifest. Hakutaku are the
ultimate scholars of things supernatural. They speak human
language and know of the 11,520 types of Yokai as well as
how to defeat them all.

Hakutaku are Chinese in origin where they are known as
bai ze. Legends tell that Hakutaku only appear when the cur-
rent king is a virtuous ruler. One the Yellow Emperor or Huáng
Dì was doing an imperial tour of his lands. Climbing a moun-
tain to the east near the sea, he encounters a fabulous beast.
The Hakutaku offers to share information about all 11,520

Kaibutsu Creatures

types of Yokai with the emperor. The emperor listens and has his scribe write everything down in the greatest bestiary of all time, the Hakutaku-zu, or Book of the Hakutaku. Inside are all the causes of illness and natural disasters and how to prevent them. While the book itself is lost, fragments survive.

The story of Hakutaku mostly exists in supposed fragments of Hakutaku-zu. These date back at least to the Tang dynasty (618–907). A fragment was found among the Dunhuang manuscripts, discovered in the Mogao Caves of Dunhuang, China. No one knows exactly how old the legends are. Stories are told of those who read the book. A story is told of Zhuge Ke, governor of Danyang. Hunting in the mountains, a child-like monster appeared who reached up a hand to him. Without a moment's hesitation, Zhuge Ke grabbed the outstretched hand and pulled the creature from its place. It died immediately. The rest of his hunting party looked own with amazement, while Zhuge Ke said it was nothing incredible. He learned to defeat this creature by reading the Hakutaku-zu.

The Chinese Ming dynasty encyclopedia *Sancai Tuhui* (1609) has an entry on Hakutaku saying it appeared in Towangshan, Jiangsu Province. Its appearance is said to resemble a white lion. While the book itself was lost, images of Hakutaku were worn as talismans to ward off misfortune. Hakutaku was thought to have immense power. A picture of a Hakutaku is drawn on the cedar door leading to the shogun's seat at Nikko Shrine.

Toriyama Sekine illustrated Hakutaku in *Konjaku Gazu Hyakki Yagyo* (1781). His illustration bears little resemblance to previous pictures which look like a white lion with a human face. Sekien's depiction is the oldest known with the unusual feature of eyes running along the side of its body. Whether Sekien invented this or not is unknown.

Shirime Perverted Tricksters

Walking down the street at night, you see a stranger in front of you. Their bodies are strange, featureless, and grey. As you get closer, then lean over and spread their butt. When you see a giant eye staring back at you, you know you have met the Shirime.

Shirime are essentially a gross-out Yokai, but one where the joke is funny enough to have never gotten old over the years. Shirime are a variation of Nopperabo, Yokai who enjoy startling humans. But while Nopperabo have no face, Shirime have an eyeball in their butts.

A Shirime is presented in a naughty pose by the poet and painter Yosa Buson, in his humorous Yokai collection *Buson Yokai Emaki*. (1754) Yosa Buson.

Shirime is written 尻目
尻 (shiri) butt
目 (me) eye

The only known image of Shirime comes from poet and artist Yosa Buson. He included it in *Buson Yokai Emaki* (18th century). The original scroll has been lost, and we only know it from a 1928 reprinting. The best guess is it was made sometime between 1754 and 1757. *Buson Yokai Emaki* has only eight Yokai, one of which is labeled Nopperabo of Kyoto, which has become known in modern times as Shirime.

Buson's illustrations are lyrical and humorous. Some have stories, and some do not. Shirime does not. Labeled as a Nopperabo, the best guess is it does its usual form of surprise attack. Like many of this type of Yokai, there isn't much more to the story than a mischievous creature that likes to startle people. Japan has a high tolerance for body humor and grotesqueness, and the Shirime is a good example of this.

Shirime, although clearly ridiculous, is equally beloved. Mizuki Shigeru did a full painting for his *Mujara* (1998) series. Shirime also shows up in the Studio Ghibli film *Pom Poko* (1994). Sometimes all you need to make a lasting Yokai is a good joke.

CHAPTER 3
CHOSHIZEN
Super Nature

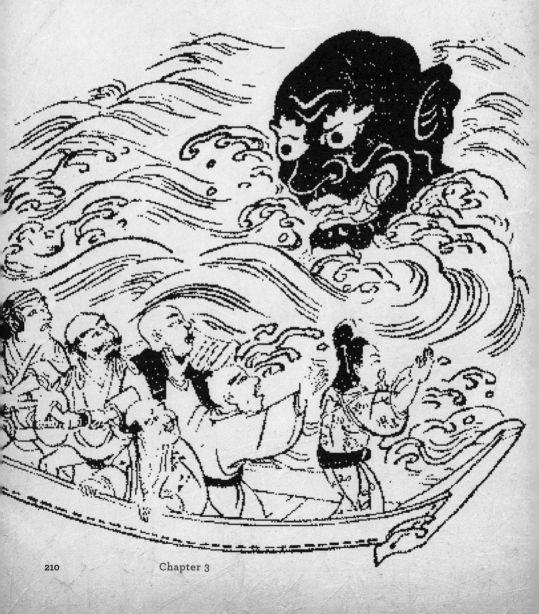

What are Choshizen?

Choshizen are super nature, which is different from supernatural. They are aspects of the natural world with Yokai natures. Choshizen Yokai can be massive fish, unnatural plants, strange sounds, winds, pretty much anything of the natural world that has grown unnatural.

An Umi Bozu (facing page) called "kurobozu" or "black monk" is pictured from the book *Kii zotan-shu*. A man brings his wife on his boat, which enrages the water god. His wife throws herself overboard where she is promptly eaten, satisfying the deity Kuronyudo (1850) Artist unknown.

> **Choshizen** is written 超自然
> 超 (cho) – super, ultra, extreme
> 自然 (shizen) – nature

Generally, Choshizen did not historically have personalities and identities. But as with many Yokai, artists and authors have personified them over the years. In this section, you'll find an eclectic collection of nature spirits, disease gods, spirits of plants, and animals that grew too big. As well as a few odds and ends that didn't fit anywhere else.

Basho no Sei Banana Tree Spirits

Although she knew it was forbidden, the woman snuck out from her village to wander thought the banana groves at night. She had heard to other women giggle about it and wanted to know if the rumors were true. Parting the giant leaves, she gasped. Before her stood the most beautiful man she had ever seen. She knew she was in the presence of the spirit of the banana trees, the Basho no Sei.

Basho no Sei are spiritual manifestations of banana plants. They are found mostly in Okinawa where the banana fields are. Basho no Sei were considered evil and dangerous, as well as seductive. Basho no Sei are incubi of the Yokai.

> **Basho no Sei** is written 芭蕉精
> 芭蕉 (basho) Japanese banana plant
> 精 (sei) spirit

Japanese banana trees, known in Japanese as *basho* and in English as *musa basjoo*, are grown for the fiber of their massive leaves. While they do fruit, their fruit is inedible. But their leaves can be used as pulp to make paper, tablecloths, and even kimono. *Musa basjoo* are native to subtropical southern China but traveled to the Ryukyu islands of southern Japan. The largest, Okinawa, is home to large fields of musa basjoo. Hardy plants, they have recently been seen in ornamental gardens where they provide a tropical touch while being able to withstand freezing temperatures. The famed haiku poet Basho named himself after this plant.

Basho no Sei legends originated in China. Their enormous leaves marked them as supernatural even while being an eminently useful plant. These stories were adapted into the *noh* performance *Basho* (16th century), using the plant as a symbol of impermanence. The leaves of the *musa basjoo* are strong in the summer but wither into fragility in the winter. The *noh* performance asks if even such a ruthless plant can achieve Buddhahood.

Edo period herbalist Sato Narihiro wrote about Basho no Sei stories in *Churyo Manroku* (1862). Sato said that in Okinawa there were miles of *musa basjoo* fields. The spirits of these fields came out only at night, and it was said that if a man walked through them, they might be startled but not directly harmed. Carrying a sword was ample protection. The spirits of the banana plants would not disturb an armed man. Women, however, met a different fate. Women were forbidden to walk through *musa basjoo* fields after dusk. If they did, it was said they would meet a beautiful man. Any woman who

Basho no Sei (facing page) from *Konjaku Hyakki Shui.* (1780) Toriyama Sekien.

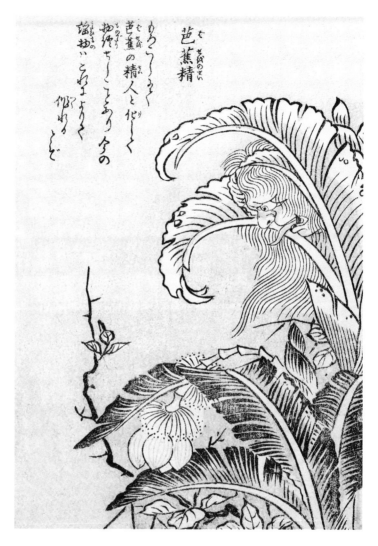

芭蕉精

もろこしにて

芭蕉の精人と化して

抱擁ちぎることありとの

端抱いとありやうりく

伽婢ぶ

encountered this man would get pregnant and give birth to a demon child. The children would be born with fangs like a beast. And this was not a single birth. That woman would continue to give birth to the same child year after year. When it was born, it was given powdered *kumazasa* to drink. This bamboo grass killed the child. Families kept a supply of powdered *kumazasa* on hand for this occasion.

Toriyama Sekien illustrated Basho no Sei in *Konjaku Hyakki Shui* (1781). He cites China as the origin of the legends and references the *noh* song "Basho." Sekien's illustration is more comedic than seductive and bears little resemblance to the Ryukyu Island legends.

Azukiarai Bean Washers

After a hard day's work burning charcoal at the kiln, you head down to the river to wash away the sweat and grime. Making your way through the trees, you hear the bubbling sound of water ahead. And something else—the distinct sound of beans being washed in a bowl. A brief smile crosses your lips. He is here, then. The old bean washer himself, the Azukiarai.

Azukiarai are the sound of beans being washed in rivers. They make a sound like "shoki shoki," sometimes accompanied by a whimsical tune. Azukiarai are never seen, but it is said that those who try to catch them fall into the water.

> **Azukiarai** is written 小豆洗い
> 小豆 (azuki) red beans
> 洗い (arai) wash

Azuki are sweet, red beans common in Japanese cooking. They're used in all sorts of dishes, from desserts to the red beans and rice dish called sekihan used to celebrate auspicious occasions. And like most beans, you give them a good washing before cooking. In old times this would have been done in a bamboo basket, with a back-and-forth rocking motion that gave off a shoki shoki sound. This same sound heard by riverbanks gave rise to Azukiarai legends.

Azukiarai are found all over Japan and known by regional names. They are Azuki Sarasara in Okayama Prefecture. Azuki Yaro in Kagawa Prefecture. In Ehime Prefecture, they are called Sunaarai, meaning "sand washer." They are Azukitogi in multiple prefectures. There are slight variations in legends, with Azukiarai being more or less dangerous. Some have Azukiarai spiriting away those that encounter it. Most are harmless, fleeing before humans.

In *An Introduction to Yokai Culture* (2006), researcher Komatsu Kazuhiko identifies Azukiarai as an entirely auditory phenomenon for most recorded history. People heard the sounds but gave little thought as to what was making them. Azukiarai was the sound itself. In many places, this was assumed to be the work of prankster Henge Yokai, either Tanuki, Mujina, or Kitsune. In Nagano, it was said to be the cry of an itachi, a Japanese weasel. Their chittering voices made the sound of the Azukiarai's song.

In the Edo period, when more and more Yokai began to be visually represented, auditory phenomena like Azukiarai were given bodies for the first time. If you heard a sound, something needed to be making it.

Azukiarai (facing page) from *Ehon Hyaku Monogatari,* an illustrated book of Yokai intended as a continuation of Toriyama Sekien's work. (1841) Takehara Shunsensai.

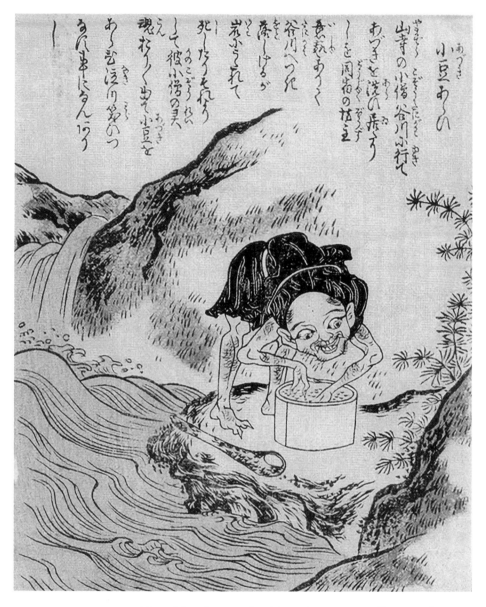

あづき小豆あらい
山寺の小僧谷川へ行て
あづきを洗ひ居たりしを　
一を同宿の坊主　

（右側縦書き）
あづきあらひ　
谷川へつれ　
添しけるが　
岩ふり落れて　
死し　けり　それより　
その彼小僧の臭　
魂ぶらりと出て小豆を　
あらひはじめものの　
あるまじきとぞ　

The oldest known Azukiarai image is in *Ehon Hyaku Monogatari* (1841), by Takehara Shunsensai. *Ehon Hyaku Monogatari* was a follow up to Toriyama Sekien's successful Yokai books. Most likely the inspiration came from Ibaraki Prefecture and Sado Island, where Azukiarai was said to be a short, big-eyed monk who washed beans while laughing. The same legends said if any woman with a daughter who saw the Azukiarai, her daughter would soon be in love.

Umibozu Dreadful Sea Monsters

Sailors in Japan's waters had many things to dread. Dark nights and stormy waters meant danger as well as chance encounters of any number of Yokai swimming the haunted waters. But it was clear skies and calm waters that brought fear of the Umibozu.

Rising suddenly from the placid surface of the water, by most accounts Umibozu looked like a giant black head that lurched upwards sending the sailors into murky waters. By other accounts, they were more like sea monsters. But whatever form they took, Umibozu were massive, rising as much as 33 feet (10 meters) tall, and strong enough to snap a ship in two.

Umibozu is written 海坊主
海 (umi) sea
坊主 (bozu) monk

Umibozu are known by other, similar names such as Umi Boshi and Umi Nyudo, both of which are variations of the world "sea monk." Boshi and Nyudo are other words for monk, meaning "teacher of the Buddhist laws" and "walker of the way" respectively. The name Umibozu is entirely linked to appearance—the rounded head was said to resemble the shaved head of a Buddhist monk—and has no deeper connections to Buddhism.

Traditionally, Umibozu rise from calm waters. Their appearance is sometimes said to herald a coming storm, and they can be accompanied by other strange ocean phenomena. Or even just feelings of dread. In any case, wise fishers could read the signs that an Umibozu and refuse to launch their boat until the waters were clear.

Accounts of Umibozu differ wildly. The oldest known account comes from *Kii Zodan Shu* (1687). A boatman taking passengers on a crossing forced his wife on board. They encountered a storm, and thinking they must have angered the dragon gods began tossing items over. The storm raged unabated. A massive black head burst from the sea, five to six times the size of a human head, with glowing eyes, and a horse-like mouth about two feet long. Resolved to her fate, the boatman's wife threw herself over the side where she was caught in the creature's mouth. The storm ceased as suddenly as it started. *Kanso Jigo* (1793–9) tells of an Umibozu that washed up on the shores of Osaka where it stayed for three days before returning to the ocean. Children were warned to stay away from it, *Usokanwa* (19th century) said sailors from Mie Prefecture were prohibited from sailing at the end of the month because Umibozu would appear.

Encounter between the sailor Tokuzo and an Umibozu (facing page). Part of his series *Fifty-three Parings along the Tokaido Road*. The monster demands Tokuzo name "the most horrible thing he knows." Tokuzo replies "Being a sailor." Satisfied, the Umi Bozu retreats under the water. This same subject was later interpreted by Kuniyoshi's pupil Yoshitora. (1814?) Utagawa Kuniyoshi.

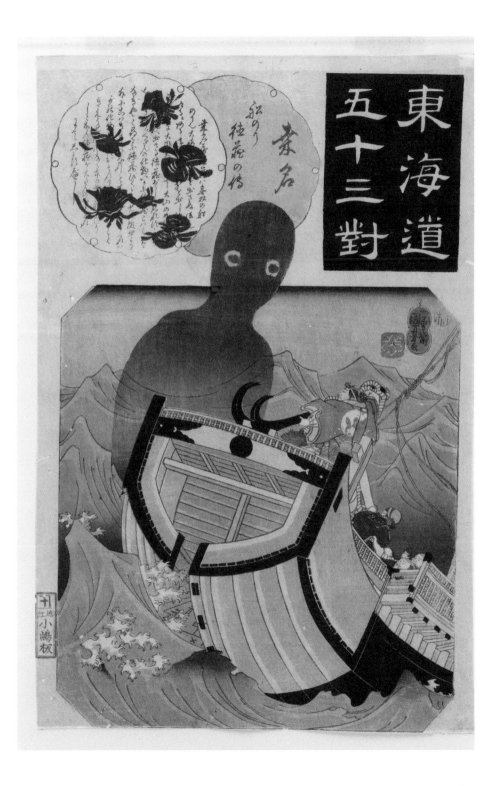

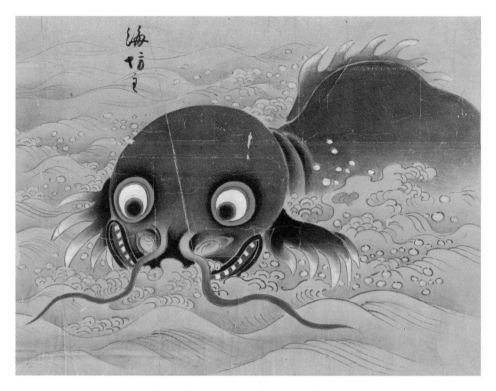

Other Umibozu stories described anything from a hairy creature resembling a sperm whale to a beautiful woman who can shape-change into a vicious monster. The classic Umibozu is the one most often represented by *ukiyo-e* artists; that of a giant black head with two massive eyes thrusting up from the water. When they attack, some say that they cling to the hull of a ship to drag it down or have great stretching arms that can pull a ship down by its mast. Some say that they try desperately to quench any lit fires on the boat. Some say they cry "kuya kuya" as they attack, and that striking them with the oars will bring cries of pain, "oitata!" from the smaller species. In some legends, they can be repelled by tobacco smoke.

The oldest known image of an Umibozu comes from the aforementioned *Kii Zodan Shu*. The giant head was called Kurobozu, or black monk. *Bakemono no e* (17th or early 18th century) shows a more classic sea monster, with a ridged back and whiskers like a catfish. Utagawa Kuniyoshi produced the most famous image, of a giant black monster with massive eyes rising from the sea in his series *Fifty-Three Parallels for the Tokaido* (1843–845).

There are many proposed origins of Umibozu, and probably all of them have some truth. The Osaka account is clearly

Umibozu from the *Bakemono no e* scroll illustrating various kinds of Yokai. This shows the dragon-like appearance of Umibozu seen in some stories. (17th or 18th century) Artist unknown.

a beached whale. Still others are likely surfacing jellyfish or sea creatures such as the Portuguese man o' war, although they are quite small. A more recent discovery offers another possible origin. Thought mythical until 1995 when first recorded, rogue waves are massive waves that can rise suddenly from calm seas. They can reach heights of more than a hundred feet and are known to smash ships to pieces. In fact, some believe Katsushika Hokusai's famous The Great Wave off Kanagawa (1831) is also an image of a rogue wave, and thus, an Umibozu.

Namazu Monstrous Catfish

The ground shook under your feet. Trying not to fall, you moved to a safe spot where you could brace yourself until the awful quake was over. The shaking got worse and worse until cracks appeared on your walls. Then as suddenly as it started it was over. You sigh in relief, knowing that it is calm once more—the great catfish at the center of the earth called Namazu.

Namazu, also known as Onamazu, is a titanic catfish said to live at the center of the earth under the islands of Japan. The shakings of this catfish cause the earthquakes that Japan is so prone too. Where this catfish came from or who put it there, no one knows. All they know is that the Namazu must be held down before its shaking destroys the world.

Namazu is written 鯰
鯰 (namazu) catfish

Set right on the Pacific Ring of Fire, Japan is earthquake country. Along with the massive city destroying earthquakes that make international news, there are hundreds of minor quakes that happen every year. When an earthquake begins, the question always runs through your mind "Is this the time I die?" When you realize it is not, you find a safe space to ride the quake out.

In mythology across the world, there are legends of serpents coiled at the center of the earth who cause earthquakes. This idea of a world snake is not limited to Asia. Norway has Jörmungandr, the Midgard Serpent. Some believe this is because snakes are sensitive to vibrations in the ground and can predict earthquakes. In Asia these legends expanded to dragons. China's first seismograph was a bronze pot with eight dragon heads, each holding a ball in its mouth. Beneath a dragon was a toad. If the dragon dropped its ball into the toad's mouth, an earthquake was coming in that direction. In Japan, this legend expressed

A giant catfish is set upon by villagers (top) in an attempt to pin it down using a keystone amulet. Made after a major earthquake in 1855. (19th century) Artist unknown.

Legendary Heian period Onmyoji sorcerer Abe no Seimei (facing page) uses magic to transfer the Yakubyogami from the body of the monk Chiko to his disciple Shoku. The Yakubyogami are later transferred to the body of the god Fudo Myo-o where they are burned up. From *Fudo Riyaku Engi Emaki*. (14th century) Artist unknown.

itself as a huge dragon underneath the archipelago. To contain it, two shrines were established. The capstone for the head is at Kashima Jingu in Ibaraki Prefecture. The capstone for the tail is in Katori Jingu in Chiba. Together, they pin the great dragon.

Japan also, for reasons unknown, evolved this giant dragon into a giant catfish. How the association began of when is unknown. Omura shrine in Mie Prefecture claims to have a keystone that pins the giant Namazu catfish that lives under Japan. They claim the capstone was laid down in 767 by the demigods Takemikazuchi-no-Okami and Futsunushi-on-Kami. In 1592, when Toyotomi Hideyoshi built Fushimi Castle, he insisted it was strong enough to withstand the catfish. The legends appear ancient.

Namazu legends took off following the Ansei great earthquakes that struck between 1854–1860. *Kawaraban* broadsides were distributed claiming it was the work of the Namazu. This was a time of societal upheaval, with the arrival of the black ships from the United States ending the Edo period. Over two hundred wood block prints were created and distributed, saying that sharing the picture of the Namazu would act like a talisman. All the psychic energy of all the people of Edo was believed to be powerful enough to hold it down. That proved not to be the case.

Yakubyogami Plague Spreaders

The village was busily putting up the straw figures at the gates and urging households to hang up protective amulets. Word had come from a village a few miles over that a terrible sickness had killed almost everyone. They died covered in red pustules and burning in fever. There was no mistake—Yakubyogami were on the move.

Yakubyogami are malevolent spirits or deities believed to cause illness and misfortune to humans. Invisible creatures said to travel across the country spreading disease, they were said to cause smallpox, the plague, and all the other pandemics that regularly killed thousands of people.

> **Yakubyogami** is written 疫病神
> 疫病 (yakubyo) epidemic, plague
> 神 (kami) god, deity, Kami

For much of human history disease was a mystery. Until Louis Pasteur proved germ theory between 1860 and 1864, little was known about how disease spread or why. Sickness was terrifying. It appeared suddenly without observable cause and killed vast swaths of humanity. From 735–737 CE, a smallpox epidemic killed about a third of the population of Japan. The personification of these diseases were Yakubyogami.

Yakubyogami seem to have their origins in the Chinese Wen Shen, demon children of ancient Chinese emperors who spread disease. They wandered between the underworld and the living world, unleashing plagues as punishment for the sins of humanity. Yakubyogami were influenced by Wen Shen but adapted in a way unique to Japanese mythology and culture. The illness they bring is not divine judgment, but merely a consequence of who they are. Yakubyogami were considered a part of nature. Which, like the germs they represented, they were.

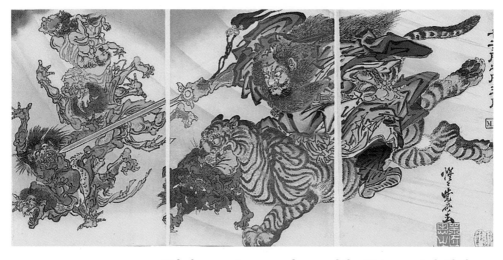

Yakubyogami appeared around the Heian period. *Shoku Nihongi* (797) says that plague gods were enshrined across Japan to placate them. *Onmyoji* court sorcerers calculated when Yakubyogami would be on the move. People stayed inside, bolting their doors against the plague gods. Supernatural countermeasures were created to repel them. The Chinkasai festival was held in the imperial capital of Kyoto with the aim of fighting off Yakubyogami. Villages held local ceremonies and posted straw figures at their gates as wards against the disease-spreading spirits. Shinto festivals held rituals of purification and sold amulets to protect their bearers. The Chinese folk hero Shoki the Demon Queller was said to be a particularly powerful talisman. Yakubyogami would not dare pass the threshold of a house decorated with his fierce countenance.

With the popularity of Yokai in the Edo period, myths of Yakubyogami became attached to Yokai who were said to cause disease and death in their wake. But Yakubyogami persisted as well. In *Miyagawa no Yamanpitsu* (1862) it says that houses that eat red beans on the third day of every month will not be visited by Yakubyogami.

Belief in Yakubyogami disappeared in the Meiji period, when modern science and medicine was brought to Japan. But the festivals, amulets, and other countermeasures persist. The Chinkasai festival is held to this day. And in writing this book, admittedly the Yakubyogami were hard to place? Which category did they fit? None of them really, so they found a home here. Like the Yakubyogami themselves, they wander where they will and there is little we can do to oppose them.

Yakubyogami is battled by Shoki the Demon Queller, Chinese deity of medicine, riding on a tiger. (1887) Kawanabe Kyosai.

Bakekujira Spectral Whales

The fisherfolk quaked in fear as the massive white shape floated into the bay. Strange birds flew in the sky above it. The seas writhed with fish foreign to these shores. They desperately rowed back to shore, hoping to escape the Bakekujira.

Legends of a Great White Whale usually bring the book *Moby Dick* to mind, but the white of this whale refers to the color of its bones...for bones are all you can see of the Bakekujira. It is a massive, skeletal baleen whale that appeared and then disappeared under mysterious circumstances off the coast of Japan. Is it a monster? Is it a ghost? Is it a god? No one really knows for sure.

Bakekujira is written 化け鯨
化け (bake) changing
鯨 (kujira) whale

Bakekujira is a skeletal whale that swims into shore, bringing with it a phantom vision of a strange world and mysterious animals. There is only a single story.

One rainy night, something massive and white appeared off the coast of Okino Island, Shimane Prefecture. Village fishers watched it get closer and closer, and finally decided to take a rowboat out and see what it was. From its size, they knew it must be some sort of whale, but no one had seen a whale like that before. As they rowed out, they saw the waters of the ocean glimmer with thousands of fish, the likes of which they had never seen.

As they neared the white whale, one of the fishers threw his harpoon. It passed through unnoticed. Their vision obscured by the pounding rain, the fishers finally got a good look at the monster—it was the skeleton of a great baleen whale, without an ounce of skin nor meat on it. But it was moving and alive.

As the water writhed with unknown fish, the skies were filled with strange birds. In the distance they saw an island that hadn't been there before, as if they had rowed into some mysterious country. Then as suddenly the vision ended, and the massive Bakekujira retreated to the open sea. When the fishers went back to shore, they speculated that it might have been the ghost of a whale killed in a hunt or some strange god. Whatever it was, the Bakekujira was never seen again.

The first account of Bakekujira comes from *Shonen Magazine* (1969), in feature called "Mizuki Shigeru's Kaikina Gashu." In this feature, Mizuki Shigeru introduced various Yokai. There are no period accounts of Bakekujira nor artwork.

Chapter Three

Kodama Tree Spirits

Bakekujira (facing page) attacks a boat from the unpublished comic *Supernatural Geographic*. (2014) Image courtesy Daniel Govar.

Kodama (below) from *Gazu Hyakki Yagyo*. (1776) Toriyama Sekien.

It has been known in Japan since ancient times, you never walk in a forest alone. Whenever you walk through nature, you are there with the spirits of nature—the strange beings called Kodama.

The Japanese long considered some trees special. For whatever reason—maybe because of an interestingly shaped trunk, or a sequence of knots resembling a human face, or just a certain sense of awe—some trees were identified as being the abodes of spirits. Depending on where you lived, these spirits went by many names. But the most common term, the one still used today, is Kodama.

> **Kodama** is written 木魂
> 木 (ko, ki) tree
> 魂 (dama, tameshi) soul

In ancient times, Kodama were said to be Kami, nature deities that dwelled in trees. Some believed Kodama could move nimbly through the forest, traveling freely from tree to tree. Others believed Kodama were rooted like the trees themselves. Woe betides any unwary woodsman who took an axe to what looked like a regular tree, only to draw blood as he chopped into a Kodama. A Kodama's curse was something to be feared.

They were also a sound. Echoes that reverberated through mountains and valleys were said to be Kodama. The sounds of trees crashing in the woods were the plaintive cries of Kodama. Whatever form they took, Kodama possessed supernatural powers. Kodama properly worshipped and honored would protect houses and villages. Kodama mistreated or disrespected brought down powerful curses.

The first known mention of tree spirits is in Japan's oldest known book, *Kojiki* (712). The tree god Wakunochi-no-kami is the second born of Izanagi and Izanami. The oldest known reference to Kodama comes from the Heian period, *Wamuryorui Jyusho* (931–938 CE). A dictionary, *Wamuryorui Jyusho* lists Kodama as the Japanese word for spirits of the trees. Another Heian period book, *Genji Monogatari* (11th century) describes Kodama as a sort of tree-dwelling goblin. *Genji Monogatari* also uses the phrase "either Oni or Kami or Kitsune or Kodama," showing these four spirits were thought to be separate entities.

Around the Edo period, Kodama lost their rank as gods of the forest and were included as just one of Japan's ubiquitous Yokai. Kodama became humanized as well—there are stories of Kodama falling in love with humans and taking human shape to marry them.

Visually, no one agrees with what Kodama look like. In ancient legends they were either invisible or indistinguishable from regular trees. Toriyama Sekien drew Kodama as an ancient man or woman standing near a tree in *Gazu Hyakki Yagyo* (1776). Miyazaki Hayao used Kodama extensively in his film *Princess Mononoke* (1997) and illustrated Kodama as dual-color bobble-heads. Modern interpretations vary widely showing Kodama as humans young and old, or small nature sprites borrowing from European pagan traditions, or cute, animated characters. Clearly, they are open for interpretation.

Onikuma Demon Bears

You hear its footsteps before you see it. The great beast makes no attempt to hide itself. Crawling into a tree, hoping to escape notice, you see a titanic bear. It walks on its hindlegs like a human and easily pushes trees aside. A full-grown horse is slung across its shoulders. You hold your breath, hoping to survive an encounter with the demon bear Onikuma.

Onikuma are unnaturally large bears. They are rarely seen but said to come into human villages at night to grab horses, their favorite meal. They look like any other bear

other than their massive height and disturbing preference for walking upright.

Onikuma is written 鬼熊
鬼 (oni) demon
熊 (kuma) bear

Onikuma come from Kiso province (modern day Nagano Prefecture). They have no special powers but are said to be exceptionally strong. Legends say an Onikuma can move rocks that 10 men together can't push. There are still some rocks in odd places around Nagano Prefecture that legends say were put there by Onikuma,

Onikuma first appear in *Ehon Hyaku Monogatari* (1841). A follow up to Toriyama Sekien's popular Yokai books, artist Takehara Shunsen illustrated legends for his book. There is some debate over what type of Yokai Onikuma are. By some accounts, they are Henge Yokai, bears that lived long lives and transform into Yokai. Mizuki Shigeru did not find any accounts of Onikuma transformation and considers this a modern addition.

An Onikuma
from *Ehon Hyaku Monogatari*. (1841)
Takehara Shunsensai.

Jinmenju Human-faced Trees

Deep in the mountain valleys you hear a strange giggling sound. Is it a Kodama nature spirit? A Tanuki prankster? You decide to follow the sound and are rewarded with the delightful sight of a tree heavy with fruit, each with a happy, giggling face. You have found the Jinmenju.

Jinmenju are trees whose flowering fruit resemble human heads. The heads are said to be childlike. They cannot speak but laugh constantly.

> **Jinmenju** is written 木魂
> 木 (ko, ki) tree
> 魂 (dama, tameshi) soul

Legends of trees that have flowering fruit with human faces are found across Asia. The *waqwaq* tree comes from Islamic lore, possibly deriving from the Tree of Zakkum in the Quran, which produces fruit shaped like the heads of demons. The Chinese encyclopedia *Tongdian* (801) mentions the *waqwaq* tree, based on Arabic sources. According to *Kitaab Ajaaib al-Hind* (900–953) bears fruit that looks like a human being. When the wind blows, a voice comes out of it. Later this is described as having the faces and more of beautiful women. In all sources, the *waqwaq* tree is described as growing on some faraway, exotic island. The Japanese version comes from China. In keeping with tradition, they are said to be found on islands to the south.

Jinmenju are first described in *Wakan Sansai Zue* (1712). It says the Jinmenju trees are found in the south, and the fruit of the tree is called the *jinmenshi*, or human-faced child. *Jinmenshi* ripen in autumn, and if you eat them, they have a sweet/sour taste. It is said that the Jinmenju seeds also have human faces, eyes, ears, noses, and mouths.

Toriyama Sekien drew Jinmenju in *Konjaku Hyakki Shui* (1781), where he calls them ninmenju. His image resembles a Chinese woodblock print from *Sancai tuhui* (1609). Whether he was familiar with this version or not is known. It may be coincidence based on the description.

Many researchers think the origin of Jinmenju and the *waqwaq* tree are pineapples. They grow in southern islands, and while they don't exactly resemble human faces, they have the same general shape and spiky hair. It's possible.

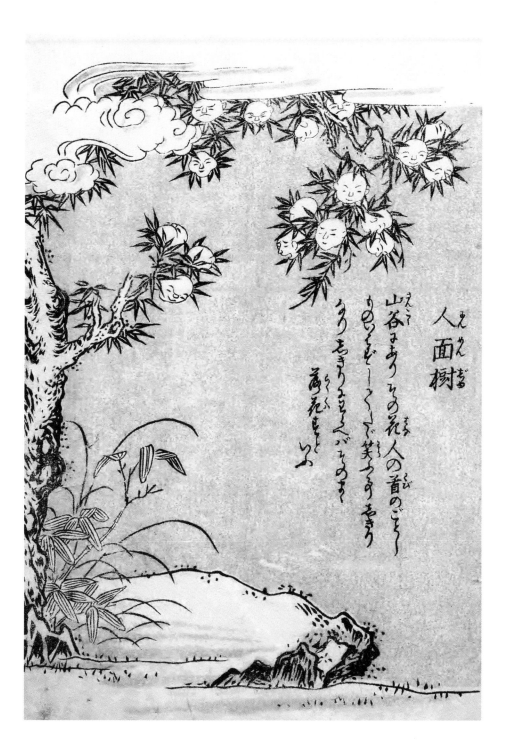

人面樹

山谷まあり その花人の首のごとくのりくらでーくで笑うもう

YOKAIOLOGY
Honjo Nanafushigi
The Seven Wonders of Honjo

During the Edo period, the area known as Honjo (modern day Sumida ward in Tokyo) was a melancholy and shadow-haunted place that drew legends about it like a cloak. Vast fields spread about Honjo, with only a few houses scattered here and there, and many a night-traveler would walk far to avoid a trip though those fields at night.

Several of the ghost legends of Honjo were collected and called the Honjo Nanafushigi the Seven Wonders of Honjo. The number seven is purely nominal; as in many places in the world, the number seven carries mystical significance and when you are telling ghost stories the "seven wonders" sounds scarier than the "nine wonders" or "eight wonders."

Honjo Nanafushigi is written
本所七不思議
本所 (honjo) – Honjo
七 (nana) – seven
不思議 (fushigi) mysteries

Many localities had their own "seven wonders." They form a typical model of urban legend, passed down through word of mouth, told and retold over kitchen fireplaces, then transitioning from local legend to stage performance.

The Seven Wonders of Honjo moved from the streets of Edo into the halls of *rakugo* theater performers, who took the seven wonders on tour. In the late 1880s Utagawa Kuniteru made a series of prints called *Honjo Nanafushigi*

(1886). Shinko Kimura filmed *Honjo Nanafushigi* (1937) which was remade by Katano Goro as *Kaidan Honjo Nanafushigi* (1957). The films featured Yokai stories and did not really focus on the authentic Seven Wonders.

Today the Seven Wonders of Honjo are largely remembered as tourist

The Seven Wonders of Honjo (1886) Utagawa Kuniteru III.
 Oite Kebori (bottom)
 Ashiarai Yashiki (facing page, top left)
 Kataha no Ashi (facing page, top right)
 Akaranashi Osaba (facing page, bottom left)
 Okuri Hyoshigi (facing page, bottom right)

Choshizen Super Nature

Chapter Three

attractions. You can buy special sweets in the shape of the seven wonders and take walking tours of Sumida.

The Seven Wonders are:

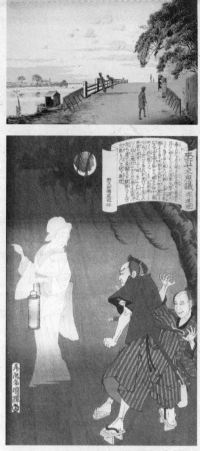

* Oite Kebori (Leave it Behind Straggler) – A mysterious voice telling fishers to leave behind their catch.

* Okuri Chochin (Sending-Off Lantern) – A light in the distance that leads you off the path.

* Okuri Hyoshigi (Following Wooden Clappers) – A sound of wooden clappers that follows people on rainy nights.

* Akarinashi Osoba (The Unlit Soba Shop) – A lantern in front of a soba shop that burned without candle or oil.

* Ashiarai Yashiki (The Foot Washing Mansion) – A giant, dirty foot that came from the ceiling of a mansion. If you washed the foot, it went away.

* Kataba no Ashi (The One-sided Reed) – A woman was killed, and her body thrown into a ditch. Now the reeds only grow on the other side of the road.

* Ochiba Naki Shi (Chinquapin of Unfallen Leaves) – A tree whose leaves do not fall in autumn.

* Tanuki Bayashi (The Procession of the Tanuki) – The sounds of a great party in the woods that you can never find.

* Tsugaru no Taiko (The Taiko of Tsugaru) – A fire tower that sounded a huge *taiko* drum in times of danger.

Tanuki Bayashi (facing page) (1886) Utagawa Kuniteru III.
Ochiba Naki Shi (top) A chinquapin tree drapes over the Mikurabashi bridge at Honjo (19th century) Kobayashi Kiyochika.
Okuri Chochin (middle) 1886 – Utagawa Kuniteru III.
Tsugaru no Taiko (bottom) Shinkawanishi Fire Lookout Tower. TECHD/photo-ac.com.

Ochiba Naki Shi Chinquapin Trees

"There it is." Your guide points at an otherwise unassuming tree, tall and broad with branches and leaves spreading wide. Underneath it where you would expect to see autumn detritus there was not so much as a single leaf. The legends were true. You stood in the presence of one of the Seven Wonders of Honjo, the chinquapin of unfallen leaves, Ochiba Naki Shi.

Ochiba Naki Shi is a tree whose leaves did not fall during autumn. No one could explain why this particular chinquapin tree didn't lose its leaves.

> **Ochiba Naki Shi** is written 落葉なき椎
> 落葉 (ochiba) – fallen leaves
> なき (naki) – lacking, non-existent
> 椎 (shi) – chinquapin tree

Chinquapin trees are native to southern Japan and southern Korea. They are related to beech and oak. Chinquapins are evergreen, not deciduous, but even then, at least a few of their leaves fall with the seasons.

In Honjo, in the Hiradoshinden-han fiefdom, in the house of Matsura, there stood a *daimyo*'s mansion. More than a simple mansion, this was the *daimyo*'s *kami-yashiki*, a residence where the *daimyo* lived during his required year in Edo by edict of the Shogun. The *daimyo*'s *shimo-yashiki* was in his native land, but the *daimyo* currently resided in Edo.

This *kami-yashiki* was bordered by a large wall, which ran parallel along the banks of what was then called the Great River, but what we now call the Sumida River of Tokyo. Planted in the *daimyo*'s garden was a prodigious chinquapin tree whose leaves hung over the wall. No one had ever seen so much as a single leaf fall from its branches.

The *daimyo*'s gardener was a diligent fellow, but not even he could clean up every leaf that ever fell. This particular chinquapin tree was truly a wonder. And what was the origin of this chinquapin tree's fantastic abilities? That is a mystery to this day.

The *daimyo* was unsettled by the

A chinquapin tree sports its unfallen leaves, one of the Seven Wonders of Honjo. T.Kai/ Shutterstock.com.

tree—perhaps fearing some unknown fox power or mysterious spirits—and used his *kami-yashiki* as little as possible. But the fame of the tree spread until the mansion was no longer known as the Matsura house but was locally called the Chinquapin Tree Mansion. The tree hanging over the wall near the banks of the Great River was considered an elegant scene and was popular for strolls.

When the stories of the Seven Wonders of Honjo became popular in *rakugo* storytelling, the Chinquapin Tree of Unfallen Leaves was included in its ranks.

Neither the *daimyo*'s mansion nor the famous chinquapin tree survive today. During the Meiji era, the territory was purchased by the Yasuda Zaibatsu financial conglomerate which created a private garden called Yasuda Park. In the fifteenth year of Taisho, the Yasuda Zaibatsu donated the garden as a public park. The park is now located in the Sumida ward, in the Honjo district. Like all of the Seven Wonders of Honjo, the old location of the Chinquapin Tree of Unfallen Leaves is marked with a sign and stone monument.

Kamaitachi Dust Devils

Walking down the street on a clear day, you are suddenly forced to your knees as a whirlwind that spins about you. As quickly as it came it is over. The skies are calm again. Your body screams in agony as if sliced to ribbons, but you see not a single wound. You know that you have fallen victim to the Kamaitachi.

Kamaitachi are minor whirlwinds of the type commonly called dust devils. Inside the whirlwind are three weasels with claws like sickles. It's said the first weasel cuts your legs, knocking you to the ground. The second weasel slices you with a thousand tiny cuts. And the third applies a magic salve that heals all your wounds. Their attack is over in an instant, and you find yourself on the ground in pain but otherwise unhurt.

> Kamaitachi is written 鎌鼬
> 鎌 (kama) – sickle
> 鼬 (itachi) – weasel

Tornadoes and whirlwinds are rare in Japan but not unheard of. They tend to occur in coastal areas with Okinawa having the most recorded tornadoes and Hokkaido the least. Vertical vortices favor flat lands, and Japan's mountainous geography does not support them. Yet for all that they do occur. And perhaps it is their rarity that made them into Yokai.

Kamaitachi have their origins in China, in a creature called Qiongqi. Chimeras with the body of an ox, quills of a hedgehog, and a howl like a dog, Qiongqi are one of the Four Perils of Chinese mythology and are brutal monsters. *Huainanzi* (139 BCE) says they are the offspring of the Northern Desert Wind and have wind powers. The association between the two is vague. Most likely Qiongqi merged with existing Japanese folklore. There is also some thought that the name Kamaitachi is a pun on the sword stance *kamae tachi* which holds your sword forward in a threatening pose. But this may be coincidence.

The oldest known account of Kamaitachi comes from *Kokon Hyakumonogatari Hyoba* (1686). It says Kamaitachi do not attack those of samurai lineage or those who live in cities. These are said to have true spirit and thus cannot be affected by creatures of malice. The book also says Kamaitachi are found up north, where the air is cold and the wind fierce.

Toriyama Sekien included Kamaitachi in *Gazu Hyakki Yagyo* (1776). He used the characters for Qiongqi and wrote a separate script for Kamaitachi. Sekien's illustration shows a vortex of wind with what looks like a single creature in the middle. *Kyoka Hyaku Monogatari* (1853) also shows a single weasel with sickle-like claws. It is not known when the three-weasel version appeared.

Mimibukuro (1814) says a child was caught in a whirlwind, and that weasel-like footprints and claw marks were left on its back. *Shozan Chumon Kishu* (1850) warns that while Kamaitachi wounds do not bleed at first, later there will be sever bleedings and cuts open to the bone. The book also says Kamaitachi live in water. It said a person crossing the Azabu-Furukawa Bridge was attacked by a Kamaitachi.

There are multiple variations of the Kamaitachi legend across Japan, often with different names and different creatures riding the whirlwind. Sometimes Kamaitachi is an evil god. Sometimes it is the wind itself that cuts and requires no rider.

A Kamaitachi
from *Kyoka Hyaku Monogatari.*
(1853) Masasumi Ryukansaijin.

Kanibozu Crabs Priests

If a wandering priest knocks on your door and asks you a riddle, beware. Or at least bop it on the head while it is waiting for an answer. Because chances are you're having an encounter with the dread Kanibozu.

Kanibozu are massive crabs, able to shapeshift into human form. They disguise themselves as monks and ask riddles, killing any who fail to answer. Kanibozu are said to live at the bottom of waterfalls amongst the skeletons of their victims.

Kanibozu is written 蟹坊主
蟹 (kani) – crab
坊主 (bozu) – monk

In a rare case the term *bozu* in Kanibozu actually refers to a Buddhist monk. That is the preferred disguise for this monster. There is a single legend of Kanibozu that comes from Chogen-ji Temple in Manriki, Yamanashi City, Yamanashi Prefecture. The story is written on the scrolls *Kakugani Densetsu Kakejiku* (1885) held at Chogen-ji. As the scrolls reference Mt. Kanizawa, it is thought the story was told sometime after 1726 when the mountain's name was changed from Mt. Fuko.

In the story, a wandering priest comes to Chogen-ji and asks to meet the abbot. During their meeting, the priest asks a riddle, saying "What has two legs, eight legs, and eyes that point to the sky?" Unable to answer, the wandering priest beat the abbot to death.

Successive generations of abbots met the same fate, until the temple was abandoned. One night, another wandering

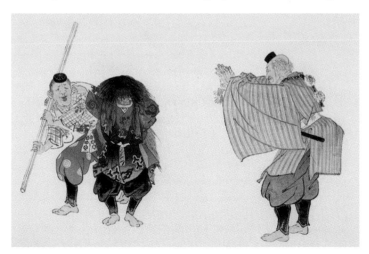

monk Honin who had heard the stories decided to pass the night in Chogen-ji. Sure enough, the mystery priest appeared and asked it's question. Honin replied "A crab, like you!" and bashed the priest over the head with his prayer staff. Following it to a nearby lake, Honin found a massive crab, twelve feet across. It was dead, its shell cracked from a mighty blow. Honin stayed on and became the abbot of Chogen-ji.

There are other legends of monstrous crabs. The kyogen play Kani Yamabushi (16th century?) features a confrontation between a priest, his acolyte, and a crab. Harima Meisho Junran Zue (1804) tells of a giant crab that tormented people. The great monk Kobo Daishi banished the crab, and the slope where it lived is called Kanigazaka, or crab slope, to this day.

Shinkiro Mystical Visions

Sailing at sea, you spot an island on the horizon. It is a scintillating vision, with towers rising into the sky. Could this be the mythical city of Horai, home of the immortals? Or is it merely the breath of a clam? Breathing out the visions known as Shinkiro.

Shinkiro is the Japanese word for mirage, or more specifically Fata Morgana, an optical phenomenon that appears to show castles in the air. In Japanese mythology, Shinkiro visions are the breath of undersea dragons or giant clams.

> **Shinkiro** is written 蜃気楼
> 蜃 (shen) – clam monster
> 気 (ki) – energy
> 楼 (rō) - tower

Fata Morgana are well understood today. Named after Morgan le Fay of Arthurian legend, they can often appear in the Italian Strait of Messina and the Baltic Sea. They occur when different layers of air temperature bend light rays in a thermal inversion, making the air act as a reflecting lens, producing an image of something floating in the sky. The image is not stable and flickers with the air currents.

Shinkiro legends are linked with both the underwater kingdom of Ryugu, a magical place ruled by the dragon god Ryujin and the legendary island of Horai. According to the Chinese classic text Shanhai Jing (4th century?), Horai is where those who have found the secrets of immorality dwell. There are many tales of visits to both Ryugu and Horai.

In the military tactics book Hokuetsu Gundan (1697), Makishima Akitake records seeing a city of shells and wonders if it is, as the elders say, a vision from a giant clam.

In *Wakan Sansai Zue* (1712) it says the mirage is caused by huge clams called *watarigai*. More specifically, they are Shen, mythical Chinese creatures sometimes said to be a clam and sometimes dragon. Shen are produced when a snake mates with a pheasant. Their egg is buried for several hundred years until it is born as a Shen. There is much disagreement over what a Shen is, dragon or clam, but everyone agrees that a Shen's breath expels *ki*, the vital energy of all living things.

Shinkiro stretches the definition of Yokai, and is perhaps better thought of as Kai, or strange phenomenon. However, Toriyama Sekien was happy to include them as Yokai and depicted Shinkiro in *Konjaku Hyakki Shui* (1781). He states Shen are giant clams, and that their *ki*-breath creates the vision of a multi-storied city.

Tengu Tsubute Stone Showers

Walking along a mountain trail alone, you are suddenly hit by a shower of small stones. Looking rapidly around you, you see no one. There is no one who could have thrown the fistful of gravel you were hit with. And now you know you have experienced Tengu Tsubute.

Tengu Tsubute is a small shower of stones that appear to have been flung by no one. It is more irritating than harmful, with only very small stones flung with little force. In some stories being hit by Tengu Tsubute makes you sick and die. As the name implies, many blame spiteful Tengu as the invisible throwers of stone.

Tengu Tsubute is written 天狗礫
天狗 (tengu) – tengu
礫 (tsubute) – pebble

Phenomena of strange things falling from the sky has been recorded since ancient times. There are old tales of rain of fish, frogs, and other assorted critters. Pliny the Elder documented rains of frogs and fish in Rome in 1 CE. Rains of stones, however, are uncommon. Except in Japan.

Tengu Tsubute is most often the work of Tengu, but can be Tanuki, Mujina, or any other prankster Yokai. When Tengu are involved, it is often said they throw stones to make people repent their bad behavior. The stone throwers are often said to be a lower class of Tengu called guhin. Living in the mountains, guhin are servants of the mountain Kami. Their primary task is to inspire proper fear and awe in humans walking in the mountains. Sanshu Kidan (1764) tells of a man walking in the mountains gathering leaves when he is assaulted with a sudden and ferocious hailstorm. The man fled back to the villages where locals told him that a guhin lives in those woods, and that anyone who took a single leaf would die.

Toriyama Sekien illustrated Tengu Tsubute in *Konjaku Hyakki Shui* (1781). In his description, he references Zuo Zhuan (4th century BCE) and a story of seven stones that fell in the Song dynasty.

Akaei Island Fish Rays

Lost at sea, the sailors were starting to lose hope. The storm had battered them around and they had lost all sense of direction. But then they saw an island, with sandy beaches and some vegetation. Landing their small craft, they happily stood on dry land. But something wasn't right. The sand was only a thin layer. Underneath was something soft, and spongy. And red. Too late, they realized their mistake. They watched in horror as their boat splintered to shreds and the massive ray they were standing on started to submerge into the ocean once more.

Akaei are Japan's version of the island fish. They are said to be giant rays, more than 6 miles (10 kilometers) long. Their backs are covered in sand, rock, and algae that looks like vegetation. But they are not stable to land on. When they submerge, they create a giant maelstrom that drags everything down with them.

Akaei is written 赤鱏
赤 (aka) – red
鱏 (ei) – ray

Island fish, known as *aspidochelone*, are classic folkloric creatures. *Aspidochelone* can be turtles, fish, whales, or any other sea creature large enough to be mistaken for an island. The oldest legend comes from *Physiologus* (2nd century), a book of allegorical stories of Christianity. The Arabic island fish is called Zaratan. In Icelandic sagas it is Hafgufa and Lyngbakr. Perhaps the most famous is the island fish Jasconius, landed on by St. Brendan the Navigator recorded in *Navigatio Sancti Brendani Abbati* (900).

Sangoku Tsuran Zusetsu (1785) was one of the first attempts by Japan to map all the Japanese outer islands and distinguish itself from its neighbors. Along with the usual islands, in includes a description of a massive trout that inhabits the seas near

The island-sized red ray from *Ehon Hyaku Monogatari.* (1841) Takehara Shunsensai.

Hokkaido. It was said to be about 656 feet (200 meters) square and often mistaken for an island.

Ehon Hyaku Monogatari (1841), by Takehara Shunsensai, tells the story of a massive ray. It is said the fish was more than 7.5 miles (12 kilometers) long. Sand occasionally accumulated on its back, and it would rise to the surface to shake it off. Any poor ship that mistook it for an island would be destroyed when the Akaei submerged.

Kakure Zato Magical Villages

The wood suddenly parts before you. You have walked these paths a hundred times, yet never seen that opening before. Looking inside, you see houses that shouldn't be there. People are bustling about their business. Everyone looks happy and healthy. You realize with a gasp that you have been lucky enough to stumble upon one of the legendary hidden villages, the Kakure Zato.

Kakure Zato are magical hidden villages said to exist scattered throughout Japan. They are often utopias, peaceful places of plenty where everyone has enough to eat. Time passes slower in the Kakure Zato, and someone who enters might find upon their return that years passed in the outside world.

> **Kakure Zato** is written 隠れ里
> 隠れ (kakure) – hidden
> 里 (sato) – village

Kakure Zato are said to derive from Japan's ancient mountain worship, a type of heaven before the introduction of Pure Land Buddhism. In *Rekishi Tokuhon Tokubetsu Sokan* (1992) ethnologist Arima Eiko says Kakure Zato represented a wish for utopia by the common people. Entry points can be through old mounds, or even at the bottom of pools or rivers.

Stories of Kakure Zato are influenced by actual hidden villages. These were remote villages in inaccessible mountain valleys, operated by *daimyo* to hide military, economic, and trade secrets. Gold mines were often carefully hidden, both as protection and to hide from taxation from the shogun. Valuable skills such as pottery were also carefully hidden. Okawachiyama in Saga Prefecture was built deep in the mountains. The Nabeshima family imported the most skilled craftsmen to produce matchless porcelain exclusively for the use of nobility. Other stories told of the fugitives of the Heike clan who fled to the mountains after their defeat in the Genpei War. One such hidden village, called Heikedari, still exists.

Kakurezato from *Konjaku Hyakki Shui*, the third book in Toriyama Sekien's Edo period Yokai collections. (1780) Toriyama Sekien.

Over time legends sprang up about these hidden villages. They had golden dragon fountains, and everyone wore white silk. People lived to be a hundred years old, with no separation between the rich and the poor. Often, they have magical implements, such as bowls that never empty of rice. A common feature of Kakure Zato is that if once found, they can never be found again. People who stumble upon them will need to go home for one important thing, then find they can no longer return. Because time flows differently in these hidden villages, they are considered some of the oldest versions of time travel stories.

Toriyama Sekien illustrated Kakure Zato in *Konjaku Hyakki Shui* (1781). He included characters from popular folktales such as a man who fell down a mouse hole to find paradise but was undone by his own greed. These would have been familiar to his Edo period readers. Katsushika Hokusai illustrated Kakure Zato in his *Hokusai Manga* (1814) series, showing mice hauling huge bails of rice and other food.

Tono Monogatari (1910) tells the story of a woman from a poor family who gets lost deep in the woods. She discovers a Kakure Zato and a beautiful home filled with beautiful things. Realizing she was not in the human realm. She fled. Later, she found a red bowl floating in a river. It said the bowl was in thanks for being virtuous and not stealing anything from the house. The bowl never emptied of rice, and she used this bowl to become the richest person in the village.

Kakure Zato live on in modern manga as the secret homes of ninja clans and Yokai. In his comic Kitaro, Mizuki Shigeru has the Yokai all living together in a Kakure Zato called Yokai Mura, or Yokai Village.

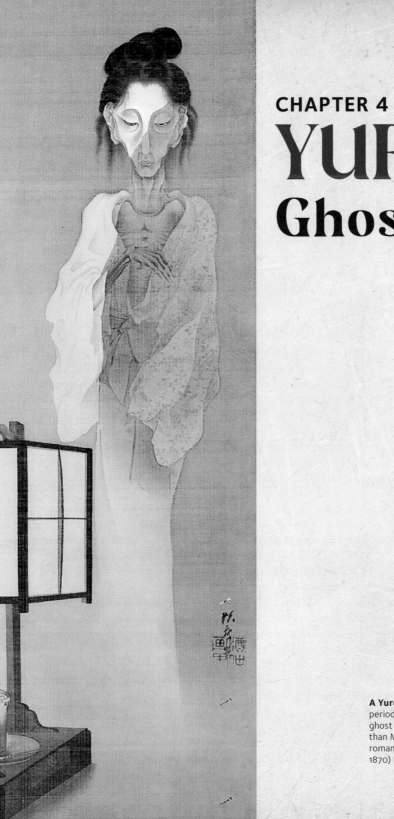

CHAPTER 4
YUREI
Ghosts

A Yurei in the Edo period style. Kyosai's ghost is more grotesque than Maruyama Okyo's romantic vision. (1868–1870) Kawanabe Kyosai.

What are Yurei?

Yurei are the easiest category to explain. They are ghosts. Spirits of the dead. Spooks.

Yurei are one of the oldest—if not the oldest—of Japan's supernatural pantheon. The pacifying of the souls of the dead was one of the earliest expressions of ritual, with ancestor worship and nature worship going hand-in-hand to form the religion now known as Shinto. Japan has a complex and sophisticated relationship with their dead. The living care for the dead, and the dead watch over the living in return.

Obon, the Festival of the Dead, is one of the most important holidays on the Japanese calendar. It is a time to honor ancestor spirits, when the walls between the living and the dead grow thin. Ancestor spirits come back to visit and are welcomed. Their graves are washed, and they are feasted at family gatherings. These are the peaceful dead.

But the dead do not easily move on. Attachment, strong emotions, can bind a soul to the living world. When this happens, the spirit manifests as a Yurei. They are bound to the living world by their desires. Yurei want something. And the best way to exorcise them is to give them what they want. With their attachment cut, they vanish. Rituals also soothe their souls. When they are acknowledged, respected, calmed, they can rest.

But some are not so easily satiated. Some have emotions so powerful they rage terror across the entire nation, forcing all to feel their pain. In all of Japanese folklore, there is nothing more terrifying than a Yurei.

> **Yurei** is written 幽霊
> 幽 (yu) – dim, faint
> 霊 (rei) – spirit

Whether Yurei are Yokai is one of the great questions of Yokai studies. In *Yokai Dangi* (1954) Yanagita Kunio

Chapter Four

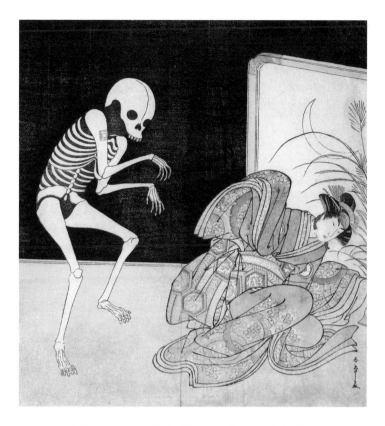

separated them, saying Yokai haunt places while Yurei haunt people. However, as with Yanagita's supposition that all Yokai are fallen Kami, a little bit of research shows this does not hold up. There are many Yurei stories of wayward souls haunting the places they did. Tokyo is full of stories of taxi drivers picking up Yurei and dropping them off at the graveyard, only at the end realizing they were carrying a dead passenger. Equally, there are stories of Yokai who target people. The Tsuchigumo appeared in Minamoto no Yoshimitsu's bedroom. Yuki Onna leave their frozen homes to fall in love with villagers.

Ancient Japanese Yokai enthusiasts included Yurei in their Yokai collections and painted them along hyakki yagyo scrolls. Toriyama Sekien included Yurei in *Gazu Hyakki Yagyo* (1776). The great Japanese masterpiece *Ugetsu Monogatari* (1776), published the same year, has some of Japan's most famous Yurei stories along with other Yokai. In *Yokaigaku Shinko* (1994), researcher Komatsu Kazuhiko concludes that while Yurei are a distinct category of Yokai, they are Yokai, nonetheless.

Yurei Ghosts

Onryo Vengeful Ghosts

He had run for hundreds of miles, leaving behind everything he knew and loved. Hiking up a mountain with no trail, he desperately thought that maybe here in forgotten lands he could lose her at last. But as he turned a corner and saw her standing there, blazing in all white, face twisted in rage, he knew that all was lost. The ghost of his wife would have her revenge...the woman he killed...her Onryo.

Onryo are vengeful ghosts. They are spirits of the dead who died with some great grudge or anger. Onryo are either invisible or appear as the person they were in life. They often wear a white burial kimono and a white face drained of blood. They are the most powerful and feared creatures in Japanese folklore. Their power is limitless. Wielders of fire, flood, and earthquake, they can kill hundreds in their thirst for revenge.

> **Onryo** is written 怨霊
> 怨 (on) grudge, vengeance
> 霊 (ryo) spirit

Onryo are the great villains of Japanese history. More than Oni or the Hyakki Yagyo or any other manifestation of supernatural energy. They have dictated the geography of the country, forcing the capital to be moved after every emperor until finally settling in its permanent location in Kyoto. Onryo drive storytelling, from *noh* to *kabuki* to manga to film. The modern movie genre J-Horror is almost entirely Onryo tales. And of all the Yokai, they are the most real.

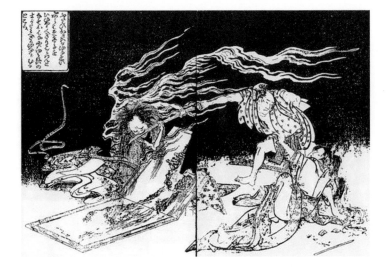

A samurai defends his wife from an attacking Onryo, in *Modern Kaidan: Shimoyakusei*, an early adaptation of the Onryo legend that would inspire *Tokaido Yotsuya Kaidan*. (1808) Katsuhika Hokusai.

The Onryo of Sugawara no Michizane summons thunder to attack the imperial palace, from the series *The Twenty Four Imperial Merits*. Suguwara no Michizane Evoking a Thunderstorm Above Kyoto (1881) Tsukioka Yoshitoshi.

Onryo stretch back to ancient Japan. That was a belief that all humans had what amounted to a god inside them, their soul called *reikon*. After death, if all went well, this *reikon* would pass on and become a guardian ancestor spirit, protecting the living. However, if a person died with negative emotions, such as hatred, then the *reikon* could manifest as an Onryo and exact revenge. The nature of this revenge depended on the nature of the grudge. It could target a single person or be a general rage that swept across the country. The only way to stop an Onryo is through ritual. Shinto rites can be held elevating them to goryo, honor spirits and Kami. This pacifies their rage. Sometimes.

The oldest known reference to Onryo is in *Shoku Nihongi* (797), saying Fujiwara Hirotsugu caused the death of Genbo, scholar of the imperial court at Nara. Hirotsugu had died in 740, executed for his role in raising an unsuccessful rebellion.

Genbo had supplanted his influence in court leading to Hirotsugu's exile. Genbo was eventually exiled and died, with Hirotsugu's Onryo given credit. Hirotsugu's Onryo was also thought to be responsible for a tuberculosis epidemic. A ritual was held to elevate Hirotsugu to goryo in 863.

The Three Great Onryo of Japan are Emperor Sutoku, Taira no Masakado, and Sugawara no Michizane. The story of Emperor Sutoku is told in the entry on the Three Great Evil Yokai. He is the only one evil enough to make both lists. Masakado was another who led some failed rebellions before being beheaded at the Battle of Kojima in 939. His head is said to have flown all the way to Edo in its rage. A shrine was built where his head landed, where it stands to this day. Sugawara no Michizane was a scholar and poet. He found himself in political intrigue with rival Fujiwara no Tokihara, resulting in Michizane's exile and death. His Onryo brought plague and drought and killed the sons of Emperor Daigo. The imperial palace was struck by lightning and battered by storms. To pacify him, they deified Michizane, raising him to be the god Tenjin. The Kami of scholarship, Tenjin is still worshipped across all of Japan today.

The Onryo of the Heian period tended to be aristocrats who died because of palace intrigue. By contrast, the Onryo of the Edo period tended to be poor and helpless who only found their power after death. Oiwa is the most famous of these, the murdered wife of Iemon who took her vengeance to an artful level. Oiwa played with her murderous husband like a cat with a mouse.

Ikiryo Living Spirits

She woke suddenly, wondering why she was lying on the corridor floor. In another room she heard screaming, as the palace was aroused saying her ladyship had been killed. Oh no, she cried. It couldn't be. But in her heart, she knew it was. Her jealousy had caused her spirit to fly from her body and murder her ladyship. Her Ikiryo.

Ikiryo are ghosts of the living. They are caused through a separation of your *reikon*, your soul, leaving your body while still alive, thus gaining access to its ghostly powers. This is most often caused by strong emotions such as jealousy or hate. The person whose spirit leaves their body is often unaware it even happened.

Ikiryo is written 生霊
生 (iki) life
霊 (ryo) spirit

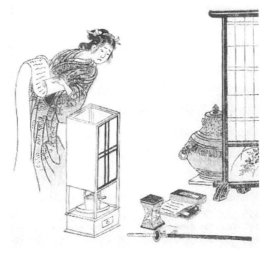

Ikiryo are rare in Japanese storytelling. It takes something tremendous for a living person to gain access to the powers available to them after death. Ikiryo generally take the form of invisible assassins or as doppelgangers of their physical body. They can possess others and tend to be more personal and targeted in their vengeance than the wrathful Onryo.

The first and most famous Ikiryo comes from *Genji Monogatari* (11th century). In the story, Genji's lover Lady Rokujo's jealousy manifests her Ikiryo to torment and eventually kill Genji's pregnant wife Aoi. The story became a famous no play, *Aoi no Ue* (14th century). After her death, Lady Rokujo also became an Onryo further tormenting those Genji dared find favor with. Lady Rokujo became the template for stories of the vengeful ghosts of women so popular in the Edo period and the modern J-horror genre.

Other cases involve possession. In *Okinagusa* (1791), Kanizawa Horiuchi records the story of a boy named Matsuoka, who was possessed by the Ikiryo of two women who loved him. The women were able to speak through his lips and apparently cause him to hover in midair. A priest named Zokai performed an exorcism freeing Matsunoke of the Ikiryo spirits.

There are other instances of souls leaving their body before death for reasons other than vengeance. Omakage describes ghostly visits home from those on the brink of death. During World War II families reported visitations from children who were dying hundreds of miles away on unknown pacific islands. Yanagita Kunio recorded an ability called *tobi-damashi*, which was essentially voluntary astral travel.

Hanako San Toilet Girl

You have heard the rumors. You creep silently to the third bathroom stall. There is no one else there, and the silence chills you. Summoning your courage, you knock three times on the stall door and whisper "Hanako San, are you there?" The door slowly opens....

Hanako San, also known as Hanako of the Toilet, is the spirit of a girl killed during a World War II bombing raid. She wears a red skirt and has bobbed hair. Hanako haunts the toilet where she was killed, and rumor has it that if you knock three times and call for her, she will appear and drag you into the toilet to kill you.

> **Hanako San** is written 花子さん
> 花子 (Hanako) Hanako, a girl's name
> さん (san) san, an honorific, like miss

Hanako San, the spirit of a little schoolgirl who haunts a toilet. (2023) Image courtesy Cat Farris.

Hanako San is often characterized as an urban legend. Much like Kuchisake Onna, Hanako San was born from the whispers of school children. Urban legends are modern folklore, often presented as true stories overheard by a friend of a friend. What separates urban legends from traditional folklore is time. Many Yokai in this book were once urban legends of the Heian and Edo periods. Given enough time, urban legends become tradition, and new Yokai are born.

Hanako San is part of a long history of bathroom Yokai. Kanbari Nyudo is said to come out on New Year's Eve and peek in on people using the toilet. The cry of the cuckoo gives away the invisible monster. Kanaide is a set of hands that reach up from the toilet bowl and stroke people's bottoms on the festival of *Setsubun*. Karasade Baba is more vicious. It is said she rends the flesh of those sitting on the toilet she haunts with her claws.

Hanako's story is a form of *kimodameshi*, or test of courage. This evolved from the Edo period game *Hyakumonogatari Kaidankai*, where people told scary stories, challenging each other to be the first to stop the contest out of fear. This evolved to challenges to walk down forest paths at night or knock on haunted bathroom stalls. *Kimodameshi* are usually played in summer months, the traditional Yokai season. Western equivalents include the Bloody Mary catoptromancy where a horrific ghost is summoned by staring at a mirror and repeating her name thirteen times.

In *Gendai Minwa* (1987), folklorist Matsutani Miyoko says Hanako San stories started around 1948 in Kitakami City, Iwate Prefecture. Originally called Hanako of the Third Stall, the ritual was the same. However, instead of a ghostly girl, Hanako San was a pair of white hands that reached up from the toilet. Her story remained local until the mid-1980s, when schoolteacher Tsunemitsu Toru began gathering children's ghost stories. He asked students for legends that took place at school and received 160 in two weeks. Tsunemitsu published these in *Gakko no Kaidan* (1990), which included the story of Hanako San. Tsunemitsu published three volumes in the series, all of which were later adapted into a television series.

The 1990s saw an explosion in interest in occult and supernatural phenomena not seen since the Edo period. TV programs showcased alien abductions, local monsters, and ghost stories. Tsunemitsu's school ghost stories arrived at the right time, captivating audiences. This modern folklore found its way into academia and entertainment, inspiring movies, video games, comics, and more. Hanako San, now dubbed Hanako of the Toilet, was one of the most popular. Matsuoka Joji adapted her story as the film *Toire no Hanako San* (1995).

Hanako's story expanded, giving her an origin, a physical form beyond a pair of arms, and in some cases even companions. Her boyfriend Taro was said to haunt the boy's bathroom in the same way. As is often the case, Hanako San eventually evolved from her horrific origins into a sympathetic figure, appearing in comic series such as *Hanako and the Terror of Allegory* (2005) and the children's game franchise *Yokai Watch* (2013).

Kyokotsu **Well Ghosts**

Be careful when you pull up a bucket of water from an ancient, abandoned well. You might get more than you bargained for if a Kyokotsu springs up from the bucket like a Jack-in-the-Box to deliver its curse.

Clad in a white burial kimono, Kyokotsu look like a classical Yurei with white skin and white kimono, but with shocks of white hair that spring from its bleached-white skull. They appear as little more than bones wrapped in a shroud. Kyokotsu are the spirits of bodies thrown down wells and forgotten.

> **Kyokotsu** is written 狂骨
> 狂 (kyo) crazy, insane
> 骨 (Kotsu) bones, skeleton

In Japanese folklore, water was a channel to the world of the dead, and the bottoms of wells were directly connected. Wells also served as a convenient hiding place for murders committed in the dark of the night. Others died from falling in wells, by accident or murder. Their forgotten bones connect to the well. There are several stories of abandoned bones in Japanese folklore.

Toriyama Sekien illustrated Kyokotsu in *Konjaku Hyakki Shui* (1781). There are no prior mentions of this spirit, and it is most likely a Sekien creation.

It is thought that Kyokotsu derives from a play on words. In some regional dialects, such as Kanagawa Prefecture, the term Kyokotsu, meaning "crazy bones," was used as slang for those with a piercing or wild look about them. It is also possible Sekien was referencing *gyokotsu*, meaning dried bones, and *keikotsu*, meaning "from the bottom," which was a term for drifters. Most likely Sekien thought of the name Kyokotsu and designed a Yokai to match these meanings.

Itsuki Suicidal Specters

Peacefully walking home one night, without a care in the world, you are suddenly overcome with an irresistible desire to hang yourself. You look around for rope, cords, anything you can use to end your life by strangling. Finding what you need, you begin to carefully climb a tree, caught in the grips of an Itsuki.

Itsuki are the Yurei of those who died by hanging who seek to lure others to follow. They are invisible and only make their presence known when someone otherwise fine is suddenly overcome with a desire to strangle themselves. This is the only way Itsuki are able to free themselves from hell, by forcing another to take their place.

> **Itsuki** is written 縊鬼
> 縊 (i, kubiru) strangle
> 鬼 (ki, oni) Oni

Itsuki come from Chinese legends, where it is said the underworld always maintains an exact population. In order to be reborn, someone must die in the same manner. Because of this, the ghosts waiting in Meikai, a shadowy underworld, eagerly away the deaths of the living. Itsuki are the spirits of those who died of suicide by hanging. Impatiently waiting for someone to hang themselves, they travel to earth to encourage suicides.

Kyokotsu from *Konjaku Hyakki Shui*. This is Sekien's original creation. (1780) Toriyama Sekien.

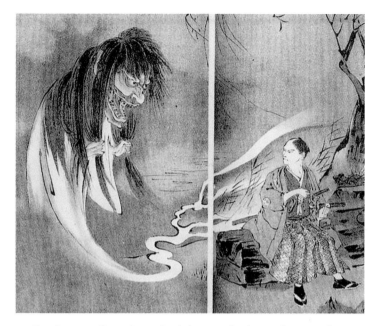

Itsuki were first described during the late Edo period, in volume one of Monono Suzuki's series, *Hogo no Uragaki* (1848). The story tells of a massive banquet, where an honored guest suddenly announces they must hang themselves from Kuichigai gate. He is held down by fellow revelers until the urge passes. Later, they learn a different person hung themselves from Kuichigai gate and speculate the Itsuki found another victim.

Itsuki were illustrated by Kubota Beisen in *Yasokidan* (1889). His illustration shows a Yurei with an exaggerated, oversized head. This has become the template for all depictions of Itsuki.

Ubume Ghastly Mothers

At night you are approached by a terrifying apparition. A woman, naked from the waste up, holds a baby in her arms. Her clothes below are soaked in blood. Crying desperately, she holds out her child to you. "Please, take my baby," she begs. Feeling pity, you take the child. In an instant you realize your mistake, as the baby grows in weight, dragging you to the ground. You are the victim of an Ubume.

Ubume are women who died while pregnant. Their attachment to their unborn child drives them mad, and they haunt the living world seeking either comfort or revenge, depending on the story. Ubume appear as living women and are distinct from other Yurei mothers by their blood-soaked

Itsuki, called a Kubireoni, from the book *Ikai Mangekyo.* (1889) Kubota Beisen.

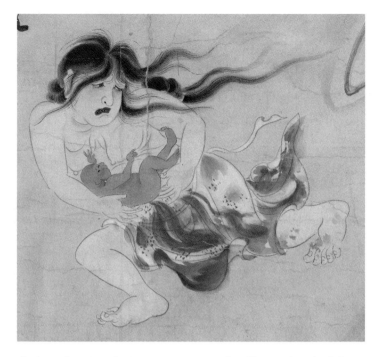

Ubume from the *Bakemono no e* scroll illustrating various kinds of Yokai. (17th or 18th century) Artist unknown.

clothes showing their connection to the Chi-no-ike, the lake of boiling blood in hell. In some legends they are birds.

> **Ubume** is written 産女
> 産 (umu) birthing
> 女 (onna, me) woman

From ancient times Japan has believed in a system of ancestor worship that requires propagation. New children must be born to care for the graves of those who came before. Beginning around the Kamakura period (1118–1333), it was thought that a woman who died while pregnant had committed a grave sin. As they were a vessel for their unborn child, they had in essence murdered their child and ended the line. For this the woman's soul would be condemned in hell to the Chi-no-ike. In addition, in Buddhism, attachment to the living world could cause restless spirits. To pacify these women, it was recommended that fetuses be cut out and placed in their arms for burial. If not possible, a doll might be used as a substitute.

Ubume are a mix of legends, from a magical bird called Kokakucho, to a lethal woman called Nagare Onna, and a pitiful mother who died mourning her unborn child. They have origins in China, where they appear in the Tang Dynasty

Youyang Zazu (9th century) as nocturnal birds that steal human babies. It's said these birds are the souls of women who died in childbirth.

Stories of ghostly mothers appear in Japanese literature as early as *Konjaku Monogatari Shui* (12th century). In these legends, a woman, known as Nagare Onna, stands on the side of a river and tries to get someone to hold her baby as they cross. Anyone who helps her finds themselves drowned as the baby increases in weight. *Kokon Hyaku Monogatari Hyoban* (1686) says a woman who dies while pregnant is bound to the living world and is soaked in blood below her waist. *Kizo*

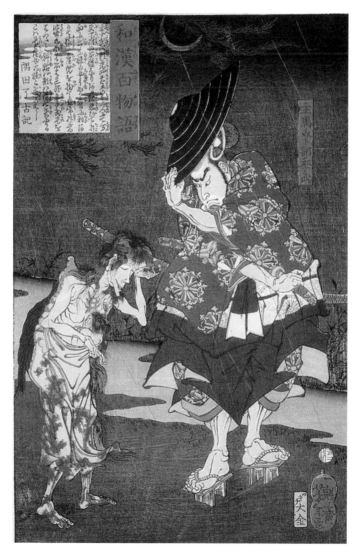

Urabe no Suetake encounters an Ubume. Urabe no Suetake was a Heian period samurai in the service of Minamoto no Yorimitsu. The 12th century *Konjaku Monogatari* tells of an encounter between Suetake and an Ubume. She handed him a baby on a riverbank, but when he reached the other side, he found himself holding a leaf. From *One Hundred Tales of China and Japan.* (1867) Tsukioka Yoshitoshi.

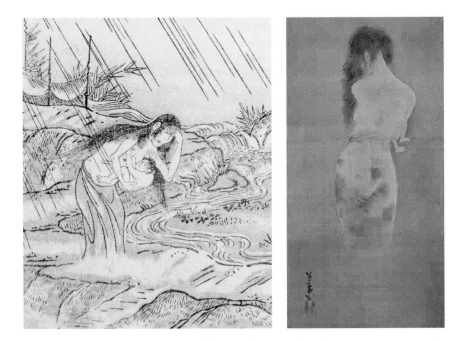

Danshu (1687) tells a happier story of an Ubume. In it, the body of a woman who died in childbirth is flung into a field. Her baby does not die, however, and is born from her dead body. The mother's spirit manifests, carrying the child. She is soaked in blood from the waist down. It says anyone brave enough to take the baby will become wealthy.

Ubume legends tend to be regional, mixing some versions of the bird, the mother, and the vengeful spirit. They go by different names, such as Ugume in Saga Prefecture, or Obo in Fukushima Prefecture. In some, the baby is equally dangerous, biting the faces of those who hold it. In others, it is not a baby at all, but a rock or even a statue of the deity Jizo.

Wakan Sansai Zue (1712) had an entry for Kokakucho describing the bird of Chinese legend. Sawaki Sushi painted an Ubume in *Hyakki Zukan* (1737) without using kanji, creating a classic image of a blood-soaked woman carrying a baby. Toriyama Sekien combined the various legends in *Gazu Hyakki Yagyo* (1776). He used the kanji for Kokakucho but subtitled it Ubume, then showed a woman with a child in the river referencing the Nagare Onna legends. Ubume became a popular subject for Edo period artists, appearing in *Bakemono Emaki* (18th century?) and Yosa Buson's whimsical *Buson Yokai Emaki* (18th century). When Mizuki Shigeru used Ubume for his comic *Kitaro*, he returned to the Chinese roots depicting a monstrous, child-stealing bird.

Ubume (top left) holding her child from *Gazu Hyakki Yagyo*. (1776) Toriyama Sekien.

A dead mother cradles her child (top right) in this poignant image. The blood from the waist down marks her as an Ubume. 19th century) Tsukioka Yoshitoshi.

Chapter Four

Kosodate Yurei Maternal Ghosts

The woman slipped into the store at night, just before closing. She looked ragged and tired and pale. Holding her baby tight in her arms, she bought some candy and slipped over a few coins. Taking the candy, she vanished into the night. The coins she laid on the counter were covered in dirt, and the shopkeeper knew he had been paid a visit by the Kosodate Yurei.

Like Ubume, Kosodate Yurei are women who died while pregnant. However, their babies did not die with them but were born from their dead wombs. The mother's spirit manifests at night and tries to buy trifles for her child, small toys and candy. Stories often end when people track the Kosodate Yurei to her grave and dig up the still-living child.

> **Kosodate Yurei** is written 子育て幽霊
> 子育て (kosodate) child-rearing
> 幽霊 (yurei) ghost, Yurei

Legends of Kosodate Yurei are found all over Japan. Told as urban legends, they are repeated with slight variations. In his book *Nihon no Yurei* (1978), Ikeda Yasaburo told of a local version he had heard from Tsukiji fish market in Tokyo. The bereft mother bought amazake sweet sake for her child. They are distinct from Ubume in that they are not covered in blood and represent a mother's love stretching beyond death instead of Buddhist punishment.

Kosodate Yurei stories are often linked to rokumonsen, the six coffin coins placed in graves to pay the tolls to the underworld. The story may continue for five nights until on the sixth night the body is dug up showing only the one remaining coin. In other tales, the Kosodate Yurei changes leaves into coins, which return back to leaves after they vanish.

Kosodate Yurei have their origins in China, where they can be traced back to the book *Yijian zhi* (12th or 13th century), with the story of the mochikae onna, the rice cake-buying woman. It tells the story of an odd woman coming to a shop every night with her baby to buy sweet rice cakes. Finding her suspicious, the shopkeeper stealthily tied a red string to her and followed her after she left. The string led to a grave. When the grave was dug up, they found her living child she had given birth to in her coffin. The woman's family was overjoyed to find the child still alive.

It is thought that stories of Kosodate Yurei were spread as Buddhist parables, showing children why they should be grateful to their parents. In many cases, the children of

these ghostly mothers were blessed and grew up to become great priests. They were often marked by streaks of white hair. Zuhaku Shonin, priest of the Tendai sect, was called White Head for the pure white hair he was born with. Tsugen Jakurei, head of 16,000 temples of the Soto sect, was also the child of a Kosodate Yurei.

A famous *rakugo* performance was set in Kodaiji temple in Kyoto, playing on the pun of the name "Kodaiji" sounding like "caring for children." Never one to let a good legend go by, Minatoya candy shop in Kyoto produced kosodate ame, or kosodate candy, claiming to be the shop where the Kosodate Yurei came calling.

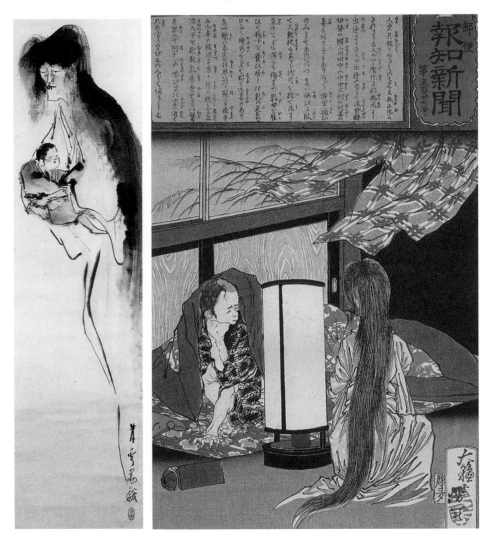

YOKAIOLOGY
Nihon san dai Yurei
Three Great Yurei of Japan

Yurei have long haunted Japan. From the Onryo of the Heian period such as Sugawara no Michizane whose angry spirit ravaged the country until it was placated by being enshrined as the deity Tenjin, to lesser-known spirits who appeared for only a little while before vanishing into the ether. Japan is the most haunted country on earth.

But only three Yurei have persisted through the centuries, being rediscovered by new generations, and remade anew. Ghosts of love, ghosts of hate—Oiwa, Otsuyu, and Okiku. Their stories have never stopped being told since they first rose again from the grave in spectral glory.

> **Nihon san dai Yurei** is written
> 日本三大幽霊
> 日本 (nihon) – Japan
> 三 (san) – three
> 大 (daiaku) – great
> 幽霊 (yokai) - ghost, Yurei

No one knows exactly where this list was first created, but there is no disagreement with its contents. Unlike the Three Great Onryo of Japan and Three Great Evil Yokai who all hail from the Heian period (794–1185), the Three Great Yurei of Japan come from the Edo period (1603–1867). All three have stories that found their way into popular Edo period theater, and then were adapted to film. New versions of their stories are regularly filmed every decade or so, with each generation getting their own bespoke version.

Oiwa – Tokaido Yotsuya Kaidan

Oiwa was the wife of Iemon, a poor samurai resentful of his lowly status. Oume, the daughter of a rich merchant, fell in love with Iemon. Oume's father Ito Kihei conspired with Iemon to rid himself of his wife Oiwa so he would be free to marry Oume. Poison was secured and administered to Oiwa, but not in enough quantity to kill her. Instead, the side of her face melted like candle wax and chunks of her hair fell out. Even more horrified at her appearance, Iemon nailed Oiwa to a door and set her adrift in

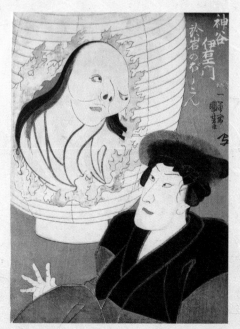

Oiwa appears before a frightened Iemon played by Danjuro VII in the *kabuki* play *Tokaido Yotsuya Kaidan* (1848) Utagawa Kuniyoshi.

the river to kill her. On his wedding day, Iemon raised the veil of Oume only to see Oiwa's ruined face. He beheaded her instantly. But of course, it was Oume he had killed. Fleeing, Oiwa chased after Iemon, tormenting him. She caused the deaths of all of those around him but kept Iemon alive. Finally, at a confrontation at Snake Mountain, Iemon met his end.

Oiwa was created by playwright Tsuruya Nanboku IV for his *kabuki* play *Tokaido Yotsuya Kaidan* (1825). The play was an overnight success. Artists created print after print of Oiwa and her ruined face. Perhaps the most famous by Katsushika Hokusai in his *Hyaku Monogatari* series (1830). It shows a scene in the play of Oiwa emerging from a lantern to torture Iemon. The first film adaptation of her story was made in 1912 and has been adapted multiple times into every medium. Oiwa is one of the models for Yamamura Sadako in *Ring* (1998).

Otsuyu with her attendant (top) carrying the peony lantern from Lafcadio Hearn's *Kwaidan.* (1904) Takeuchi Keishu.

Otsuyu's maid (left) waits outside carrying the peony lantern. (1892) Kunichika.

Otsuyu – Botan Doro

Lonely samurai Ogiwara Shinnojo sat on his porch the night of Obon, when a lovely woman and her servant came by, bearing a peony lantern. The woman was named Otsuyu, and she and Ogiwara swiftly fell in love. She would stay the night and always leave before morning. One night a nosy neighbor peeked in on them, seeing Ogiwara embracing a skeleton. Realizing Otsuyu was dead, he told Ogiwara who covered his house with protective amulets. That night when Otsuyu came, she begged Ogiwara to remove the amulets so they could be together. Overcome by love, he did as she asked. The next day his dead body was found embracing Otsuyu's skeleton, a look of bliss upon his face.

Otsuyu's story originally comes from the Chinese *Jiandeng Xinhua* (1378) as a Buddhist parable. It was adapted into Japanese by Asai Ryoi in *Otogi Boko* (1666) removing the didactic elements and creating a romance. It was adapted into a *rakugo* play and later *kabuki*. The first film version was in 1910, and Otsuyu's story continues to be adapted today.

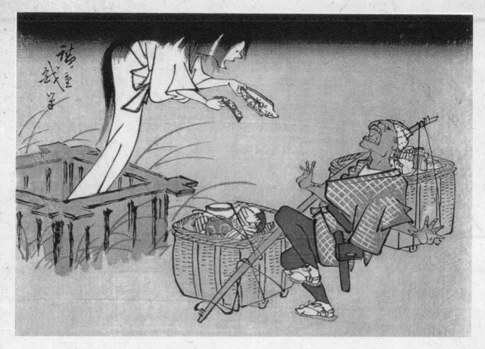

Okiku – Bancho Sarayashiki

Okiku was a servant to Aoyama Tessen. He attempted to seduce Okiku, but she refused. When Aoyama broke one of his family's precious heirloom plates, he threatened to blame Okiku if she did not relent. She still refused and Aoyama had her thrown down a well. Nightly, Okiku's ghost rose from the well counting the plates, looking for the tenth plate that had been her doom.

While Oiwa and Otsuyu have their roots in literature and theater, Okiku was born from a folktale. There are many versions told across Japan set in various locations. The most famous is the grand Himeji castle, where the Well of Okiku is a popular tourist attraction. Okiku's story was adapted into *bunraku* puppet theater in 1741, and later *kabuki* in 1850. The first film adaptation was in 1914 and there have been many since. Like Oiwa, her story was a model for Yamamura Sadako in Ring (1998).

The Yurei of Okiku (top). (1830–1844?) Utagawa Hiroshige.

Okiku (bottom) rises from the well trailing the plates behind her in her ghostly form. From the series Hyakumonogatari. (1831) Katsushika Hokusai.

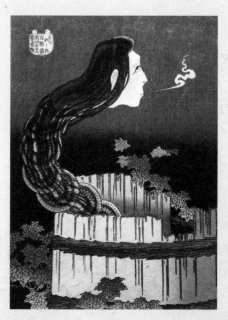

Hone Onna Lovesick Specters

The woman you love loved you back. There was nothing more perfect in the world. After a night of passion, you held her in your arms falling blissfully asleep. But you awoke to horror. Instead of your beautiful lover, you found yourself tangled in a pile of bones—a Hone Onna.

Hone Onna are the Yurei of women who come back from the grave for love, either in search of that which they have never known or to spend one last night with their husbands. They appear as flesh and blood women at night, with only the light of day exposing them as the skeletal remains that they truly are.

Hone Onna is written 骨女
骨 (hone) bone
女 (onna) woman

To appear as a Yurei requires a powerful emotional attachment to the living world. In most cases these attachments are born of negative emotions such as hatred, jealousy, or revenge. But sometimes they are gentler emotions of love and loneliness. A woman who died a premature death, having never known love, might seek out one to fulfill that need. Another might long for a husband who left them for business or to seek their fortune, dying slowly hoping to see their beloved one last time.

Hone Onna appear as far back as *Konjaku Monogatari* (12th century). In the story *In which a wife, after death, meets her former husband,* a samurai living in poverty is summoned by his lord to an important duty in a distant land. Eager to rise to his new station, the samurai abandons his wife of many years and takes a new woman with him to his post. Years later, his duty discharged, he finds himself longing for his wife. He goes back to their old home and finds her there. She is not resentful at being abandoned and greets him lovingly. Swearing never to leave her again, he embraces his wife. He awakes the next morning embracing her skeletal corpse in the dilapidated remains of their old house.

In 1666, author Asai Ryoi adapted a Chinese tale from *Jiandeng Xinhua* (1378) of a woman Yurei in search of love. In the story renamed Botan Doro, the Yurei Otsuyu seeks out the living Ogiwara Shinnojo. They become lovers, and eventually Ogiwara choses death with his ghostly love Otsuyu than life without her. Otsuyu's story became one of the most beloved in Japan, where she is one of the Three Great Yurei of Japan.

Hone Onna (facing page) as interpreted by Sekien from *Konjaku Gazu Zoku Hyakki.* (1779) Toriyama Sekien.

これは、骨女

牡丹燈記とくあり

これは、仲好らうてよろこべる年ふる女の髑髏 牡丹の燈籠と

えへ人ゆへの愛をなせし⋯形うつくしくは夢燈新話のうちよ

Toriyama Sekien illustrated Otsuyu as Hone Onna in
Konjaku Gazu Zoku Hyakki (1779). His illustration references
Otsuyu and Botan Doro, showing a thin woman not quite
skeletal but not quite human either.

Lafcadio Hearn adapted the story of the Hone Onna as
"The Reconciliation" in his book *Shadowings* (1900). This
was adapted by Kobayashi Masaki as "The Black Hair" in his
film *Kwaidan* (1964).

Funa Yurei Drowned Spirits

Your boat stalls in a sudden calm in what should have been a briskly moving sea. Fog gathers, obscuring the moon overhead. In terror, you see lights rising from the deep. As the first white head crests the water, you hear their whispering demands. "Give us a *hishaku*. Give us a spoon." You know you are surrounded, trapped by Funa Yurei.

Funa Yurei are the ghosts of those who drowned at sea. They seek to swell their ranks by drowning boats that come into their path. Funa Yurei appear as other Yurei, in white funeral robes even though their drowned bodies were never given a proper burial. Funa Yurei demand a *hishaku*, a bamboo ladle. If given one, they will use it to fill the boat with water and sink it. If refused, they swarm the decks and capsize the boat.

> **Funa Yurei** is written 船幽霊
> 船 (funa) boat
> 幽霊 (yurei) ghost, Yurei

Funa Yurei legends appear across Japan with variations. They usually appear on rainy or foggy nights. Funa Yurei are sometimes depicted as sailing phantom ships, but usually arise first as glowing lights from the sea before manifesting physical form. Funa Yurei appear in traditional funeral wear, including the white triangle hat associated with Edo period burials. This shows Yurei manifest in traditional burial

A massive Funa Yurei attacks a boatman. (19th century) Kawanabe Kyosai.

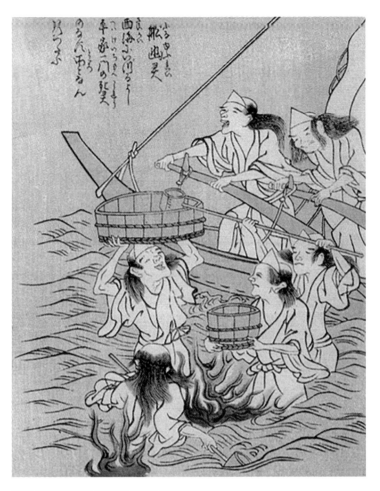

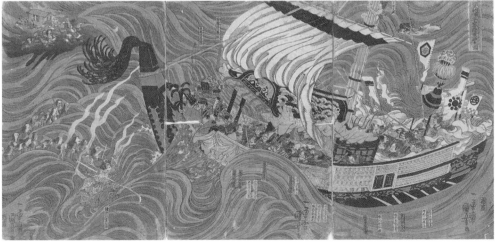

Funa Yurei (top) from *Ehon Hyaku Monogatari.* (1841) Takehara Shunsensai.

The ghosts of the defeated Heike clan (bottom) attack Yoshitsune's ship at Daimotsu Bay in Settsu province. (1839–1842) Utagawa Kuniyoshi .

Yurei Ghosts

舟幽霊

両国まさは小國をも海上の風
をげしく浪ろきとまさ、波のよる
人のうちのものあらくあるそれ
感るき柄杓なく水を波すあり
これと舟幽霊とこれにらうら
毎の揖をさくゆくえもよな瑶鱸の
残ト（略）

costume regardless of if their bodies were actually dressed
in it or not. The most common defense against Funa Yurei
is to hand them a *hishaku* filled with holes, so that the water
drains out before they can drown the ship. Frustrated, they
will sink back into the sea. In other legends, you can disperse
them by flinging a lighted match at them or satiate them with
offerings of incense, rice, or beans.

Funa Yurei are speculated to have Chinese origins. In
Keirin Manroku (1800), Morishima Churyo writes of *guǐ kūtān*,
a beach near the Hainan Islands called "ghost crying beach."
Sailors are warned that if they sail into these waters their ship
will be swarmed by more than a hundred hairless dead bodies.
These ghosts can be evaded by throwing rice at them.

Funa Yurei from
*Konjaku Gazu Zoku
Hyakki.* Sekien's
version shows only
the waves. (1779)
Toriyama Sekien.

Toriyama Sekien illustrated Funa Yurei in *Konjaku Gazu Zoku Hyakki* (1779). Interestingly, he does not show the ghosts at all, only implying their existence in cresting waves. Takehara Shunsen did a more graphic representation in *Ehon Hyaku Monogatari* (1841), showing Funa Yurei crewing their phantom ship carrying buckets and ladles looking for boats to drown.

And explanation for Funa Yurei has been proposed as a nautical effect of dead water, where water layers of fresh and saltwater form internal waves that can slow down ships to a standstill. This combined with atmospheric ghost lights such as St. Elmo's fire or luminous jellyfish create the illusion of lights under the ocean waters.

Yurei Taxi Haunted Taxis

As the driver opened the door to let the young woman in, a chill ran down his spine. He picked her up outside of Aoyama cemetery, which was not unusual. Many people visited recently deceased relatives or friends. But his fellow cabbies had whispered stories of just such a woman. When she said the address, he knew. This was no living person riding in the back of his cab. This was one of the wandering souls trying to get home on a Yurei Taxi.

The Yurei of Japan are not confined to ancient graveyards and shadowy haunted shrines and the taxis of Tokyo are more haunted than hearses. Many cab drivers can tell tales of ghostly passengers who climb in, ask to be taken to a destination, then mysteriously vanish before paying their toll. Since taxis appeared around the late Taisho period Yurei have long been hailing cabs to find their way home.

> **Yurei Taxi** is written 幽霊タクシー
> 幽霊 (yurei) ghost, Yurei
> タクシー (takushi) taxi

Yurei Taxi legends have been told for decades, usually with a similar pattern. A driver picks up a passenger, either a customer for a taxicab or a hitchhiker. The passenger says little but requests a destination. Upon arrival, the driver turns around to find the passenger vanished—always leaving some trace as proof they existed. The trace can be a lost glove, or a puddle of water from the rain. There is often some additional confirmation, such as a graveyard with their name, or a father coming out to pay the fare. The father explains to the confused cabbie that his daughter died tragically, and occasionally hails cabs in an attempt to go home.

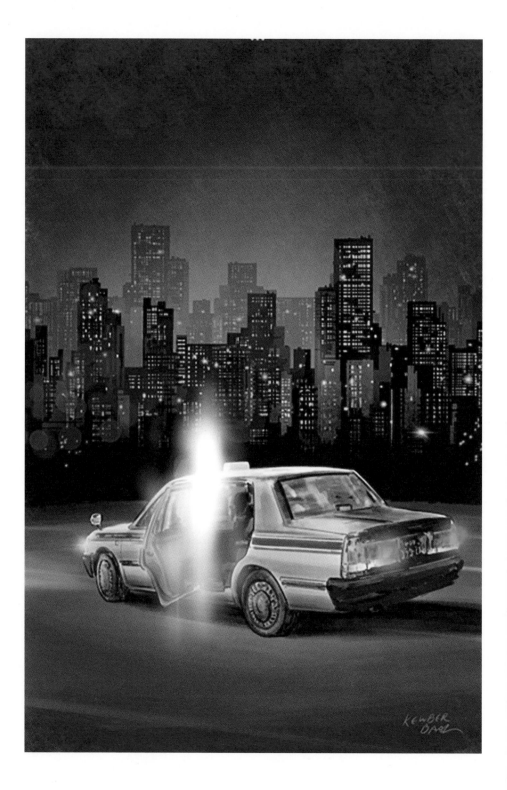

Chapter Four

Stories of phantom passengers and driverless vehicles have long been told in Japan. In *Mujara* (1998), folklorist and artist Mizuki Shigeru talks about a phantom rickshaw seen around the Gotembo area. A white rickshaw with an unknown family crest was seen near burial mounds or places where murders occurred. In the 1930s, there were rumors of a driverless taxi operating near the Imperial Palace. Those who saw it were said to meet with accidents within seven days. More common are ghostly passengers who suddenly vanish. These stories have parallels worldwide, generally known as Vanishing Hitchhiker legends. Stories of Yurei Taxis tend to increase after natural disasters or instances of mass death. Following the 2011 Fukushima disaster, the news was full of accounts of ghostly passengers hailing cabs. They are always told as true stories, not legends—and maybe they are.

Like many ghost stories, tales of Yurei Taxis have found their way into popular entertainment. Ryutei Chiraku adapted the stories into the *rakugo* performance *Yurei Taxi* which was adapted to film in 1956. A comic called *Yurei Taxi* (1957) by Tatsumi Yoshihiro was the first labeled *gekiga*, an adult approach to comics more akin to the English language graphic novel.

Dorotabo **Vindictive Parents**

Coming back from a night of carousing, the wastrel son tromps through the neglected fields, staggering towards his house. His inheritance meant he could live an easy life, not subject to the hard labor of his parents. Suddenly, his foot got stuck in the mud. Looking down, he sees a three-fingered hand wrapped around his ankle. The face of his father emerges from the muck of the rice paddy, mouth open in rage. The son knew his mistake, watching in horror as his father rose as a Dorotabo.

Dorotabo are the spirits of parents whose children neglected the rice fields they labored so hard to build. They are formed from the mud of the thick paddies, with a single bulging eye and three-fingered hands.

Dorotabo is written 泥田坊
泥田 (dorota) rice paddy with thick layer of mud
坊 (bo) monk, boy

A Yurei (facing page) climbs into a taxi at night. (2023) Image courtesy Kewber Baal.

Rice fields are generational possessions. Even now, families might own a single rice field in the countryside which they come home to seasonally to manage and harvest. These rice fields often reap enough rice to feed the family for the year.

泥田坊
<ruby>泥田坊<rt>どろたぼう</rt></ruby>

むかし<ruby>小國<rt>せうこく</rt></ruby>よ
<ruby>翁<rt>おきな</rt></ruby>ありて<ruby>子孫<rt>しそん</rt></ruby>のため
いさゝかの<ruby>田地<rt>でんぢ</rt></ruby>をひらく
<ruby>風雨<rt>ふうう</rt></ruby>をさけず<ruby>時〻<rt>じ〳〵</rt></ruby>の<ruby>耕作<rt>かうさく</rt></ruby>おこたらず
しこうして<ruby>翁死<rt>おきなし</rt></ruby>してより その子
<ruby>酒<rt>さけ</rt></ruby>をこのみ<ruby>農業<rt>のうげふ</rt></ruby>を<ruby>事<rt>こと</rt></ruby>とせずその<ruby>田地<rt>でんぢ</rt></ruby>を<ruby>他人<rt>たにん</rt></ruby>のもの
おろ〳〵<ruby>目<rt>め</rt></ruby>の<ruby>一<rt>ひとつ</rt></ruby>あるくろきものいでゝ<ruby>田<rt>た</rt></ruby>へせくとのゝしりける
<ruby>泥田坊<rt>どろたぼう</rt></ruby>といふよし

A Dorotabo (facing
page), rises from a
neglected field to
enact revenge, from
Konjaku Hyakki Shui.
(1780) Toriyama
Sekien.

In the Edo period (1603–1868), rice was both currency and
sustenance. Families' entire fortunes could be tied to the rice
fields that they worked lifetimes to acquire. Neglect of these
fields was a grievous sin.

Dorotabo first appeared in Toriyama Sekien's *Konjaku
Hyakki Shui* (1781). There are no other records of Dorotabo,
and it is most likely a Sekien invention. Sekien's entry
speaks of an old man who purchased a small field for his
heirs. He worked it day and night, in wind, rain, or blazing
sun. When he died, his son inherited the field. But his son
was interested in drinking, not working. He sold the field to
pay his debts. In the paddy appeared a dark, one-eyed figure
every night screaming "Plow my field!"

There is much speculation over Dorotabo. Japanese liter-
ature scholar Abe Masamichi notes that the five fingers on
the human hand represent three vices and two virtues. The
three-fingered Dorotabo has only the vices, hatred, greed,
and folly, without the virtues of wisdom and mercy. The
name is thought to reference the proverb of "beating a mud
field with a stick" which means doing something reckless.
Another theory is it references the pen name of *kyoka* poet
Shinagawa Genko who went by Dorotabo Yumenari. Sekien
exchanged poems with Shinagawa and may have been
inspired by his name.

On the other hand, Yokai researcher Tada Katsumi
says Dorotabo is a play on words, representing the Shin-
Yoshiwara pleasure quarters. Also known as Yoshiwara
fields, to "plow the fields" was a euphemism for sexual activ-
ity and "*doro*" was slang for debauchery. Dorotabo might
be a commentary on this, as well as Dorotabo Yumenari's
known love of Shin-Yoshiwara.

As the ghost of a dead man, Dorotabo only marginally fits
in the Yurei category but for such a spooky mud monster we
make an exception.

YOKAIOLOGY
Yurei and Kabuki Theater

Like most supernatural creatures of Japan, Yurei have evolved over the years. In the oldest stories, they are invisible, formless creatures like the Onryo Sugawara no Michizane who show themselves only by their devastating effects of earthquake and storm. Or they look the same as they did in life. *Noh* performances are exemplified by chance meetings with seemingly normal people who reveal themselves to be Yurei in the second half of the play. In many stories these Yurei had physical form. Stories are told of women who are killed, but come home, bear and raise children, and only later are revealed to be Yurei. And then they vanish.

Heian period storytelling was the province of aristocrats. *Noh* performances and hand-written books were entertainment for the wealthy and refined. They were often sophisticated moral lessons of repentance and forgiveness. Only a few, like the jealous Lady Rokujo of *Genji Monogatari* (11th century) gave a taste of what was to come.

Modern depictions of Yurei, dressed in a white burial kimono with wild, unkempt black hair and a pale, screaming visage, is largely a product of the Edo period. Entertainment in the Edo period was for the masses. Woodblock prints and *kabuki* theater encouraged spectacular displays. Storytellers and

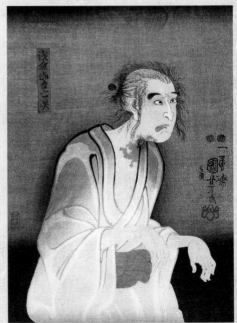

Chapter Four

artists found a ready audience for gory tales of revenge, the bloodier the better.

Maruyama Okyo established the modern Yurei look as a vision of lost love. He painted her in a white kimono with loose white hair in a portrait called *The Ghost of Oyuki* (1750). This became the template for all Yurei to follow.

Kabuki theater in particular had a need for recognizable costumes. Without stage lighting, they couldn't afford to be subtle. The pure white burial kimono offset the bright, colorful costumes of heroes and villains. The wild hair was in defiance of Tokugawa shogunate rules of control over caste hairstyles. The white face and indigo eyes appeared hallowed and sunken on stage. *Kabuki* had found its villain.

Kabuki plays often referenced local Yurei stories, expanding them into full-scale tales of revenge with plots, subplots, and enough characters to fill hours on the stage. Being a theater of special effects, *kabuki* created spectacular scenes to awe the audience and showcase acting talent.

As *kabuki* innovated, artists followed. They adopted the look of *kabuki* Yurei. Scenes from *kabuki* plays became best sellers, with multiple artists doing their own take on some of the classic scenes. Famous Yurei like Oiwa, Otsuyu, and Okiku were resurrected again and again on paper and on stage, feeding audiences hungry for visions of supernatural revenge.

Otsuka haunted by the Yurei of her husband (facing page, left) portrayed by actor Kohada Koheji. From the series *Hyaku Monogatari.* (1830–1832?) Shunbaisai Hokuei.

The Yurei of Asakuri Togo (facing page, right) portrayed by actor Ichikawa Kodanji IV. (1780) Utagawa Kuniyoshi.

Oiwa possesses Iemon's young bride (top) played by the actor Ichikawa Kodanji IV in this scene from *Yotsuya Kaidan.* (1848) Utagawa Kuniyoshi.

Hangonko Invoking Incense

Framing his true love's face in his mind he prepared himself for the ritual. He sat in a darkened room. The room was sparse, only the man and a small dish in front of him, upon which rested a small stick. When he was ready, the man sparked a flame and used it to light the precious treasure in front of him, a small slice of priceless incense that could call forth the dead, Hangonko.

Hangonko is legendary incense that can call back the dead for as long as it burns. Made from the magical Hangonju tree, in a secret recipe, the incense comes from the tree's roots boiled to release the sap. The sap is then hardened into incense. Even a small sliver is said to summon the dead. However, these brief meetings often leave the user sadder at the second parting.

Hangonko is written 反魂香
反魂 (hangon) calling spirits back from the dead
香 (ko) incense

Incense plays a larger role than smelling nice in Japan and Asia. It is often used as an offering at funerals as well as

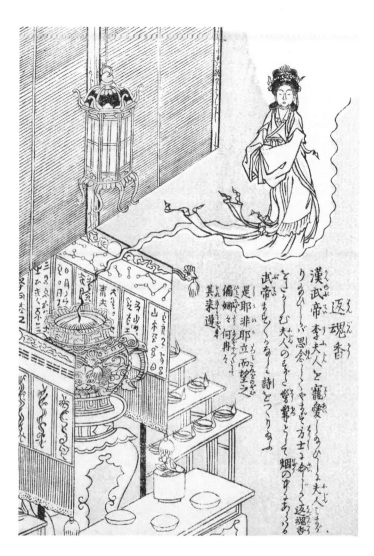

漢武帝李夫人を寵愛しのひかへ夫人こくなとうにむ夫人の心を鬱として烟のゆきあるよりむ思念のひとりふ方士少翁にめいして返魂香をたき夫人のすがたを詩とつくりぬ

武帝李夫人を寵愛しのひかへ夫人

其来遅
偏娜々何冉々
是耶非耶立而望之

返魂香

Hangonko from
Konjaku Hyakki Shui.
(1780) Toriyama
Sekien.

sacred places such as temples and shrines. The smoke is thought to waft up to higher planes. During Obon, the festival of the dead, incense fills the air as families light it to honor their ancestor spirits. It is also used as a sense of refinement and culture. During the Edo period, it became popular to host incense parties where hosts would light rare sticks and attendees displayed their knowledge by identifying the scent and its origin.

Hangonko comes from China. According to the poem *Lǐ fūrén* (8th century) by poet Bai Juyi, Emperor Wu mourned his adored concubine, Li Furen. To ease his grief, a Taoist sorcerer prepared a stick of Hangonko. The tree sap was brewed

and kneaded in a jade pot then burned in a gold furnace. In its smoke the emperor could see his lost love one last time. Supposedly even a pea-sized amount is enough to summon the dead, for a while.

Hangonko was a popular subject in the Edo period. It appeared in the erotic short story collection *Koshoku Haidokusen* (1703). A man in love with a dead prostitute uses Hangonko to summon her. Bai Juyi's poem is referenced in the classic work *Ugetsu Monogatari* (1776), talking of the phantom of the Han palace summoned by Emperor Wu.

Toriyama Sekien included Hangonko in *Konjaku Hyakki Shui* (1781) showing Emperor Wu summoning his beloved Li Furen.

Hitodama Spectral Fireballs

Walking though the rain, you see the soft glow of an orb of fire floating gently in the air. It fills you with a sense of sadness, knowing that it is a lost soul, not yet able to move on yet with no reason to remain. You wish it the best on this rainy night, the little Hitodama.

Hitodama are small balls of fire said to be wayward human souls. They have weaker attachments to the living world, not able to manifest themselves as full Yurei. Hitodama have little agency and seems to not do much other than float through the air. Yurei often appear accompanied by these little glowing balls, as if attracted to the superior will and attachment of the manifest phantom.

Hitodama from the *Kaidan Ektoba* scroll profiling thirty-three Yokai and human oddities from Japan and overseas. Labeled a Russian Hitodama, this is likely a pun based on "oroshia" (Let me down!) which sounds like the old Japanese pronunciation of "Russia." (mid-19th century) Artist unknown.

> **Hitodama** is written 人魂
> 人 (hito) person, human
> 魂 (dama, tameshi) soul

Japan has many types of glowing orbs of light, attributed to many actors. Kitsune summon Kitsunebi. Oni manifest onibi. Shiranui are lights in the Yatsushiro Sea and the Ariake Sea off Kyushu. There are dozens more. These lights are equivalent to the Western Will o' the Wisp and others that appear in all cultures on earth. They are explained away by myriad natural phenomena, from swamp gas to combusting phosphorus to fireflies to refracted light to ball lighting. And yet some still go unexplained.

Hitodama from *Konjaku Gazu Zoku Hyakki.* (1779)
Toriyama Sekien.

Yurei Ghosts

Hitodama are mentioned as far back as the poem collection *Man'yoshu* (759) which mentions the melancholy blue light and the sorrow it brings on rainy nights. Hitodama are generally described as bluish, but sometimes orange as well. They are often round with long tails. *Kabuki* theater made great use of Hitodama, presenting them as firepots on long poles accompanying Yurei characters when they came onto the stage.

Toriyama Sekien illustrated Hitodama in *Konjaku Gazu Zoku Hyakki* (1779) as looking something like a misshapen balloon with a long string. Other artists illustrated them as wisps of red or blue flame, often accompanying famous Yurei such as Oiwa. Utagawa Toyokuni showed actor Matsusuke Onoe as Oiwa, accompanied by dramatic flaming streaks as large as herself.

Hitodama are often seen in modern manga, where they present a pleasing visual effect accompanying all manner of Yokai.

Gashadokuro Gigantic Skeletons

A Hitodama, a willow tree, a Tsukumogami mirror, and a sickle. (19th or 20th century) Artist unknown.

The great skeleton towered over you, larger than anything you had ever seen. It shambled forward, shaking the ground with each step. The bones rattled as it walked inevitably forward, the great doom of the Gashadokuro.

Gashadokuro are enormous skeletons, standing as tall as skyscrapers. They are built of the bones of soldiers and those who died of famine and were left to rot on the ground. Their resentment at their deaths and rage at being forgotten binds them. Their accumulated bones merge together to form the massive skeleton.

Gashadokuro is written **餓者髑髏**
餓者 (gasha) starving person
髑髏 (dokuro) skull

Famines were once a part of life in Japan. Bad harvests could kill thousands in months, depopulating villages. One of the worst, the Tenmei Famine from 1781–1789 was estimated to have killed around one hundred and thirty thousand people. Combine this with war and plagues and other disasters, and you have a country littered with acres of unburied corpses.

Gashadokuro is a modern Yokai, first appearing in *Bessatsu Shoujyo Friend* (1966). By all accounts it was created by writer Saito Morihiro. Yamauchi Shigeaki wrote about Gashadokuro in *Sekai Kaiki Thriller* (1968) and around the same time Mizuki Shigeru began to include the new Yokai in his works.

Gashadokuro is based on a 10th century legend of Princess Takiyashi, daughter of Taira Masakado. Caught up in intrigues in the imperial court, Masakado led an unsuccessful revolt in 939. He was beheaded by Fujiwara no Hidesato in 940. That is the historical part of the story. The legend continues that Masakado's daughter Takiyashi was a powerful sorceress. Using her magic, she summoned

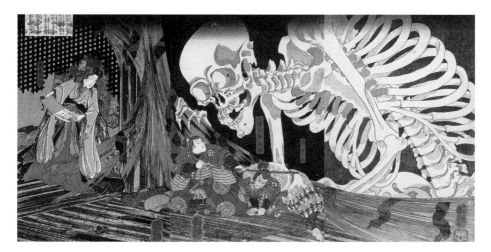

the bones of the dead who died fighting for her father and created a massive skeleton creature. Using her monster, she attacked the capital city of Kyoto. Takiyashi's creature was too powerful to resist, and the court surrendered her father's head where it was buried with honors in Edo. The grave still stands near the Tokyo Imperial Palace.

Saito Morihiro and other artists were inspired to create new Yokai by Utagawa Kuniyoshi's famous print *Takiyashi the Witch and the Skeleton Spectre* (1844). One of the most famous works of Japanese art, it shows the huge skeleton summoned by Takiyashi to revenge her father. All other artists have copied this image, adding backstory to create the new Yokai.

Aoandon Summoned Ghoul

With a single candle remaining, those gathered in the circle trembled in fear. The game of *Hyakumonogatari Kaidankai* had been entertaining and terrifying, but now it was getting real. They all looked at each other, hoping someone would stop the ritual. After all, they knew that if the last story was told and the last candle extinguished, they would summon the final monster, Aoandon.

Aoandon is the Yokai said to appear when the final candle is extinguished during games of *Hyakumonogatari Kaidankai*. It wears a white kimono and glows with a blue light. It has sharp teeth, claws, and horns.

> **Aoandon** is written 青行燈
> 青 (ao) blue
> 行燈 (andon) paper lantern

Hyakumonogatari Kaidankai was a popular parlor game during the Edo period. A hundred lanterns or candles would be lit, and then guests would take turns telling scary stories. With each story told, a single candle would be extinguished. As the room got darker and darker, the tension would rise. The game was a test of courage. Before the final candles were put out, someone would inevitably call a halt to the game, freeing everyone from what lay beyond. It was said that with the final candle out a Yokai would appear. When playing the game, blue paper was sometimes pasted over lanterns to create an atmosphere. That is where Aoandon gets its name.

Sekien illustrated Aoandon in *Konjaku Hyakki Shui* (1781). It is not known if this is an original Sekien creation or not, or even if Aoandon refers to the creature or the lantern. Older versions of *Hyakumonogatari Kaidankai* summon creatures

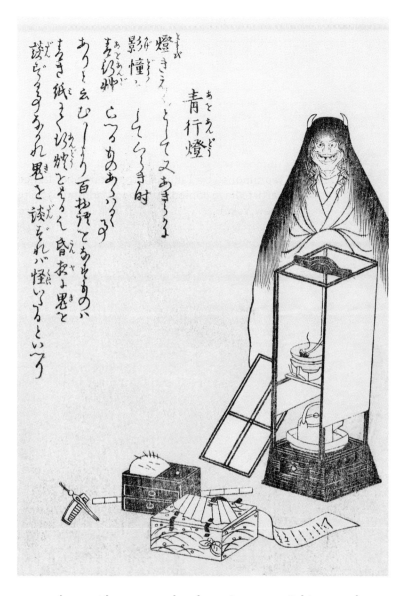

燈きえんとしてまたもゆる
影憧（かげぼうし）ひとつものあやしく
青行燈（あをあんどう）
ありとてもむしろ百物（ひゃくもの）
あつき紙まく坊神（ぼうじん）ともろく昏夜（くらよる）の鬼（き）
談（かた）らるるほうれば鬼（き）を談（かた）らるれば怪（あやし）ひろといふ

such as spiders to test the players' courage. Sekien may have been inspired by the blue lanterns used by the game to imagine the final creature that appeared with the last lantern.

There are few legends that mention Aoandon, but it seemed a fitting Yokai with which to end this book. If you want to learn more, perhaps you can play the game yourself and see what secrets Aoandon has to give.

But be sure to heed Toriyama Sekien's warning.

"Speak of monsters and monsters appear."

Aoandon from
Konjaku Hyakki Shui.
(1780) Toriyama
Sekien.

Yurei Ghosts

Further Reading

In addition to the Selected Bibliography, the works below will help you further explore the world of Yokai and supernatural Japan. Enjoy!.

Komatsu, Kazuhiro. (2018). *Introduction to Yokai Culture: Monsters, Ghosts, and Outsiders in Japanese History*. Tokyo: Japan Publishing Industry Foundation for Culture.

Meyer, Matthew. (2015a). *The Night Parade of One Hundred Demons: A Field Guide to Japanese Yokai*

_____. (2015b). *The Hour of Meeting Evil Spirits: An Encyclopedia of Mononoke and Magic.*

_____. (2021). *The Book of the Hakutaku: A Bestiary of Japanese Monsters*, 2018.

_____. (2022). *The Fox's Wedding: A Compendium of Japanese Folklore.*

Murakami, Kenji. (2023). *Strange Japanese Yokai: A Guide to Weird and Wonderful Monsters, Demons and Spirits*. Rutland, VT: Tuttle Publishing.

Nishimoto, Keisuke. (2021). *Strange Tales from Japan: 99 Chilling Stories of Yokai, Ghosts, Demons and the Supernatural*. Rutland, VT: Tuttle Publishing.

Yoda, Hiroko, and Alt, Matt. (2012a). *Yurei Attack!: The Japanese Ghost Survival Guide*. Rutland, VT: Tuttle Publishing.

_____. (2012b). *Yokai Attack!: The Japanese Monster Survival Guide*. Rutland, VT: Tuttle Publishing.

Yumoto, Koichi. (2013). *Yokai Museum: The Art of Japanese Supernatural Beings from YUMOTO Koichi Collection*. Tokyo: PIE International.

Selected Bibliography

The majority of sources used were primary sources. However, since this book was written for English-speaking readers, I have not included most of the Japanese language sources that were referenced.

Cavaye, Ronald, Griffith, Paul, and Akihiko Senda. (2004). *A Guide to the Japanese Stage: From Traditional to Cutting Edge*. Tokyo: Kodansha.

Comee, Stephen. (2012). *Supernatural Beings from Japanese Noh Plays of the Fifth Group: Parallel Translations with Running Commentary*. Ithaca, NY: Cornell East Asia Series.

Davis, Frederick Hadland. (1914). *Myths and Legends of Japan.*

Davisson, Zack. (2018). *Yokai Stories*. Seattle: Chin Music.

_____. (2020). *Yurei: The Japanese Ghost*. Seattle: Chin Music.

_____. (2021). *Kaibyo: The Supernatural Cats of Japan*. Seattle: Mercuria Press.

Eastburn, Melanie. (2020). *Japan Supernatural: Ghost, Goblins, and Monsters, 1700 to Now*. Sydney: Art Gallery of New South Wales.

Figal, Gerald A., and Masao Miyoshi. (1999). *Civilization and Monsters: Spirits of Modernity in Meiji Japan*. Durham, NC: Duke University Press.

Foster, Michael Dylan. (1998). "The Metamorphosis of the Kappa: Transformation of Folklore to Folklorism in Japan." *Asian Folklore Studies*, Jan. https://doi.org/10.2307/1178994.

_____. (2009). *Pandemonium and Parade: Japanese Monsters and the Culture of Yokai*. Berkeley: University of California Press.

_____. (2015). *The Book of Yokai: Mysterious Creatures of Japanese Folklore*. Berkeley: University of California Press.

Harada, Violet H. (1976). "The Badger in Japanese Folklore." *Asian Folklore Studies* 35 (1): https://doi.org/10.2307/1177646.

Hearn, Lafcadio. (1894). *Glimpses of Unfamiliar Japan.*

_____. (1899). *In Ghostly Japan.*

_____. (1900). *Shadowings.*

_____, (1904), *Kwaidan: Stories and Studies of Strange Things.*

Hellyer, Robert, and Fuess, Harald. (2022). *The Meiji Restoration: Japan as a Global Nation.* Cambridge, UK: Cambridge University Press.

Katz-Harris, Felicia. (2019). *Yōkai: Ghosts, Demons & Monsters of Japan.* Santa Fe: Museum of New Mexico Press.

Lowell, Percival. (1894). *Occult Japan: Shinto, Shamanism, and the Way of the Gods.*

Masato, Mori. (1982). "Konjaku Monogatari-Shū: Supernatural Creatures and Order." *Japanese Journal of Religious Studies* 9 (2–3). https://doi.org/10.18874/jjrs.9.2-3.1982.147-170.

Mayer, Fanny Hagin. (1986). *The Yanagita Kunio Guide to the Japanese Folk Tale.* Bloomington: Indiana University Press.

Mizuki, Shigeru. (2004). 水木しげる妖怪大百科.

_____. (2005). 水木しげる妖怪百物語.

_____. (2012). *NonNonBa.* Montreal: Drawn and Quarterly.

_____. (2014). 決定版日本妖怪大全: 妖怪・あの世・神様.

_____. (2016). *The Birth of Kitaro.* Montreal: Drawn and Quarterly.

_____. (2021). *Tono Monogatari.* Montreal: Drawn and Quarterly.

_____. (2023). *Yokai: The Art of Shigeru Mizuki.* Montreal: Drawn and Quarterly.

O'Neill, Daniel. (2002). "San'yutei Encho's Ghosts and the Aesthetics of Things Unseen." *Review of Japanese Culture and Society* 14 (Dec.): 1–8. https://ci.nii.ac.jp/naid/110000068406.

Reider, Noriko T. (2002). *Tales of the Supernatural in Early Modern Japan: Kaidan, Akinari, Ugetsu Monogatari.* Lewiston, NY: Edwin Mellen.

_____. (2003). "Transformation of the Oni-From the Frightening and Diabolical to the Cute and Sexy." *Asian Folklore Studies* 62 (1): 133–57. http://ci.nii.ac.jp/naid/40006001985.

_____. (2009). "Animating Objects: Tsukumogami Ki and the Medieval Illustration of Shingon Truth." *Japanese Journal of Religious Studies*, July. https://doi.org/10.18874/jjrs.36.2.2009.231-257.

_____, (2010), *Japanese Demon Lore: Oni from Ancient Times to the Present.* Logan, UT: Utah State University Press.

_____. (2016). *Seven Demon Stories from Medieval Japan.* Denver, CO: University Press of Colorado.

_____. (2017). "Shuten Dōji (Drunken Demon):" *Utah State University Press EBooks*, August, 30–52. https://doi.org/10.2307/j.ctt4cgpqc.8.

_____. (2019). "Yamauba and Oni-Women: Devouring and Helping Yamauba Are Two Sides of the Same Coin." *Asian Ethnology* 78 (2): 403–27. https://ci.nii.ac.jp/naid/120007042340.

_____. (2021). *Mountain Witches: Yamauba.* Denver, CO: University Press of Colorado.

Sekien, Toriyama. (2017). *Japandemonium Illustrated: The Yokai Encyclopedias of Toriyama Sekien.* Mineola, NY: Dover.

Shamoon, Deborah. (2013). "The Yōkai in the Database: Supernatural Creatures and Folklore in Manga and Anime." *Marvels and Tales* 27 (2): 276. https://doi.org/10.13110/marvelstales.27.2.0276.

Stone, Jacqueline I., and Walter, Mariko Namba. (2008). *Death and the Afterlife in Japanese Buddhism.* Honolulu: University of Hawaii Press.

Storm, Jason Ananda Josephson. (2012). *The Invention of Religion in Japan.* Chicago: University of Chicago Press.

Tales of Japan: Traditional Stories of Monsters and Magic. (2019). San Francisco: Chronicle Books, 2019.

Tyler, Royall. (2002). *Japanese Tales.* New York: Pantheon.

Ueda, Akinari. (2007). *Tales of Moonlight and Rain.* New York: Columbia University Press.

Yanagita, Kunio. (1910). *The Legends of Tono.*

Yanagita, Kunio, and Sasaki, Kizen. (2015). *Folk Legends from Tono: Japan's Spirits, Deities, and Phantastic Creatures.* Lanham, MD: Rowman & Littlefield.

Yoda, Hiroko, and Alt, Matt. (2012a). *Yurei Attack!: The Japanese Ghost Survival Guide.* Rutland, VT: Tuttle Publishing.

_____. (2012b). *Yokai Attack!: The Japanese Monster Survival Guide.* Rutland, VT: Tuttle Publishing.

Index

Published by Tuttle Publishing, an imprint of
Periplus Editions (HK) Ltd.

www.tuttlepublishing.com

Copyright © 2024 Zack Davisson
Photos: All photos are in the public domain
unless otherwise noted.
Front cover image: Eleonora D'Onofrio

Isbn: 978-4-8053-1773-0

27 26 25 24 10 9 8 7 6 5 4 3 2 1
Printed in Singapore 2403TP

Distributed by

North America, Latin America & Europe
Tuttle Publishing
364 Innovation Drive
North Clarendon, VT 05759-9436 U.S.A.
Tel: 1 (802) 773-8930
Fax: 1 (802) 773-6993
info@tuttlepublishing.com
www.tuttlepublishing.com

Japan
Tuttle Publishing
Yaekari Building 3rd Floor
5-4-12 Osaki
Shinagawa-ku
Tokyo 141-0032
Tel: (81) 3 5437-0171
Fax: (81) 3 5437-0755
sales@tuttle.co.jp
www.tuttle.co.jp

Asia Pacific
Berkeley Books Pte. Ltd.
3 Kallang Sector #04-01
Singapore 349278
Tel: (65) 6741 2178
Fax: (65) 6741 2179
inquiries@periplus.com.sg
www.tuttlepublishing.com

"Books to Span the East and West"

Tuttle Publishing was founded in 1832 in the small New England town of Rutland, Vermont
[USA]. Our core values remain as strong today as they were then—to publish best-in-class
books which bring people together one page at a time. In 1948, we established a publishing
outpost in Japan—and Tuttle is now a leader in publishing English-language books about the
arts, languages and cultures of Asia. The world has become a much smaller place today and
Asia's economic and cultural influence has grown. Yet the need for meaningful dialogue and
information about this diverse region has never been greater. Over the past seven decades,
Tuttle has published thousands of books on subjects ranging from martial arts and paper
crafts to language learning and literature—and our talented authors, illustrators, design-
ers and photographers have won many prestigious awards. We welcome you to explore the
wealth of information available on Asia at **www.tuttlepublishing.com**.